The Business of PHOTOGRAPHY

The Business of
PHOTOGRAPHY

by Robert M. Cavallo and
Stuart Kahan

A Herbert Michelman Book
CROWN PUBLISHERS, INC., NEW YORK

Printed in the United States of America
Published simultaneously in Canada by General Publishing Company Limited

Library of Congress Cataloging in Publication Data

Cavallo, Robert M.
 The business of photography.

 "A Herbert Michelman book."
 Includes index.
 1. Photography—Business methods. I. Kahan,
Stuart. II. Title.
TR581.C38 1981 770'.68 81-905
ISBN: 0-517-539454 AACR2
Design by Lauren Dong
10 9 8 7 6 5 4 3 2 1
First Edition

To Mary and Dominick—
and to the memory of Donna Cavallo

Contents

Introduction

You have just graduated from photography school. You are technically proficient. You go to your local camera shop and buy a 35mm Nikon, flash equipment, a tripod, and seven hundred rolls of Kodacolor II. And, while you're in such an expansive (and expensive) mood, you buy a genuine elephant-skin bag to carry everything in.

You call your favorite aunt and tell her you will now take care of her impending marriage . . . the photography, that is. Confidently, you assure her that she will get the best wedding pictures ever made and you will charge her whatever it costs you for film and processing, plus a few extra bucks for your time and effort. After all, you want to make a profit out of this, too.

You are in the photography business, right?

But comes the day of the shooting, and the flash doesn't seem to work properly; you find yourself taking the shades off the lamps to obtain more light. Then, someone named Clyde trips over your tripod and breaks a thumb. A bald-headed character from the catering establishment wants to see your license and all you can do is blink—a license? And whatever shots you did take have been ruined by the laboratory, which says, "It ain't our fault." The result is that in appreciation, your aunt decides you aren't worth a plugged nickel and cuts you out of her will.

You are in the photography business, right?

And, to make matters even worse, the pièce de résistance: the local tax authorities are now billing you for failure to file state unincorporated business tax forms.

Quite a photography business you've got there, eh?

It sounds as if all this is a fabricated nightmare, but the nightmare is that it is all true.

We have been dealing with professional photographers for more than twenty years—on the legal and business side—and what we have found has been frightening. Photography as a profession is indeed a business, and if you intend to stay in this occupation long enough to enjoy the photographic aspect of it, then it is mandatory that you understand the basics in operating such an enterprise.

What are we talking about? First of all, this book is *not* intended to show you how to load a camera, or what kind of film to use in a snowstorm, or where to rent strobes on a Sunday afternoon in July. The technical aspects of photography can be found in numerous books and in a variety of courses taught at schools all over the country. (We cover some of those in Chapter 1.)

Our thrust is on setting up the business, the legal requirements, the question of licenses, permits, incorporation, record keeping, insurance, taxation, contracts with clients, selling your work, and all those ways to keep your operation afloat and to make it worthwhile. Most photographers fail to establish and stay in business because they lack knowledge. They don't understand what it takes to manage their trade. The management and marketing of this trade are essential.

If you were with us on our first go-around, you should have a pretty good idea of the law of photography. Here is the business of photography.

Robert M. Cavallo
Stuart Kahan

October 1980

PREPARING TO GO INTO PHOTOGRAPHY

Educational Requirements

What should you know and where do you get the knowledge? Leading questions.

One fact should be obvious: you shouldn't be going into photography unless you have some idea of what it is you're supposed to be doing. You wouldn't start brain surgery unless you knew what would greet you in the operating room, would you? Photography is no different. It is insanity to suggest that people jump into any business without knowing something about it, but facts today belie that statement. More and more people are opting for their own businesses, and as a result, there are many opening and just as many folding because of a lack of management knowledge. Witness all those frozen-custard and hamburger franchises popping up around the country. See how many close or change hands within a year.

It doesn't seem to matter what you did before. Former dock workers are operating haute cuisine restaurants. Granted, some succeed, but most fail. Don't forget the interior designer who gave up a multimillion-dollar business to open a Carvel stand on the Jersey shore. When things don't quite pan out, she has to review the wreckage. Was it the location? Was it bad business sense? Was it a combination of things, including not understanding what is involved?

Keep this in mind. Photography, despite all the talk about its "artsiness," is a business, and if you want to be in it after you pay the piper on April 15, then you had better know what it is you are doing. Naturally, if you are independently wealthy and your livelihood doesn't depend on what you do behind the camera, then it doesn't really matter, does it?

For example, we know a photographer who is perhaps the worst businessperson in the world, at least when it comes to photography.

However, he inherited a quarter of a million dollars and has more stocks and bonds than his lawyer. He doesn't really care too much if he makes only $5,000 a year from photography, but with proper business practices, he could earn considerably more. He is the only photographer we know with that kind of background, and he is the exception to the rule. Most photographers we deal with are not in that category.

Now, let's look at the title of this chapter. Do you need a formal education to be a professional photographer? The answer is obvious—a big, fat NO! You don't need a college degree, a doctorate, a master's, or even a high-school diploma. You could have gone only as far as kindergarten. Formal education is not a prerequisite. Some of the finest photographers received their education by working in the field—learning by trial and error. Others served apprenticeships with great photographers or were assistants to working professionals. There are also a number who carry bachelor's degrees from universities. One client has a doctorate from Yale and is considered one of the top moneymaking photographers on the scene today.

As you can see, acquiring knowledge cuts across many areas and fields.

Now, what if you really want to learn? Where can you get the required knowledge?

There are a number of sources. You can exhaust a bank account just buying the abundance of books dealing with photography. The subjects range from filters to lenses to cameras to tripods. You name the subject, and no matter how specific, someone has written about it.

You can also ask. Call or write the professionals and ask questions. Most will give you the answers you need. Photographers enjoy sharing information. You can get a list of the photographers in your area by consulting your local telephone directory.

The third way is to obtain the knowledge through courses taught at various schools around the country. There is hardly a community that doesn't offer some course in photography, whether an adult-education program at the neighborhood high school or at a photography studio specifically set up for that purpose. Check your telephone directory or contact the schools in your area for further information.

For example, at New York University in New York City, a wide program is offered to beginning and advanced students covering everything from the essentials of camera use to darkroom procedures.

You don't have to be a full-time student to attend. Many of these courses are taught at night as part of a continuing-education program for the community. The courses are designed to give students "greater experience and awareness of the medium's potential for creative expression." In addition, the university says that all workshops have limited enrollments to ensure individual attention for each student.

Take NYU's Introduction to Photography course. Here is what you get if you sign up for the seven-session program:

A beginning course in the theory and practice of photographic techniques. Students acquire a knowledge of the essential aspects of camera use—optics, camera formats, lenses, f-numbers, light meters, film selection, basic composition, electronic and tungsten flash, lighting and filters. Other topics include: determining sources and standards for equipment and supplies and obtaining maximum results from commercial processing houses and custom laboratories. Distinctions between black-and-white and color are made throughout the course. Students are encouraged to complete several assignments which illustrate class lectures.

That's just a beginning course; you can imagine what the advanced courses are like. In addition, a number of schools offer business and legal instruction. For instance, we taught photography and the law at NYU as part of their continuing-education program. Our course covered ten sessions, every Wednesday night, from six to nine. Our students ranged from full-time professional photographers to weekend camera buffs. What we taught, however, applied to all. We supplied answers to basic questions such as, Can I shoot anything I want? Can I copyright my pictures? Do I need a subject's release to sell a photograph? How should a release be worded? Who owns the rights—subject or photographer?

Photography is no longer in the Dark Ages. It has grown so much that most of the major universities are now offering courses leading to a degree with a major in photography. In fact, in 1972 Princeton became the first university to establish a professorship in the history of photography.

Are there that many photographers, anyway? There are millions, but try these statistics: it is estimated that there are more than 115,000 *professional* photographers in this country alone and over 25,000 photographic studios.

The latest survey shows that within the past three years enrollments at schools for photography and graphic arts courses has risen

to more than 162,000. There are now more than 800 institutions in the United States offering photographic instruction.

Along with this increase in student enrollments has come a 21 percent increase in colleges and universities offering programs in motion pictures, still photography, and graphic arts.

Furthermore, the number of students who graduated from associate, bachelor's, master's, and doctoral programs with majors in the above three fields increased from 5,111 in 1974 to 6,481 in 1978. In fact, with respect to photography alone, there is a large number of schools in the United States that offer instruction in still photography, and many offer specific degrees.

The following is a listing of some of those schools, arranged by state. If any one is in your area, you might want to investigate what is taught and what degrees or certificates are issued. For example, Boston University in Boston, Massachusetts, and Princeton University in Princeton, New Jersey, both offer Ph.D. degrees in still photography.

ALABAMA

Alabama A & M University
Normal

Alabama State University
Montgomery

Auburn University
Auburn

Birmingham-Southern College
Birmingham

George C. Wallace Community
College
Dothan

Jacksonville State University
Jacksonville

Jefferson Davis State Junior
College
Brewton

John C. Calhoun State Community College
Decatur

Judson College
Marion

University of Alabama
University

ALASKA

Juneau Douglas Community
College
Juneau

Sitka Community College
Sitka

ARIZONA

Arizona State University
Tempe

Mohave Community College
Kingman

Northern Arizona University
Flagstaff

Northland Pioneer College
Show Low

Pima Community College
Tucson

Scottsdale Community College
Scottsdale

University of Arizona
Tucson

Yavapai College
Prescott

ARKANSAS
Arkansas State University
State University

Harding College
Searcy

University of Arkansas at Little
Rock
Little Rock

CALIFORNIA
Allan Hancock College
Santa Maria

Ambassador College
Pasadena

Bakersfield College
Bakersfield

Brooks Institute
Santa Barbara

California College of Arts and
Crafts
Oakland

California Institute of the Arts
Valencia

California Polytechnic
San Luis Obispo

California State University, Chico
Chico

California State University, Fres-
no
Fresno

California State University, Long
Beach
Long Beach

California State University,
Northridge
Northridge

Chaffey College
Alta Loma

Citrus College
Azusa

City College of San Francisco
San Francisco

Cuesta College
San Luis Obispo

Cypress College
Cypress

De Anza College
Cupertino

Foothill College
Fresno

Fresno City College
Fresno

Hamilton School of Photography
Los Angeles

Lone Mountain College
San Francisco

Long Beach City College
Long Beach

Merced College
Merced

Mount San Jacinto College
San Jacinto

Ohlone College
Fremont

Pierce College
Woodland Hills

Saddleback College
Mission Viejo

San Francisco Art Institute
San Francisco

San Jose State University
San Jose

University of Southern California
Los Angeles

West Valley College
Saratoga

COLORADO
Colorado Mountain College
Glenwood Springs

University of Colorado, Boulder
Boulder

CONNECTICUT
Connecticut College
New London

Paier School of Art
Hamden

Western Connecticut State
 College
Danbury

DELAWARE
University of Delaware
Newark

DISTRICT OF COLUMBIA
George Washington University
Washington

Howard University
Washington

FLORIDA
Art Institute of Ft. Lauderdale
Ft. Lauderdale

Brevard Community College
Cocoa

Daytona Beach Community
 College
Daytona Beach

Florida Atlantic University
Boca Raton

Pasco-Hernando Community
 College
Port Richey

University of South Florida
Tampa

GEORGIA
Art Institute of Atlanta
Atlanta

Georgia Institute of Technology
Atlanta

HAWAII
University of Hawaii, Manoa
Honolulu

IDAHO
Ricks College
Rexburg

University of Idaho
Moscow

ILLINOIS
Belleville Area College
Belleville

College of Du Page
Glen Ellyn

Governors State University
Park Forest South

Illinois Institute of Technology
Chicago

Illinois State University
Normal

Southern Illinois University
Carbondale

University of Illinois, Chicago
 Circle Campus
Chicago

INDIANA
Indiana University
Bloomington

Purdue University
West Lafayette

University of Notre Dame
Notre Dame

IOWA
University of Iowa
Iowa City

KANSAS
Garden City Community College
Garden City

Hesston College
Hesston

KENTUCKY
Northern Kentucky University
Highland Heights

Western Kentucky University
Bowling Green

LOUISIANA
Louisiana Tech University
Ruston

MAINE
Portland School of Art
Portland

University of Maine, Portland–
 Gorham
Gorham

MARYLAND
Allegany Community College
Cumberland

Catonsville Community College
Catonsville

Cecil Community College
Northeast

College of Notre Dame
Baltimore

Essex Community College
Baltimore County

Frederick Community College
Frederick

Maryland Institute College of Art
Baltimore

Visual Arts Institute
Baltimore

MASSACHUSETTS
Bridgewater State College
Bridgewater

Endicott College
Beverly

Fitchburg State College
Fitchburg

Boston University
Boston

Hallmark Institute
Turners Falls

Lesley College
Cambridge

New England School of
 Photography
Boston

School of the Museum of Fine
 Arts
Boston

Tufts University
Medford

Worcester State College
Worcester

MICHIGAN
Center for Creative Studies
Detroit

Central Michigan University
Mount Pleasant

Cranbrook Academy of Art
Bloomfield Hills

Kalamazoo Valley Community
 College
Kalamazoo

Lansing Community College
Lansing

Madonna College
Livonia

Washtenaw Community College
Ann Arbor

MINNESOTA
Film in the Cities
St. Paul

Lightworks
Minneapolis

Mankato State University
Mankato

Rochester Community College
Rochester

Saint Cloud State University
Saint Cloud

Staples Area Vocational
 Technical Institute
Staples

University of Minnesota
Minneapolis

MISSISSIPPI
University of Southern
 Mississippi
Hattiesburg

MISSOURI
Kansas City Art Institute
Kansas City

Northeast Missouri State
 University
Kirksville

Northwest Missouri State
 University
Maryville

University of Missouri, Columbia
Columbia

Webster College
St. Louis

MONTANA
Montana State University
Bozeman

NEBRASKA
Southeast Community College
Lincoln

NEW HAMPSHIRE
Plymouth State College
Plymouth

NEW JERSEY
Brookdale Community College
Lincroft

Glassboro State College
Glassboro

Gloucester County College
Sewell

Princeton University
Princeton

Rutgers University
New Brunswick

Stockton State College
Pomona

Trenton State College
Trenton

NEW MEXICO
College of Santa Fe
Santa Fe

University of New Mexico
Albuquerque

NEW YORK
Colgate University
Hamilton

Community College of the Finger
 Lakes
Canandaigua

Fashion Institute of Technology
New York City

Lake Placid School of Art
Lake Placid

New School for Social Research
New York City

New York University
New York City

Pratt Institute
New York City

Rochester Institute of Technology
Rochester

School of Visual Arts
New York City

State University of New York at
 Buffalo
Rochester

State University of New York at
 Oneonta
Oneonta

State University of New York at
 Plattsburgh
Plattsburgh

State University of New York
 Agricultural and Technical
 College at Farmingdale
Farmingdale

Sullivan County Community
 College
Loch Sheldrake

Syracuse University
Syracuse

NORTH CAROLINA
Appalachian State University
Boone

Chowan College
Murfreesboro

East Carolina University
Greenville

North Carolina Agricultural and
 Technical State University
Greensboro

Randolph Technical Institute
Asheboro

NORTH DAKOTA
Valley City State College
Valley City

OHIO
Columbus College of Art and
 Design
Columbus

Cuyahoga Community College
Cleveland

Kent State University
Kent

Ohio Institute of Photography
Dayton

Ohio State University
Columbus

Ohio University
Athens

University of Toledo
Toledo

OKLAHOMA
Central State University
Edmond

Eastern Oklahoma State College
Wilburton

Oklahoma Christian College
Oklahoma City

Oral Roberts University
Tulsa

University of Oklahoma
Norman

OREGON
Blue Mountain Community
 College
Pendleton

Clackamas Community College
Oregon City

Portland Community College
Portland

Treasure Valley Community
 College
Ontario

PENNSYLVANIA
Bucks County Community College
Newtown

Community College of Philadel-
 phia
Philadelphia

East Stroudsburg State College
East Stroudsburg

Indiana University of Pennsylvania
Indiana

Moore College of Art
Philadelphia

Muhlenberg College
Allentown

Pennsylvania State University
University Park

University of Pittsburgh
Pittsburgh

PUERTO RICO
International American University of Puerto Rico
San German

RHODE ISLAND
Rhode Island College
Providence

SOUTH CAROLINA
Trident Technical College
North Charleston

University of South Carolina
Columbia

SOUTH DAKOTA
South Dakota State University
Brookings

TENNESSEE
David Lipscomb College
Nashville

Memphis Academy of the Arts
Memphis

Memphis State University
Memphis

Middle Tennessee State University
Murfreesboro

TEXAS
Austin Community College
Austin

East Texas State University
Commerce

Kilgore College
Kilgore

Odessa College
Odessa

Sam Houston State University
Huntsville

San Antonio College
San Antonio

Stephen F. Austin State University
Nacogdoches

Sul Ross State University
Alpine

University of Texas, Austin
Austin

UTAH
Brigham Young University
Provo

Utah State University
Logan

Webber State College
Ogden

VERMONT
University of Vermont
Burlington

VIRGINIA
Madison College
Harrisonburg

Northern Virginia Community College
Sterling

Radford College
Radford

Thomas Nelson Community College
Hampton

Virginia Commonwealth University
Richmond

Virginia Intermont College
Bristol

Virginia State College, J. Sargeant Reynolds Community College
Richmond

Virginia State College, John Tyler Community College
Chester

WASHINGTON
Big Bend College
Moses Lake

University of Washington
Seattle

WEST VIRGINIA
James Rumsey Center
Martinsburg

WISCONSIN
Beloit College
Beloit

Madison Area Technical College
Madison

Milwaukee Area Technical College
Milwaukee

Milwaukee Center For Photography
Milwaukee

University of Wisconsin, Platteville
Platteville

University of Wisconsin, Stout
Menomonie

WYOMING
Central Wyoming College
Riverton

University of Wyoming
Laramie

CANADA
Banff Centre, School of Fine Art
Banff, Alberta

Conestoga College
Kitchener, Ontario

Fanshawe College
London, Ontario

Northern Alberta Institute of
Technology
Edmonton, Alberta

Sheridan College
Brampton, Ontario

Vancouver Community College,
Langara Campus
Vancouver, British Columbia

TO SUMMARIZE

You don't have to hold a doctorate to be a professional photographer. In fact, there are no specific educational requirements. However, there are plenty of places where you can learn about photography. Besides the many books on the market, there are photography courses taught in almost every area of this country. The foregoing list is just a starting point.

Four schools have already gained the accreditation of the Photographic Art and Science Foundation. They are Brooks Institute in Santa Barbara, California, Fanshawe College in London, Ontario, Canada, The Hallmark Institute in Turners Falls, Massachusetts, and The New England School of Photography in Boston, Massachusetts.

The educational process of photography is all around you. You need only to open your eyes and ears, and take advantage of what is offered. It's worthwhile!

Licenses and Permits

Do you have to be licensed to be a photographer, professional or otherwise? It depends. That's not a cop-out. The answer depends on where you are and what you are.

For example, a law on the books in North Carolina requires all "professional photographers" to be licensed. Note that it doesn't apply to amateurs. Professional photographers are usually defined as people who are paid to take photographs. The term does not apply to the weekend warrior who takes snapshots of Fido and the beetles on his elm tree. If that were the case, there would be sheer chaos in having to obtain a license in order to use your new Polaroid One-Step. Such a procedure would give the camera the aura of a weapon.

Can you imagine? "Well, Charlie, I would love to take a picture of your two cats sitting atop your stereo, but you see, I'm not licensed to use my 110 Instamatic. I should be getting the final papers in a few weeks."

When you function as a professional photographer, though, there are a number of possible restrictions to be considered. For instance, at the writing of this book, there is a bill being proposed in one eastern state whereby no person would be permitted to engage in the practice of photography "for financial compensation" unless that person is duly licensed. The photographer would have to undergo stringent written and oral examinations, and if accepted, he would have to carry a license on his person when practicing his profession.

As you can see, there is no distinction drawn between the amateur and the professional. It applies to anyone receiving money for services rendered.

Why do such laws crop up? Apparently, in this particular state,

the proponent of the bill felt his daughter's wedding was ruined because of bad photography. In other words, a number of people practice photography for "financial compensation" and they are really nothing more than amateurs with little special training.

Whether the bill is silly or not, the fact remains that it is important to understand the particular requirements, if any, in your state. In many states where legislation was enacted to license photographers, the courts have, for the most part, invalidated such new statutes on the grounds that regulation was not warranted in the first place. The classic decision emanated from Arizona in 1941:

> The business or profession of taking photographs of people, animals and things does not need regulation. It is one of the innocent, usual occupations in which everybody who wishes may indulge as a pastime or hobby or a vocation, without harm or injury to anybody, or to the general welfare, or the public health and morals, or the peace, safety and comfort of the people. It needs no policing.

We agree. And in Hawaii, the court held that any act requiring a license for the practice of photography "is an unconstitutional encroachment upon the liberty of the citizen to choose and pursue an innocent occupation."

One of the first things you should do is to check the law in your jurisdiction to see what is required in order to pursue the art of photography. You can accomplish this by writing the department of licensing at the state capitol.

The following are the current licensing requirements of the fifty states:

NO LICENSING REQUIREMENT

Alaska	Massachusetts	Oregon
Arizona	Michigan	Pennsylvania
California	Minnesota	Rhode Island
Colorado	Mississippi	South Carolina
Connecticut	Missouri	South Dakota
Georgia	Montana	Tennessee
Hawaii	Nebraska	Texas
Idaho	Nevada	Utah
Illinois	New Hampshire	Washington
Indiana	New Jersey	West Virginia
Iowa	New York	Wisconsin
Kansas	North Dakota	Wyoming
Kentucky	Ohio	
Maryland	Oklahoma	

LICENSING BY PAYMENT OF FEE ONLY

Alabama	Louisiana	Vermont
Arkansas	Maine	Virginia
Delaware	New Mexico	
Florida	North Carolina	

(*Note:* The foregoing information has been derived from individual statutes in the various states at the writing of this book. It is, of course, subject to change; therefore, to be doubly sure, write to your local department of licensing.)

While you're at it, you might want to check the local authorities for more specific laws, not only state licenses but local permits.

For example, as we pointed out in our book *Photography: What's the Law?* there might be local laws or ordinances that apply to your working as a photographer. It was not that long ago when a number of states had restrictions on what kinds of businesses could be operated on what days. Pennsylvania was the most notable with its infamous blue laws. Also, bear in mind that if you are setting up a studio, there may be a number of laws and regulations imposed by ordinances. For instance, leases by owners of buildings may have certain restrictions and there may be others set down by various authorities.

You will hear the word *license* half the time and *permit* the other half. License and permit mean pretty much the same. A permit is a formal written permission. A license is also a formal permission granted by competent authority to an individual to do some act or pursue some business that would be unlawful without such permission. For example, you receive a license to preach or to sell intoxicating liquors. A license, then, is a permission *granted* rather than authority conferred. The sheriff has authority (not permission nor license) to make an arrest. In other words, you may be in a state or area that doesn't require you to be licensed but imposes limitations on the ways you can operate under certain circumstances. One state may restrict you from taking photographs on public streets unless you have a permit, while another jurisdiction may limit that permit only to parks.

For example, although there is no state license required in Maryland to be a professional photographer, the city of Baltimore requires a permit for anyone "in the business" of taking photographs on the city's streets.

In New York City, where considerable photography is done by motion-picture companies, television studios, advertising agencies,

as well as independent photographers compiling portfolios, there are several sections of the administrative code that require permits in order to take motion pictures or to telecast or to photograph in certain public places. Other sections of that same code forbid the setting up of tripods in public parks because they may be potential hazards. However, to help facilitate the obtaining of such permits, the city has established additional branches of its licensing division in the center of Manhattan to issue such pieces of paper.

Therefore, local ordinances must be investigated and, where applicable, the proper license or permit must be secured. There are variations here, too.

For instance, the typical museum in the United States is privately owned and supported by gifts. Because of this, those museums are usually not subject to direct state or federal regulations; therefore, most have developed their own set of rules concerning the taking of photographs.

A similar case concerns military installations. The governing rule comes from the United States Code, Title 18, Section 795-797, which says that if the president declares certain vital installations or equipment "privileged," then it is unlawful to take any photographs of them without permission of proper authorities.

To cite another important case, take a look at the populous state of California. Photographers must be aware of the fact that this particular state requires all minors to have a permit in order to perform their services as models. In order to obtain that permit for the models, the photographer must adhere to certain regulations. If the shoot is for more than two and a half hours, a social worker must be hired through the teachers' union, at a cost of $144. On any shoot of two and a half hours or less, the same procedure takes place at a cost of $60. The social worker is empowered to stop the shoot at any time if it is believed to be in the best interests of the minor.

This law, termed the Jackie Coogan law, originally applied to motion pictures. It has been expanded to still photographers and has become so burdensome to the photographer in setting up shoots that many are trying to do the work outside the state. The law pertains not only to in-state photographers but any out-of-state photographers shooting minors within the state. It also covers children who are California residents and who are being photographed on location outside the state.

Failure to observe this regulation can result in a substantial fine to the photographer as well as the possibility of further action by

the state. We have no doubt that it should be changed on behalf of still photographers.

Before we leave this subject, one other thought occurs. It is mandatory for any photographer accepting an assignment to include the costs of acquiring the necessary licenses or permits. If a client wants you to photograph a particular child in California, you might want to include in your fee the cost of obtaining the permit mentioned above. If the job is in behalf of an advertising agency or any other substantial employer, then you might want to consider having the client obtain the permits or licenses directly. If the shoot is on speculation or the client is not that substantial, then it is your duty as the photographer to obtain the clearances to protect yourself.

TO SUMMARIZE

As you can see, the first step in treating your new profession as a business is to begin in a businesslike way. There is no other way: you either function in such a manner at the outset or you are doomed to failure—at least, nine times out of ten, in our experience.

Understand what is required of you in order to operate a business in photography. Write to the department of licensing in your area and find out what the requirements are. At the same time, contact the local authorities so that you know what local regulations, if any, apply. Information is as near as the nearest telephone. There is no excuse for not knowing.

Fields of Photography

By this time, you should be considering the kind of photography you want to do. Are you to be a solo performer, a freelancer with a single room, a desk, a chair, a telephone, a passport, and an American Express card at the ready? Or do you opt for more opulence with a giant studio, seventeen assistants, nine zillion cameras and fifty long-legged models?

How you perform as a photographer may depend a great deal on what it is you are doing. If you decide to open a hamburger franchise, you have a choice of hooking up with McDonald's, Burger King, Wendy's, Roy Rogers, or a few hundred others, or you can make your own. The final result is still hamburger.

With photography, though, there is a wide variety of areas from which to choose, and the end product is not always the same. For example, consider biomedical photography or investigatory photography or aerial photography.

However, before we narrow the field, let's start with some basic components. First, let's look at the difference between freelance work and studio work, and then we'll see how the particular branch of photography fits in.

THE FREELANCE PHOTOGRAPHER

A freelancer is usually the independent photographer with that telephone, desk, chair and passport mentioned above. He generally has no large studio operation and is free (as the term suggests) to go wherever he pleases and do whatever he wants. (Incidentally, we refer to the photographer as he only in the interests of readability; it is also one letter less, which adds up in a book.)

He can be located anywhere and is ready at the drop of a dollar bill (preferably more) to pick up his cameras, fling the knapsack over his shoulder and take off to complete the assignment wherever and whenever it may be.

Most freelancers operate in the area of news photography, including sports and similar current events, although there is no rule that says the freelancer can't also do architecture, portrait, and fashion photography. For the most part, you can say that the freelancer is pretty much by himself and doesn't depend on studios and a number of assistants running about. The freelancer, then, has a rather low overhead. He is also found in the great outdoors. The majority of freelancers work on location, which means at the scene of a particular event—trudging into the forest to shoot raccoons for the *National Geographic* or attending a soccer game in Madrid for *Sports Illustrated.*

Some freelancers are specialists in that they do a particular kind of photography, such as underwater, aerial, or publicity, while others may be capable of handling just about anything and everything that comes down the pike. Those are usually termed generalists.

Bear in mind that a freelancer is primed to go on assignment at the slightest request. That's why most of them keep their passports current and many keep foreign currency at the ready in case the client asks them to fly abroad at a moment's notice.

In effect, the freelancer is like the obstetrician, or better yet, the expectant father. His bag of goodies is always sitting by the front door, poised for action.

How a freelance photographer gets those assignments to utilize that passport and currency is the subject of Chapter 10.

THE STUDIO PHOTOGRAPHER

The freelancer's opposite is the studio photographer, who usually, but not always, does his work indoors. Whether the photographer has a large studio with many assistants scurrying hither and yon or a smaller one with only himself and his wife operating the darkroom, the studio man pretty much stays inside those four walls doing the work assigned. Much of it is advertising, such as catalog brochures for department stores or still-life photographs (like that bottle of twelve-year-old Scotch standing next to the cheaper brand).

What the studio photographer must generally face is a high overhead. First, there is the cost of his space and the rental or purchase

of his room or rooms. Then, it has to be equipped: cameras, tripods, lights, darkroom, kitchen, storage areas, conference room, bathroom, and so forth. And, don't forget people to help in the running of the studio: assistants and other technical personnel. It's as if you had opened up a retail store selling baked goods. All the equipment, all the help, all the rental, all the taxes, all the headaches and, you hope, all the money.

There is nothing to say that the studio photographer can't do freelance assignments outside the studio. Many do.

A good number of studio photographers, especially those in the advertising field, do plenty of work on location. This term is self-explanatory. As we said before, it means that the shooting is done either outdoors or in quarters away from the photographer's home base. For example, that new car sitting on a mesa atop the Grand Canyon was not photographed in someone's studio. And that shot of the surfboarder riding a biggie at Malibu wasn't exactly the product of a basement setup.

The studio photographer then may find himself in the position of shlepping equipment and personnel to distant lands to combat the forces of nature. Working in a sandstorm of the Sahara is not like making a sand pie on your dining-room table.

You can start out as a freelancer shooting the basketball games at Madison Square Garden and wind up taking a team picture in your living room. And by the same token, you can begin doing food photography, shooting a lovely chocolate mousse, and a year later find yourself taking shots of a unique heart transplant.

Inasmuch as we've gone from one extreme to another, let's run down some of the specific areas of photography. We are not covering all the fields, but only the major, popular ones. For ease of reference, we are listing them in alphabetical order.

ADVERTISING

This means exactly what it says—an illustration, by photography, of a particular product or service. For example, Marlboro cigarettes, Hertz Rent-a-Car, United Airlines, or Jell-O. Anything you see that advertises, that pushes a particular product or service, is in the realm of advertising photography.

Sometimes the photograph is a still life, which could be a bushel of beautiful Rome apples for A&P, and sometimes action photography is required, such as three honey-haired beauties cavorting in bi-

kinis for Macy's. Whatever it may be, the idea is to convey a message to the public about the specific product or service that is being sold. The job of the advertising photographer is to assist in that push.

Advertising photography is often called illustrative photography, because something is being illustrated. The advertiser is spending huge sums of money to get his message across to the buying public and what he generally needs is someone who is highly creative, someone who can add "zonk" to the photograph in order to insure the ad's success. Remember, the costs are enormous, not only to the advertiser but also to the photographer. Most advertising photographers have large studios and an incredible array of props and materials, ranging from bottles of expensive liqueurs to Waterford crystal to Pierre Cardin dresses to Queen Anne chairs to a refrigerator stocked with beluga caviar and Belgian chocolates. (Yes, a number of these photographers are overweight, especially those doing food photography.)

The advertising photographer may also use models a great deal of the time, and shooting a model whose legs go up to her capped teeth is not quite the same as the work of the freelancer covering a cesspool cleanup in a slum area.

The advertising person must also be an expert in detail, making sure that every item in his shot is properly lighted, framed, and color- and proportion-balanced, so that the product or service the advertiser wants pushed is made to look sensational. Nothing less will do.

AERIAL

We thought of this when we saw a shot of a jumbo jet flying through the clouds. This specialized area is where you find yourself taking photographs from up high. You can be in an airplane, a helicopter, or dropping down in a parachute. It is a rather unique field and a highly interesting one, if you'll excuse the pun.

Aerial photography is used to a great extent in the planning of cities and similar large-scale projects. In other words, to lay out an airport, survey forest conditions, or draw maps, you generally take to the air. You can work for the government in charting new highways, rivers, and pipelines, or you can work for private industry in designing shopping centers, factories, and housing projects.

As a footnote, we must caution you that the technical aspects are quite different from other fields of photography. We are not detailing in this book the technical aspects of working in any particular

field. To go into the use of a yellow filter such as the Kodak Warren Filter No. 15 for low-altitude aerials, or to consider whether EI 100 is a good starting point for meters marked for ASA exposure indexes would be sheer lunacy. Why? Because we are not experts in this field. Most importantly, we are still having trouble loading our 110 Instamatic.

For the mechanical and scholarly among you, there are plenty of books available that will give you the specific information you need.

ANIMALS AND NATURE

Needless to say, there are photographers who take pictures of neither people, cities, nor buildings. They specialize in taking pictures of animals, plants, trees, and the like. Generally, animals as photographic subjects can be categorized in the following manner: you can shoot animals for advertising purposes such as the koala for Qantas Airlines, for parks, for zoos, for preserves, for amusement centers, or for shows, and so on. It is an unusual field to be sure, and it is not simply pointing a camera at a mouse and saying cheese. One photographer who specializes in this type of photography advises that a knowledge of the animal and its habits, likes, and dislikes is essential. That's an understatement.

Nature photography involves geology and plants and other entities that make up this planet. It also includes microorganisms, as for example, bacteria, viruses, protozoa, and so on.

Generally, then, when we speak of animal and nature photography, we are talking about *all* nonhuman life, including animals, birds, insects, fish, flowers, plants, trees, landscapes, and even sunrises and sunsets.

As you can readily see, there is much to photograph within this specialty. As a prominent nature photographer once said, "There's enough here to last a lifetime . . . and more."

ARCHITECTURAL

Photographers working in this field will usually coordinate their efforts with architects. For example, the architect may need photographs at different stages of a building's design to show to the client. The photographer will find that he may be photographing the subject (which usually doesn't move) for a variety of reasons, ranging from advertising a particular project such as real estate to surveying for the government.

Architectural photography doesn't involve only outdoor work. Many photographers find themselves shooting interiors so that the client can better attract buyers to the project. Some architectural photographers also work as advertising photographers. There is one we know who shoots living rooms of famous designers for a liquor ad.

An architectural photographer is often called upon to shoot scale models. The architect may need to have the model of his project photographed so that he can see the effects of light on the building at various times of the day. The photographer must be able to simulate all this.

Unlike shooting rabbits hopping about, the photographer operating in this area will find himself with a stationary target. His concentration is different. His concern is not on getting a shot before it disappears but rather on other elements, such as lighting, proportion, and balance, to portray the subject in a specific way.

CHILDREN

Baby and child photography is indeed a special breed. Keep in mind you are not dealing with a piece of concrete that doesn't resist what you are trying to do. Photographing children is an art, not so much in the technical aspects, but in being able to capture the child's best qualities. How many of us can forget those days of trying to get our three-month-old to hold a toy telephone next to his ear so that the "cute" picture could be taken? How many of us remember hiding behind little Billy, grasping one leg so that he didn't roll over, and listening to the photographer blow whistles, shake rattles, and make weird-sounding noises with his tongue to get the baby's attention for one brief second in order to snap that shutter?

It's not easy for a three-month-old to pose, not as it would be for an adult. This kind of photography can be most rewarding, and at times, most frustrating. It requires considerable patience by the photographer. But what is better than snapping a once-in-a-lifetime shot of a bald-headed twenty-day-old baby who has smiled for the first time?

COMMERCIAL

There is some confusion as to what a commercial photographer does. Most people think the term is interchangeable with that of the advertising photographer. To some extent it is. A commercial

photographer does advertising photography, among other things; he is usually someone who can do a variety of things. He can shoot a bottle of beer for a print ad and he can film a wedding. He can do portraits of presidents and he can shoot the opening of a new supermarket.

In other words, the list of activities seems almost endless. In effect, a commercial photographer is not necessarily a specialist in any one particular area. He is a generalist and can function in a myriad of areas.

A commercial photographer usually has his own studio and within that studio he can do many, many things. For the most part, he has his own darkroom because speed in what he does is essential. He is going for high-volume and fast turnover. Look at that guy on Main Street with the framed portraits in his window. He does bar mitzvahs, weddings, class pictures, family portraits, passports, ads for the restaurant next door, catalogs for the local business college, banquets for the Rotary Club, and publicity pictures for the radio disc jockey. Now, that's a true commercial photographer if there ever was one.

If money is your goal, you can make a lot of it doing this kind of photography . . . and you will work plenty hard earning it.

DOCUMENTARY

This is the photography of record. In effect, you record what has been done or has taken place. Documentary photography generally involves pictures taken for social purposes. It reproduces events and aspects of our daily living. In fact, some of the greatest photographs ever taken are deemed documentary photographs, and some of the most renowned photographers have worked in this area.

The subjects of documentary photography over the years have most frequently been people, although they are not limited solely to human beings. For example, photographing restoration of a landmark building is documentary photography and so are photographs of closed factories in the Depression years. Documentary photography becomes the chronicle of life, the history of events and of mankind from life to death.

EDITORIAL

An editorial photographer is one who works primarily for magazines, newspapers, books, and similar print media in the areas of

photojournalism and illustration. Editorial work tells something; it is visual reporting. It is dissimilar from advertising photography in that it generally does not try to sell a product or service. Instead, it is selling a story. For example, a hotel fire comes under editorial photography; so does the circus's coming to town, or the trial of an assemblyman. These are all current news events and well outside the realm of commercial advertising ventures.

Known as a photojournalist, the photographer is generally a free-lance photographer (or sometimes the employee of one of the publications) who covers stories, whether they are created by personalities or events.

The photography done in this area is usually all on assignment. A picture editor of a magazine may call you to go shoot the landing of the Concorde or the action at the Super Bowl. As soon as you hang up the receiver, you grab your knapsack (remember the one sitting by the front door?) and off you go to record the events of the day. It can be exciting and it can be dangerous. It is certainly not boring.

FASHION

You could call this a part of advertising or commercial photography. This photographer shoots fashions of the times, whether for publication or for particular products. A fashion photographer may work for a magazine in conjunction with a specific article detailing the fashion trends of the day or she may film actual products by a particular manufacturer. (We're using the female pronoun here because many of the fashion photographers on the scene today are female; Barbara Bordnick, for example.)

Actually, it is said that some of the most creative photography is being done in the fashion area. It entails a mingling of artistry in camera work and expertness in fashion, with the ability to translate and transmit the subjects effectively.

It is probably because of this that many fashion photographers eventually move into film work. Two we know have gone into television: one is doing commercials and the other has recently directed a one-hour variety show.

FOOD

Again, it's part of the commercial photographer's world, but since it is so specialized, we have included it as a separate category. Keep

in mind that just because you can shoot a model wearing a fur coat for a magazine ad, this does not automatically qualify you to shoot a chocolate ice-cream cone.

The challenges in shooting food are unique. One, of course, is being able not to eat the product before you get a chance to put it on film. The second is to make the audience really want to taste what they see. Can you make that ice-cream cone so tantalizing that the reader feels like eating it right off the page? It's an art, no question about it.

The photographer working in this area must be fully cognizant of the truth-in-advertising law. That law says the photographer will be held liable for any deception on his part. For example, if you are the photographer shooting an ad for a company's vegetable soup and you decide to put marbles at the bottom of the bowl, thus pushing the vegetables to the top and thereby causing the consumer to think there are more vegetables than really exist, you will be liable for that misrepresentation. It makes no difference whether you were ordered to do it.

Companies are beginning to take action against deception. One in particular, General Foods, has issued the following policy statement regarding food photography:

1. Food will be photographed in an unadulterated state—product must be typical of that normally packed with no preselection for quality or substitution of individual components.

2. Individual portions must conform to amount per serving used in describing yield.

3. Package amounts shown must conform to package yield.

4. Product must be prepared according to package directions.

5. Recipe must follow directions and be shown in same condition it would appear when suitable for serving.

6. Mock-ups may not be used.

7. Props should be typical of those readily available to the consumers.

8. Theatrical devices (camera angles, small-size bowls and spoons) may not be used to convey attributes other than those normally seen in use.

Photographers must consider policies such as these and must be aware that a violation could open them to liability.

The legal points aside, this is an appetizing field to be in.

INDUSTRIAL

This area of photography covers more ground than any other, except that of the commercial photographer, because it uses many forms of photography for a wide variety of purposes. An industrial photographer usually works for a particular company and his job may encompass a large range, from shooting the company's products for its catalog to filming the portraits of the chief executives for its annual report.

A number of businesses also use photography to such an extent that they have their own photographic departments to take care of their many needs.

Some of the areas that industrial photographers embrace are brochures, promotional literature, audiovisual programs, annual reports, in-house publications, and special requirements, covering almost every aspect of the firm's business.

INVESTIGATORY

This area involves insurance, crime, and record-keeping photography. For example, it is used as a tool for police investigations, insurance reports, identification of military personnel and record keeping of governmental agencies.

Under the heading of police photography, you can be a police officer assigned to the crime scene unit shooting mug shots, crime shots, surveillance, evidence, and other requirements. Many police photographers work toward a Ph.D. in criminology. In fact, photography is a major expense to many police departments around the country. The New York Police Department's annual budget on their photo lab alone is $108,000 *for supplies.* That doesn't include salaries. In April 1980, the department processed almost 22,000 5 × 7 prints plus another 50,000 mug shots.

In addition, insurance companies and other businesses that require investigatory analysis use considerable photographic work.

The major function of an investigatory photographer is to provide coverage of a particular matter, to present credible testimony if the matter is brought into court, and to make identification possible. It may also take in certain elements of medical photography as well, but we will be treating that area separately.

NATURE

We put this under the animal category: the birds and the bees, and more. You can shoot the tiniest of beings, the microorganisms, and

you can shoot the largest of redwoods. You can shoot mushrooms and you can shoot sunsets. You can shoot animals of all sorts and you can shoot flowers of all colors. It is nice work.

NEWS AND SPORTS

This is a form of documentary photography and it's also part of editorial work. The photojournalist is the prime mover and shaker in this area: a combination of news photography and journalism to record the happening of an event. Some examples:

News: Presidential campaigns, disasters, strikes, the opening of a new zoo.

Sports: The NBA playoffs, the NFL draft, the Rose Bowl, hurling in Scotland.

Most news and sports photographers are freelancers and, for obvious reasons, little is done in a studio.

PORTRAITURE

Very simply, the taking of portraits. This is a wide-open field. A variety of photographers can do this. Maybe not all of the same quality, but fashion photographers, advertising photographers, and the generalists usually do portraits as well.

PRODUCT

This is advertising, and we are including the term here inasmuch as many people confuse advertising with product photography. It really is an offshoot of advertising whereby the photographer shoots a particular product for general use in advertising.

SCIENTIFIC

Painstaking, detailed, precise. This is the area of photographing living organisms for research and diagnostic purposes. The subjects range from microscopic forms of life to all animal forms and human beings.

There is also an offshoot into the area of biomedical photography. Medical photography covers photographs made of patients to show the success, or lack of it, relating to certain treatment. It may be

needed during operations and highly technical areas of treatment in order to record what is transpiring. Undoubtedly, this is an extremely complicated area of photography, combining technical abilities in photographing subjects under certain unique conditions and the medical or scientific knowledge required to understand what is being photographed.

The Society of Photographic Scientists and Engineers recently advised that they feel there are two directions one can take in this field. You can work toward the needs of medicine and industry or you can do pure research. To give you an idea of how wide and yet how specialized this field is, consider the following areas: biomedical research, cartography, electro-optical systems, high-speed photography, holography, micrography, optical systems design, photographic date recording, space optics, X-ray . . . to name but a few.

For specific information, contact the Society of Photographic Scientists and Engineers, 1411 K Street NW, Washington, DC 20005.

TRAVEL

You could say that this is a form of news photography, and in a way, it is. However, it is also a well-defined area in a field overlapping others. In effect, you are recording foreign and domestic lands, customs, people, etc. It is a form of documentary photography recounting social conditions.

Most travel photographers are freelancers and most are fairly good writers. Many of the articles appearing in newspapers and magazines are written and photographed by the photographer.

Although the field is sometimes thought of as being a glamorous one, it is also a field that requires organization and painstaking adherence to detail. You have to know what is required before you depart. What's the weather like in Tangiers in January? How long a flight is it to Nadi? What's the strength of the X-ray machine in London? What batteries do you need in Hong Kong? What permits do you need in Frankfurt? You have to know exactly what to expect from the place or organization you are visiting. Especially necessary to investigate are the laws and customs of a particular land. What can and what can't you do?

When you are going on vacation and you bring back shots of your hotel, swimming pool, the couple you met, and the beggàr on the street for your scrapbook, that's one thing. When you are assigned by *Life* magazine to bring back certain shots of certain mosques at

certain times by certain dates and in a certain quantity, that's something else and that's part of your business.

UNDERWATER

As you may have gathered, within each branch of photography there are subspecialities. Underwater photography is no different, and risking some puns, there are indeed a number of specialities beneath the water's level.

For example, photographs can be taken at almost any depth. You can be suited in a simple diving outfit or you can be in a vehicle or a platform resting on the ocean's floor.

There is a wide range of equipment which you can use, but more importantly, you must know what can be used best and where. An in-depth understanding of cameras, lenses, housings, lights, environment, exposures, and safety factors is a *must*.

And, let's not forget about knowing how to get yourself underwater in the first place. Diving is not merely plunging headfirst into the Gulf of Mexico with three cameras draped around your neck. Did you know, for instance, that you consume more air and burn more energy with a camera hanging from your body than without? Water does not move smoothly around equipment and a drag is created. It may seem silly now, but when you're 120 feet underwater and can't move, you may not be laughing.

We have included only the major areas in the foregoing sections, and we have only scratched the surface of the areas we mentioned. As you can readily see, there is considerable overlapping; you may yearn for a general photographic business or you may decide to specialize.

There are many fields that we have not covered, from astrophotography to stroboscopic photography to theatrical photography to wedding photography. For a complete breakdown of the various areas, including the technical aspects of photographing in a specific field, we refer you to the *Encyclopedia of Practical Photography,* a fourteen-volume set published by the American Photographic Book Publishing Company for Eastman Kodak Company.

With this immense variety you can see that there are many opportunities for a career in photography. The range is wide: from advertising to education, from journalism to medicine, from industry to public health. We cover many of these in Chapter 11. You can teach, you can sell, you can research.

TO SUMMARIZE

Once you decide where you are heading, you can point yourself in that direction and learn everything you can about the field in which you are entering.

At this stage, you should have an idea of what is required of you and how to get the information you need. You have now reached the final part of the preparation period: determining the legal format of your business.

Selecting the Proper Business Entity

Are you the sole individual in this new business or do you have a partner? Is it going to be a one-person operation or controlled by a board of directors?

You now must consider what legal form your business is to take.

Many photographers feel that all they need do is start fulfilling assignments and the business end will take care of itself. Then, when they find out too much is being paid in taxes or they have exposed themselves to liability of one kind or another, the tune changes.

What photographers must do is to get their operation off on the right foot. When that first payment does come in, you should know whether it is going into your individual account, a partnership account, or is being treated as the funds of a corporation. The proper business arrangement for you is the essence of this chapter.

In order to determine what is best for you, it is necessary to understand what options are open. As H. Cy Shaffer, a prominent Beverly Hills attorney dealing with professional photographers, advises, "Careful and detailed consideration must be afforded in deciding what kind of business entity a photographer should, and must, have."

The three basic forms of business arrangements are individual ownership, partnership, and corporation.

INDIVIDUAL OWNERSHIP

An individual or sole proprietorship simply means that you form a business by yourself. You put up the money for your equipment and your license (if required) and your studio (if you wish one) and *voilà,*

you are in business. You are the boss! For example, "Peter Photographer's Photography." Of course, you can also "d/b/a" it: "Peter Photographer doing business as Pete the Photog."

The term *doing business as* is often called d/b/a. It means that you are doing business under another or assumed name. In order to accomplish this, you simply fill out a business certificate and file it with the clerk in the county court of the district in which you intend to do business. You can obtain the form commercially (from a stationery store) or from the court itself. Do you need a lawyer to do this? Generally speaking, the answer is no.

Of course, watch this carefully. If you are buying into an existing business, or you are buying the business outright, then it is recommended that you seek the advice of an accountant or attorney. Why? Because there may be unpaid taxes or liens of some sort against the business, as a result of which you might be held liable for the payment of such sums.

By the same token, suppose you take over a particular studio. Are you renting or buying? And under what circumstances? The law in your area may require you to publish a notice of the transfer of the business in the local newspapers, and if you don't comply, you may face a penalty.

More than half of the businesses in the United States are sole proprietorships. These range from newsstands to drugstores, from barbershops to saloons. The owner is his own boss and reaps the rewards. Conversely, he also incurs all the losses and is liable for all the debts. If you as the sole proprietor of a photography business own a house and don't have enough money in the bank to pay your business creditors, it is possible that you can be sued and have liens attached to your property. In fact, your abode might even be seized to pay all or part of the debts that have accrued.

PARTNERSHIP

A basic difference between a partnership and an individual ownership is that the former is subject to a specific written agreement among the participants. Each of the partners invests his money and his time as coowner of a business. In the partnership, the parties agree that they will share any profits and all debts. This means that each person is liable for the debts of the partnership.

Partnerships are formed for a number of reasons. For instance, one party may have the money and the other may have the goods or the expertise. In photography, one may have the dough to set up

a lavish studio—that person usually serves as the business manager—while the other one has the technical and creative know-how—that's the photographer.

And, of course, there's nothing bizarre about two hardworking, knowledgeable, business-oriented photographers—both with money—combining their talents in a new relationship.

There are two basic types of partnerships. One is the general partnership, where the associates share equally in the management of the business, including the losses, profits, responsibilities, and obligations. The second is the limited partnership, where a partner's liability is limited.

In the general partnership, each partner is the manager of the business and usually has one vote, no matter how much money he has contributed. In effect, there is no boss. Each partner is the agent of the other partner, and as such can bind the partnership by his own act. Naturally, there are some safeguards here. A partner cannot give away any partnership property to creditors without the approval of the other partners, and he certainly cannot relinquish the good will (meaning the name and spirit of the business) of the partnership. In short, he cannot do anything that would make it impossible to carry on the business.

Under the limited partnership arrangement, one person usually puts up the money initially and then steps back from the daily operation of the business. For example, if you were a limited partner, you could invest money with *no* control over how the business would be run. You would simply have a profit participation. Thus, if the business succeeds, you stand to make some money; if it turns to worms, you stand to lose your investment.

Normally, a limited partner is not liable for more than his original investment. However, under certain arrangements, he may have some additional liability. For instance, if you are a photographer attempting to protect the business's financial investment, you can provide in the limited partnership agreement that in the event more money is needed for the business, the limited partner can be called on for such sums. Sometimes called an override, this obligates the limited partner to invest an additional sum in order for the business to continue. You could also arrange to have such extra sums used to pay off specific debts. The override is not mandatory in all limited partnership agreements; it is negotiable.

Suppose you decide to get out of the partnership for whatever reason. Will you still be liable for all the debts? Generally not. You will have to give the people you do business with a written notice

that you are no longer a partner and, accordingly, you will then be liable only for the debts contracted before you leave the business. In fact, creditors must try to get all of their monies from the partnership *before* they attempt to go after you personally.

If you bring somebody new into the business, will that party be liable for prior debts? No. Any new investor is liable for debts contracted by the partnership only *after* he becomes a partner. However, any monies he puts in could be used to satisfy existing debts.

The next question is a logical one. How do partnerships end? In a number of ways. One of the partners (in a two-man operation) may be declared mentally incapacitated by the court, one of the partners may go bankrupt, or the partnership may end under other conditions specified in the partnership agreement. It should be noted that you can provide for a termination arrangement in the agreement between you and your partners.

Two additional aspects should be considered by the photographer when deciding on a partnership arrangement. First, understand that there is no specific way a partner can protect himself from major liability in a partnership agreement except under the terms of the specific agreement or by the use of insurance coverage. (Insurance will be discussed in Chapter 6.) Second, it should be recognized that one partner can go bankrupt without the other. This means that an individual can have a personal bankruptcy that would not affect the partnership. Of course, if the partnership itself goes bankrupt, then that condition applies to all the partners.

The same question we raised on individual ownership arises now. It's one that photographers ask over and over: do you need a lawyer to enter into a partnership agreement? Yes and no. You definitely need a lawyer if you are talking about a complex situation involving both general and limited partners with different types of liability for each party. You may not need a lawyer, though, for a simple partnership of two general partners sharing everything equally. In the latter case you can form your own partnership agreement with a minimal amount of assistance.

Most partnerships are formed by a written agreement called Articles of Partnership, which consists of (1) the names of the partners, (2) the firm name, (3) the place of business, (4) the kind of business, (5) the duration of the arrangement, (6) the amount invested by each partner, (7) the sharing arrangement for profits and losses, (8) the accounting system, and (9) the termination method. You can get this form by contacting the county clerk's office in your jurisdiction.

CORPORATION

A corporation is a group of people (sometimes one is enough) who have banded together to do business. They obtain a charter from the state and, as a group, they may own, buy, sell, and inherit property in the corporation's name. The liability is limited: members are exempt from personal liability beyond the amount of their individual shares.

If you want a definitive, all-encompassing statement, look to Webster: "A corporation is a group of people who get a charter granting them as a body certain of the legal powers, rights, privileges, and liabilities of an individual, distinct from those of the individuals making up the group."

How is a corporation constructed? Investors become, by virtue of their investment, the shareholders of the company. As shareholders, they elect a board of directors, whose responsibility is to see to the firm's day-to-day management.

Consider a corporation to be a pizza pie owned by, for example, two persons. If the pizza is cut into eight pieces, each shareholder can get four pieces by putting in an equivalent amount of money. Or each may decide to take three slices, leaving two extra slices in the event they want to bring in more money later by selling the slices to someone else. The key for you the photographer to remember is that in order to retain a controlling interest, you must control a majority of the pieces of the pie.

To set up a corporation, you have to file a certificate of incorporation with the secretary of state in your state. Most jurisdictions require three or more parties to incorporate, although in a few states, one person is enough.

The certificate includes (1) the name of the corporation, (2) the type of business, (3) where the office will be, (4) the total number of shares authorized, (5) the value of each share, and a few other items of that sort. It is not a difficult form to complete.

In addition to the certificate of incorporation, it is also necessary to write up by-laws. These are regulations detailing the duties of the members of the corporation. The by-laws set forth the time and place of all meetings, the voting rights of the members, the manner in which amendments to the corporate papers can be made, and other rules covering the business, including the dividend schedules of various classes of stock.

What about stock? In a simple corporation, an arrangement is usually made for a 200-no-par-value share. This means that the

stock issued has no value ascribed to it and, therefore, no share receives preference over another. That's the way small business corporations are usually set up. It keeps things uncomplicated. Small business corporations, which are usually the type of corporate arrangement favored by working photographers, have both advantages and disadvantages. One disadvantage is that if the corporation loses money, the parties can't write off the loss on their personal income-tax returns. Some tax laws, however, do allow small corporations with ten or fewer stockholders to offset corporate losses against their personal losses for tax purposes. But these laws also make the profits of a small corporation taxable as though they were personal property. The arrangement is known as a Subchapter S corporation, and its real benefit is that parties can deduct certain expenses that a sole proprietor cannot. For example, a profit-sharing plan, a pension plan, and a health-insurance plan can be set up, all of which are considered legitimate business expenses.

All right now, which of the above entities do you, the photographer, wish to choose? Let us try and simplify the decision for you. If you ask most lawyers, they will tell you to start out by incorporating because of the obvious fact of limited liability. It does bring up some tax consequences, but with the Subchapter S arrangement, it shouldn't pose any big problems.

Setting up a simple corporation is a relatively easy prospect and can be done quickly. The costs involved depend on your location, but they can be anywhere from $150 upwards; opening a business on Rodeo Drive in Beverly Hills may cost considerably more.

However, try this. If your total capital consists of two Leicas, thirteen dollars in cash and a gift certificate to Kentucky Fried Chicken, then by all means, you can proceed as an individual proprietorship. There's really no need at this stage to start with articles of incorporation and by-laws.

The partnership setup can get a little tricky in that all of the partners have an equal say in the business; thus, it is best to spell out in the partnership agreement who does the shooting and who will handle business and accounting. It has been our experience that in the courtship process of a partnership, one willingly agrees to be the business head while the other is the creative head, even though later there may be a crossing of lines. The business area usually crosses into the creative end, such as when the accounting partner has the grand illusion that he can shoot better than the photographer. Also, let's not ignore the fact that the creative part-

ner is spending a great deal of time with lovely models draped in satin sheets rather than with dusty accounting sheets.

It is, therefore, good business sense to create a document between the partners at the outset to establish the rights and responsibilities of each partner. Should one attempt to transcend the line, then simply pull out the trusty agreement with the passages relating to the responsibilities of each of the partners underlined and set this before the transgressor.

A good rule of thumb is to check with your accountant as to your personal tax situation. This provides an indication of which way you should go. Remember, nothing is written in stone concerning a business relationship. Should you start out as a proprietor and wish to incorporate later on, this can easily be done. In fact, many times it is exactly what photographers wind up doing.

TO SUMMARIZE

No matter which course you elect in creating your own business entity for the purpose of practicing photography, it is imperative that you consult with your accountant and possibly a lawyer to make sure all avenues are explored fully and explained to you and that your selection is a good one. Seek out opinions of professionals in your area and question other photographers working in the field. Find out about their problems and how they have dealt with them.

II

ORGANIZING THE BUSINESS

Leases, Rentals, and Purchases

As you may have gathered by now, planning this new business venture of yours is not an easy task. Most photographers are under the impression that all they need to do is buy the necessary equipment and begin taking pictures. Of course, when they talk about necessary equipment, it invariably starts with cameras, filters, lenses, tripods, lights, and film, and then stops.

To say that there is much more to be considered would be an understatement. Once you have determined what kind of photography you want to do, you then begin to determine what it is that you really need to ply that particular trade . . . and we don't mean apparatus. For example, if you have decided to enter the world of sports photography and sit on the sidelines at Yankee Stadium to shoot the Yankee–Red Sox rivalry or squat down courtside at the Los Angeles Forum for a shot of Kareem's skyhook, you certainly do not need a 7,000-square-foot studio.

By the same token, if you have decided that you want to photograph children for high-school yearbooks, you may need that 7,000 square feet.

How much and what kind of space you need is best determined by what you are doing. Your choice of a specific area of photography will also lead you to the type of bookkeeping required.

If you're not going to be working out of your hat, you'll need some sort of roof over your head. In photographic parlance, that is referred to as a studio.

If you must have a studio (that is, your photographic specialty warrants one), then you have to understand what a studio consists of and what elements are important. In today's photographic world, the studio is not simply the place where pictures are taken. Many

professional studios provide a combination of facilities for several functions. There is a camera room, a darkroom, a conference room, a business office, a supply room, and a bathroom. They can all be contained on one floor, broken up into sections. In effect, it is akin to a small shopping mall.

For instance, when you enter the premises, you may find yourself in a reception area. It will be (you hope) tastefully furnished and have examples of your work on the walls. Off it may be a small office. This is the place where you juggle the books, answer the phones, write letters, etc. Moving right along, we find a dressing room, a toilet, a small kitchen, the shooting area, and a darkroom.

The studio should contain all those elements that are important and central to your business. It has been said many times before that the three basic areas of a studio are reception, shooting, and storage/darkroom.

Where your studio is located is another factor to consider. For example, you can work out of your home by converting a portion of it into a studio. This is not uncommon. We know of a studio in Pennsylvania which is located at the back of a large home on a very nice residential street. Clients enter by the rear door. When the weather is good, conferences are held in an exquisite garden. Ambience to this photographer is obviously important, and his billings show that it is successful.

You can have a studio separate and apart from where you live or you can combine living and working in one area. You can opt for a studio in the center of the city or out in the hinterlands. You can work in a fashionable neighborhood or on the Bowery. Whatever works best for you is perfectly fine.

For instance, a photographer who is considered by many to be not only one of the best working today but whose reputation for solid prices, exceptional work, and the businesslike manner in which he operates makes him both respected and feared, is one of the top moneymakers. Where are his facilities? Right on the Bowery in New York City.

The size of the premises is not too important. Areas as small as 15 feet by 70 feet can contain all the aforementioned elements.

As we have said, you have to determine the kind of photography you will be doing. Obviously, if you will be shooting large groups, you will need more space than if you are simply photographing one individual at a time. If you are shooting school yearbook pictures and you must shoot in the studio, a graduating class of some sev-

enty-three will need more floor-to-ceiling space than babies crawling around.

Thus, you have to look at all the requirements of the studio space you are contemplating.

In addition, certain kinds of photography dictate certain kinds of facilities. A kitchen is a necessity when doing food photography. If you are doing advertising photography where the use of models is essential, then you need an area where the models can change their clothes. Of course, if you don't mind their changing in front of you ... and if they don't mind ... then ...

Also, the number of people you have working for you will indicate how large a space you will need. It would be insane to try and do an ad for an automobile company which involves four models, twelve technical assistants, and one station wagon in an area the size of a telephone booth.

Once you get past the location, size, and basic space required, you will have to consider what each room is capable of doing. For example, make sure you have enough light in the shooting area. You must determine whether the available utilities in your studio are the proper ones for the kind of work you do. Remember, the primary concern here is not sunlight but electricity. You must have a constant, uninterrupted source of electrical power. It's important that before you sign any lease for the premises, you check this out carefully. In other words, balance the amount of electrical power you are being supplied against what you actually need.

Naturally, to say that you must carefully examine everything about the space you are considering renting or buying would be another understatement. Questions upon questions pile up.

1. Is my studio convenient for my clients and my employees? Is it also convenient for my subjects (models, etc.)? Or am I putting myself in the middle of nowhere?

2. Can the local electric company supply the necessary power? If so, at what price?

3. What about noise? Am I sitting under a jetport where vibration is going to do a tap dance on my photographic images?

4. How about air conditioning?

5. What about waste disposal?

6. Are there separate meters for water and electricity?

The list can go on almost without end.

Suppose you have found the desired space; what comes next? First, you have to decide whether you are buying or renting. Un-

derstand the difference. When you rent, you are not the owner. You simply pay for the right to use something.

RENTING

As a renter, your legal position depends on the kind of arrangement you reach with the person who owns the property. For instance, you rent for a specific period: years, months, days. If there is no written lease, then you are what is known as a tenant at will, which means that either you or the landlord may terminate the agreement at any time. Usually, it is upon thirty days prior notice.

If you are renting, you must make sure that you understand what you are getting. The basic point to remember is that a lease obligates you as a tenant to pay certain sums of money in return for the right to inhabit a specific area.

In case you're wondering, the word *rent* means a stated payment made by the tenant to the owner for the temporary possession of property. The word *lease* means the actual contract involved. Sometimes, they are used interchangeably.

You should be looking at certain elements in your lease.

1. What is the length of the lease? Keep in mind that you don't want to set up a studio and have the clients know you at a certain address and then find you must change that address after six months. If this is the area you want and the studio fits your needs, leaving some room for expansion, then try to obtain as long a lease as possible. Many photographers obtain ten-year leases to assure continuity.

Also, with the rate of inflation what it is, it is far better to get a good rate over a longer period of time than to renew your lease every few years at considerably higher rates.

2. Make sure the lease is specific as to the start dates and end dates.

3. Detail what you are getting for what you are paying. If you're supposed to have specific facilities, then spell them out in the lease.

4. Set forth the payments you are making and how. Are they to be monthly, annually, or weekly?

5. What about privileges? This means your right to particular areas. Can you use the garage? Is there an extra storage area? This should be stated in the lease. *Nothing should be taken for granted.*

6. Who is responsible for repairs and general upkeep? Are you obligated to do any of it? What if there is a problem—for instance,

a fire? Most leases provide that the tenant must notify the landlord and that the latter must repair any damage as soon as possible. If the tenant decides to stay on the premises during the repairs, does he continue to pay the rent? If the damages cause the tenant to vacate, does the obligation to pay rent cease?

7. Is there a right to sublet? Suppose after three years you need more (or possibly less) space. Can you get out of your lease by either subletting the premises to someone else, by giving the landlord reasonable notice, or by paying a certain sum of money? In short, how much running room do you have?

In addition, many leases have what are termed standard rules and regulations attached as a rider which, if read carefully, seem to be anything but standard. How do these rules affect your business? What if there is a restriction against dogs and you're an animal photographer?

And, perhaps most important of all:

8. Can you run your business on these premises? It would be a sad thing indeed to discover that you can't do the kind of photography work you want *after* you have spent a fortune fixing up the studio.

Suppose you decide not to rent, and you see a magnificent loft for sale. You are now entering a different area.

BUYING

There is even more to be considered when buying property. There are tax rates, zoning ordinances, public services, assessments, titles, deeds, surveys, covenants—the list seems endless. Let's take this slowly.

You are walking down Peachtree Street in Atlanta and you see a sign for a 4,000-square-foot loft. You call the number on the sign and are told that the loft is yours for $6,253.46. Now what happens?

The procedure is that you will be asked to sign a binder or purchase agreement and pay a deposit. The initial agreement you sign may contain the basic terms of the arrangement between you and the seller.

Rule 1: Make sure that the terms are acceptable to you. This sounds rather obvious, but there have been many people burned by thinking that the memorandum accompanying the binder is really of no effect until an actual purchase agreement is signed and title passes hands.

A binder is more than a mere receipt for a deposit. It is actually a contract and is a legally enforceable and binding agreement. Granted, there are some jurisdictions where a binder is treated as a receipt and is fully refundable. But, unless you know how the law in your state considers binders and purchase agreements, *don't* take chances.

It should go without saying that you shouldn't sign any document or pay any money until you understand all your obligations in the transaction.

Rule 2: Make sure that whatever you do sign spells out *all* of the terms of the sale, and we do mean all. This applies to the purchase price, how it is to be paid, the amount of cash required, the way it is to be financed, the interest charges, and so forth. Here's a sample checklist of such points to be covered:

1. The purchase price.
2. When it is to be paid.
3. Description of the property, plus a list of all items included.
4. Who pays what part of the taxes, insurance, and any other costs.
5. Date on which you take possession.
6. Commitment for the seller to furnish title warranty.
7. Type of deed to be furnished, plus a marketable title to the property.
8. What happens if you can't get a mortgage? (*Note:* You should be certain that you have the right to cancel if you can't get financing.)
9. What happens if the deal collapses for any reason?
10. What are the zoning regulations so that your business can be operated legally?

A contract of sale usually follows. This document spells out in even greater detail all the rights and obligations of the parties. Bear in mind that the laws regarding real property dictate that all matters be put in writing. Accordingly, any items agreed upon by the parties but *not* included in the written contract will *not* be admitted into evidence should a lawsuit arise. Agreements for the sale of houses and of all real property *must* be in writing.

Next, you should understand certain of the elements involved in buying property. For example, title clearances, taxes, special assessments, deeds, title searches, title insurance, surveys, zoning regulations, and so on. Most of this information can be supplied by your attorney, accountant, or banker.

In the meantime, let's touch on a few of the areas. What is title to a property? Simply said, this is what you are supposed to get at the closing. Title is the right of the owner to its peaceful possession and use, free from the claim of others. Therefore, when you buy your studio, you must be assured that you have the legal right to occupy it under the circumstances given without legal interference from anyone. You should also have the right to sell or mortgage it without problems. In short, you want a clear and unencumbered ownership to your property.

There are, however, a number of ways in which the use of your property may be limited. One is by a restriction in the deed; another is by local zoning laws. Almost all property is subject to taxes which, if not paid, could result in the loss of title.

As you can readily see, it gets a bit tricky.

Title searches are exactly what they say they are. You should satisfy yourself that the seller can convey a marketable title to the property to you as agreed upon in the purchase contract. Various methods ensure that the title received from the seller is marketable. One protection is through title insurance, a subject we will discuss in greater detail in Chapter 6. Title insurance insures that the title is indeed free and clear, so if there is a problem later on, you will not be held accountable.

A deed is the document that actually conveys or transfers title from one person to another.

Everybody talks about closing on the property: "We're going to a closing," "I need the receipts for the closing." The closing on a property is the transaction in which you receive all the documents required to convey the title to you. Thus, everything you need to have to prove your purchase of the studio is turned over to you at the closing.

Those documents must be reviewed carefully, preferably by a lawyer, to make sure that the conditions and promises of the purchase contract are being fulfilled.

You now have your studio. The next step is to purchase the necessary equipment . . . if you don't already have it. This is the usual panoply of cameras, lights, film, and the other equipment we've mentioned before. As we've said, this is not a technical book, and we don't really know what cameras should be bought under what circumstances. You can find a multitude of books on the market to tell you what you need in the way of cameras, strobes, lights, darkroom facilities, paper, and all the rest.

If you decide to be a freelance, freewheeling photojournalist and don't want the trappings of a large (or even small) studio, then you don't need many of the things we have been discussing in this chapter. You need only your basic equipment plus a credit card for travel and a check of local ordinances to ascertain what you can do. The rest is up to you. If you haven't already converted your bathroom into a darkroom, then you can use an outside laboratory for your processing or you can rent a darkroom and do your own processing.

The nonstudio photographer doesn't have the expense and concern of the studio photographer, but don't think for one moment that photographers find life easier simply because they don't have a studio. There is another side of this profession that cuts right across the board and applies to everyone. This is the area where many photographers lack the necessary knowledge and understanding, and it may well be the most important area of all.

RECORD KEEPING

Adequate records are an essential part of your business. It doesn't matter who keeps them. They can be kept by your wife, husband, lover, mother . . . even you. But records must be maintained and retained.

Keeping records and knowing what they mean are the heart of management and the heart of the photographic business. Let's not complicate this more than necessary; when we talk about record keeping, we're talking about a way of keeping your business in front of you at all times. It is not difficult to do. It is primarily a matter of organizing your paperwork so that you have it at your fingertips with full control over your operation.

Basically, you should have a journal which will list the monies coming in (income), a journal reflecting your expenses (costs), a checkbook for the payment of bills, and a ledger which compiles everything so that you know at a glance what's what. For example, one photographer we know uses four record books to keep his business intact: his checkbook, a disbursement journal, a cash-receipts journal, and a ledger. All of his company's payments are made by check. He keeps a complete record of all expenses. He breaks down his disbursements or expenditures journal into ten columns, headed materials, rent, utilities, telephone, sales tax, advertising, office supplies, equipment, other expenses, salaries.

For example, take a look at this chart:

January

Materials (film, etc.)	Rent/ Mortgage	Utilities (gas, etc.)	Tele- phone	Taxes	Adverts./ Publcty.	Office Suppls	Equip.	Exps.	Sal.
$	$	$	$	$	$	$	$	$	$

Total Monthly Expenses: $_____

You may not need all the items this photographer includes, or you may need more. This is his record, on a monthly basis, of his expenditures.

Conversely, the photographer keeps a journal of all income. Some photographers break it down month by month, some by job; some combine both.

For instance:

January
Job no.: _____ For X Corporation Subject: Ad for candy

Assignment fee: $_____
Additional monies: $_____

Total: $_____

There are many ways to construct a system. For example, another photographer we know keeps five sets of books: a cash-receipts journal, a disbursement journal, a payroll journal, a checkbook, and a control ledger. His method is to cross-check wherever possible.

This photographer maintains a cash-receipts journal in which he records all receipts such as cash sales, receivables collected, other receipts, and a running total column. All sales paid for on delivery are considered cash sales; all those accounts delivered to be paid later are deemed accounts receivable. As they are paid, he lists them to maintain a record of customer payments.

Other receipts might include rebate payments on purchased materials, state payments for employees (such as work-incentive programs), and other similar income not directly attributable to the business. This journal provides a number of interesting records, but primarily it gives the photographer an instant gross-income figure at the end of each month.

He also maintains a payroll journal. This is simply a record of all wages paid and the taxes withheld for all of his employees, including part-time. Except for FICA figures, the monthly totals give the photographer the amount he should deposit each month with the Internal Revenue Service. (You can obtain tax figures from the tables available at the IRS or your local bank.)

If you have regular employees, you will be responsible for withholding various amounts for income tax, social security (FICA), workmen's compensation, and other purposes. You must pay these amounts and certain employer's contributions to various government agencies.

To give you a closer look at this, suppose you are a New York City–based photographer and hire an assistant at $300 a week. The assistant is single with no dependents. He has one deduction, himself. How much of the $300 is taken out for taxes?

Federal	$55.10
FICA (social security)	18.39
State	13.90
City	5.30
NYS disability	.30
	$92.99

You, the employer, must pay these amounts over to the proper entities. In addition, you are to pay another $18.39 from your own pocket as the employer's social security contribution.

(And don't forget sales taxes, which we will discuss in detail in Chapter 7.)

Let's return to the photographer with the five books. All this information is compiled in the ledger. This photographer uses a summary sheet at the front of the ledger to keep a running profit-and-loss statement. After the summary sheet, he has sections where he lists each item shown on the summary. In this way, he has an overall view of his financial status.

Gross revenue comes from his cash receipts journal. Costs of production, which means every cost involved in the production of the

film (including materials and labor costs), comes from his disbursements journal. Gross revenue less cost of production equals gross profit.

This photographer also itemizes variable expenses and fixed expenses, and a total sum for each is shown in a column he terms total expenses. Fixed expenses are those that pop up every month: rent, telephone, electricity, insurance; variable expenses are those that are not so constant, such as travel expenses or unique supplies used on a particular assignment.

There are a few other record-keeping items which you can use. One is a cash-flow statement and the other is a purchase-order pad. The cash-flow statement is extracted from journals and ledgers and from the checkbook. It helps you to plan your bank loan (if you are at that stage) and the repayment cycle. Using your checkbook, you list beginning cash (the check stub balance at the start of the month), cash sales for the month, receivables collected, and other receipts, which then become the total cash. From that figure you deduct what you are paying out—your expenses. The total cash less total expenses gives you net cash.

We could go on until next Tuesday with the kinds of records kept by photographers. However, as we said at the outset, our intention here is to try and uncomplicate your life.

What would we suggest? For the beginner or the person with a lack of organization, we recommend the simplest form of record keeping, such as putting everything in one book. Buy a loose-leaf binder or ledger with a number of columns. Devote a full page to each job. For example, suppose you are being hired to shoot a birdbath for an ad. You are to work one day and receive $15,000 (it should happen to all of us). It will cost you $1,000 for an assistant and his bird. The client is paying for your film and processing. That will amount to $1,000. (Remember, this is all fictitious.)

You take a page in your book and break it down as follows:

Job #1
Assignment from: Jones & Smith Advertising Agency
Subject: Birdbath
Days: 1

Income
Fee: $15,000, payable at end of day Paid_____
Reimbursed expenses: $1,000 for film and processing Paid_____
 Total:_____

Expenditures
Assistant and bird: *$1,000* Paid_____
Film and processing: *$1,000* Paid_____
 Total:_____

Reconciliation
Receipts: *$16,000*
Less expenditures: *$2,000*
Net: *$14,000*

Take that last figure ($14,000) and transfer it to either your checkbook stub or some other book reflecting your current bank balance. On to the next job.

There is something else you should be doing. You should keep an accounting of what you do each month and a running total for the year. This can either be done by your accountant, friend, or even by yourself. A simple form of a receipts-and-disbursements statement is as follows:

Cash Receipts and Cash Disbursements for the 5 months ended May, 1980,
and for the month of May, 1980

Receipts	*May, 1980*	*Jan.–May, 1980*
Assignment fees		
Other income		
TOTALS:		
Disbursements		
Rent		
Telephone and telegraph		
Mailing and postage		
Stationery and printing		
Office supplies		
Xerox		
Legal fees		
Accounting fees		
Salaries to employees/assistants		
Salaries to other personnel/models, etc.		
Carfares and messengers		
Film and processing		
Self-promotion and advertising		
Insurance		
Miscellaneous		
TOTALS:		

Reconciliation
Total income for month: $_____
Total expenses for month: $_____
Profit (or loss) for month: $_____
 Total for Jan.–May: $_____
 (profit or loss)

One aspect that we haven't yet considered is the use of forms: delivery memos, purchase orders, and the like. These will be discussed in Chapter 8.

TO SUMMARIZE

Keep in mind that there must be a system to what you do. This applies whether you buy space or rent it. As for record keeping, you can't haphazardly drop receipts and checks into one big shoe box and let your accountant or local service-station mechanic try to figure out what you have been doing when April 15 rolls around. That kind of modus operandi will quickly put you out of business.

It is imperative that you keep tabs on the operation itself: what you are bringing in against what you are paying out. Only in this way can you truly determine how the business is, or is not, developing.

Insurance

According to *Webster's New World Dictionary,* insurance is defined as "a system of protection against loss in which a number of individuals agree to pay certain sums for a guarantee that they will be compensated for any specific loss by fire, accident, death, etc."

Professional photographers are no exceptions to the need for insurance. Like other businesspeople, they need insurance to protect their activities and equipment. In order to understand this area, you must first comprehend the basis of all insurance. This is known as speculative risk and pure risk.

When you made the decision to be a professional photographer, you entered into a risk situation; your new business may be a success or you may go broke. That's known as speculative risk. You don't know what will happen. You can lose or you can win.

On the other hand, pure risk concerns itself only with the possibility of loss. An example is the theft of a valuable camera. It is gone; it is lost. Insurance protects against pure risk.

What can you do about risks? You can avoid the risk, assume it, reduce it, transfer it, or utilize a combination of these methods. Avoiding risk is generally considered impractical in most cases. Assuming it is practical where there are small losses such as breakage or mishandling of goods. When you voluntarily assume a risk, you have to be aware of certain guidelines:

1. Don't risk more than you can afford to lose.
2. Don't risk a great deal for very little.
3. Calculate the odds of a loss.

When insurance enters the picture, it is known as risk transfer. You pay a certain premium to protect yourself against the consequences of an uncertain loss. Thus, when you start to plan your in-

surance program, you must consider the various categories of such loss. These can be loss of or damage to physical property, such as buildings, photographic equipment, automobiles, and so forth, loss of income, and damage to you personally.

For ease of understanding, let's break this down into its components. Note that there are four basic sections of insurance that should be considered.

PERSONAL INSURANCE

1. Life insurance, which provides that your beneficiaries receive a certain sum of money on your death. You can also provide for business beneficiaries.

2. Medical insurance, which covers expenses arising out of medical treatment. This applies to yourself and/or your family.

3. Disability insurance, in which payments are made to replace income lost through accident or serious illness.

4. Accidental death or dismemberment insurance pays for loss of life, limbs, or eyesight caused by accident.

5. Retirement funds provide income in your older years. These emanate from plans (such as IRA accounts and Keogh funds) for self-employed parties.

PROPERTY INSURANCE (GENERAL)

1. Auto insurance covers not only your automobiles but also any company cars and other vehicles which you may own or lease. It also includes those driven by your employees during the course of business.

2. Fire and theft insurance provides coverage for your home as well as personal possessions such as furs, jewelry, and the like.

3. Liability insurance covers damage to property and injury to persons. The term comprehensive personal liability covers claims for or liability arising out of your business. There is also liability insurance for independent contractors and products. There are also special coverages for specific hobbies.

PROPERTY INSURANCE (SPECIFIC)

In addition to the general kinds of property insurance, you should be aware of specific types of coverage which might be desirable for you as a photographer.

For example, a camera floater is considered all-risk insurance to protect against the loss of or damage to your equipment. Photographic equipment usually comes under what is known as a personal articles floater, although some jurisdictions may give it a different term. This extra bit of protection applies, for the most part, to all your personal property.

For instance, you would receive coverage for cameras, lenses, projection equipment, film, telescopes, etc. Each piece of equipment is individually valued. If a camera and special lens are to be insured, a specific amount of insurance would be listed for the camera and a specific amount for the lens. Accordingly, when you purchase materials, it is best to document the cost and the replacement value of each item. In order to take out insurance, you will need to know the make, model, serial number, date of purchase, etc., of each piece of equipment.

A number of insurance companies do permit a blanket coverage to be written on various small items such as filters, holders, and carrying cases. This coverage is customarily limited to 10 percent of the total amount you have decided to insure. Blanket coverage in excess of this 10 percent may be permitted if you can prove that it is unrealistic to list each article separately.

(To corroborate what we have discussed in the preceding chapter, it is insanity not to keep records of what you have purchased. You will need such records to obtain proper insurance coverage and for many other purposes.)

Rates for a personal articles floater are fairly uniform in the United States, although they may be higher in high-crime areas. The following prices reflect the costs of a personal articles floater for photographic equipment as reported by commercial insurers at the time this book was compiled. You can also obtain similar protection for personal items such as furs and jewelry.

In case you're wondering, the coverage you obtain is supposed to protect you anywhere in the world. It is also general practice to cover additionally acquired equipment not listed on the policy for at least thirty to forty-five days. Then, you can specifically list the equipment as soon as you get the necessary information.

There is a federal crime insurance program in the United States which is authorized to sell federal crime insurance in states where it has been determined that commercial insurance is essentially unavailable to those who want it. This insurance is only available for burglary and robbery and the limit for individuals is $10,000. Both crimes, it should be noted, are considered thefts: burglary implies

Personal Articles Floater—
Photographic Equipment

	Noncommercial	Commercial* (except motion-picture producers)	Motion-picture producers
Annual Rates per $100 of Insurance			
First $5,000	$1.50	$2.40	$3.25
Next $10,000	1.25	1.95	2.60
Over $15,000	1.05	1.55	2.10
Annual Rates per $100 of Insurance (North Carolina Only)			
First $5,000	1.45	2.35	3.25
Next $10,000	1.20	1.90	2.60
Over $15,000	1.00	1.50	2.10
Annual Rates per $100 of Insurance (Texas Only)			
First $5,000	1.80	2.25	3.25
Next $10,000	1.40	1.80	2.60
Over $15,000	1.00	1.45	2.10

*Insurance companies apply commerical to any individual engaged in any branch of photography for remuneration.

forced entry, such as breaking into your studio, while robbery implies force or the threat of force, such as a mugging on the street.

The states presently covered by federal crime insurance are Alabama, Arkansas, Colorado, Connecticut, Delaware, Florida, Georgia, Illinois, Iowa, Massachusetts, Minnesota, Missouri, New Jersey, New York, Ohio, Pennsylvania, Rhode Island, Tennessee, Virginia, and Washington, D.C.

Federal crime insurance applications can be obtained from any licensed property insurance agent or broker in any eligible state. In addition, federal crime insurance applications and information can be obtained by calling the toll-free number, 800-638-8780, or writing

to Federal Crime Insurance, P.O. Box 41033, Washington, DC
20014.

Other insurance to be considered are those to cover the contents
of your studio as part of a package policy applying to fire, theft, and
malicious mischief, plus insurance to protect against loss of original
photographs and valuable papers. You might also want to consider
a bailee floater to protect articles and merchandise belonging to
others but in your custody.

One particular policy that is now being developed by the Ameri-
can Society of Magazine Photographers would provide still photog-
raphers with the kind of protection that now exists in the motion
picture industry: protection against negative and film loss.

The key element is a unique insurance policy whose two main
parts are insurance for the cost of reshooting a job and insurance
for equipment. The cost of a reshoot would be covered on an all-risk
basis, including faulty raw stock and faulty processing by the lab-
oratory. Even camera malfunction is covered. Additional coverage
is included for equipment, props, sets, extra expenses, and third-
party property damage.

LIABILITY TO THIRD PARTIES

This is insurance to protect against injury and property damage to
third parties, whether on your premises or on location assignments.
In addition, don't forget about workers' compensation and various
employee protections. And how about the E&O (errors and omis-
sions) policies: this protects you against invasion of privacy claims
and litigation resulting from plagiarism, slander, and libel.

As long as we are throwing all kinds of policies at you, let's try
to narrow them down and explain something about the kinds of
available basic coverage. To do this, consider what you want in-
sured.

PHYSICAL PROPERTY

Your most obvious physical property is your photographic equip-
ment. Cameras, lenses, tripods, strobes, etc., should be insured.
That's the camera floater policy; each item is listed with the appro-
priate amount of insurance applicable. This policy generally ap-
plies throughout the world and protects your equipment in full
with certain exclusions, such as wear and tear.

There is equipment that remains at your place of business and doesn't travel with you. This, together with furniture, fixtures, and supplies, can be insured under a fire or commercial package policy. In fact, many businesspeople insure their property against fire, lightning, windstorm, hail, smoke, explosions, riots, civil commotions, vandalism, malicious mischief, and so on. In this respect, the all-encompassing coverage provided by most commercial package policies is the preferred one.

Keep in mind that an all-risk insurance policy is definitely the one to have when you own your premises.

Earthquake coverage, which is excluded in many all-risk policies, should be considered for an extra premium if you are in a vulnerable area. You might also want to consider federal support, which has made flood insurance available at a nominal cost in many communities.

Once you have decided what you are insuring your property against, you must determine its value. Value (as defined in the insurance world) is the replacement cost less depreciation. Don't use market or book value. For buildings, replacement value will enable you to rebuild after a massive loss. Some types of property other than buildings can be insured for replacement cost, while other types must be on a cash-value basis. Your insurance agent can guide you in this regard.

We would be remiss if we didn't advise you to make sure you keep a complete and accurate inventory of your photographs. This includes prints, negatives, transparencies, and so forth. This aids in determining the proper amounts of insurance necessary. An inventory of your property is intended to reflect all the items you have in your possession and will be invaluable in any claim adjustments. Keep the inventory current and away from the photographs themselves.

A tip: inasmuch as fire often produces a total loss, you should always insure your photographs to their full value; consider deductibles only to reduce premiums. Also, don't forget to increase the amount of your coverage to compensate for inflation. Review your policies at least once a year.

Automobiles, trucks, jeeps, and other vehicles are common types of business property. They are insured under an automobile policy. The key property coverages are comprehensive and collision. Collision deductibles usually start at fifty dollars. After a vehicle is five

years old, it may be best to eliminate the collision coverage altogether, because the vehicle has already depreciated too much.

Lawsuits are a hassle for every businessperson. Automobile policies which provide coverage for bodily injury liability, property damage liability and medical payments for claims avoid many lawsuits. You can also provide coverage for rented vehicles as well as for claims arising from your employees who are using their own automobiles to conduct your business.

Those of you who own your buildings should consider purchasing boiler and machinery insurance, especially if you have a steam or hot-water heating system. It is also possible to include air-conditioning equipment under this coverage.

VALUABLE PAPERS

This type of insurance pays for the cost of reproducing records. You can minimize your exposure to loss by maintaining a duplicate set of papers. Records which cannot be reproduced should be set forth in the policy in detail with an agreed determined value. Generally, the policy will apply to all records at your studio with a certain limited coverage during the time they are being transported from one location to another or are at another place for specific nonstorage purposes.

MONEY

This coverage usually insures against loss via burglary and robbery. You could include disappearance of your money from your premises. Many insurance programs do not cover you for an employee's dishonesty, so you have to protect yourself by taking out a bond. Losses due to an employee's dishonesty can be financially crippling. Protect yourself; not everyone is as honest as you.

You can secure insurance which will compensate you for money you have been unable to collect as a result of loss or damage to your records. As we have said, exposure to loss can be greatly reduced by maintaining duplicate records at a separate location. Also, try storing such records in fire-resistant containers.

While we're on the subject, this loss of income is often overlooked. If you expect to survive a major loss, you had best consider it. Damage to physical property usually causes a partial or complete interruption of operations. Insurance to cover this will pay for your loss of profits during the time your business is nonfunctional. You can,

of course, tailor it to your specific needs. Just think of what would happen if you had a major fire in the middle of a major shoot.

COMPREHENSIVE GENERAL LIABILITY

This provides coverage for claims arising from on- as well as off-premises operations. A number of insurance companies have recently put together additional liability-insuring agreements. These include personal-injury coverages such as libel, slander, and false arrest; contractual liability; broad-form property damage; and fire-legal liability. Even though you may not have a need for all these coverages (or even know what they are for), the cost is surprisingly low for the kind of protection you receive.

How much liability insurance do you need? This is one area where you should't try to save money by purchasing low limits. Court judgments are becoming more and more substantial. Limits of $300,000 or $500,000 on your general liability and automobile policies should be considered as the minimum. Protect yourself fully!

Don't forget that if you have employees, you must furnish coverage under the law. This is known as workmen's compensation. Benefit levels have increased during the past two years substantially and exemptions for small employers have been eliminated in many states. But you must provide the coverage.

Another aspect of insurance should be kept well in mind: no policy will ever compensate you for a claim which has resulted from illegal action on your part. In fact, if you withhold information or misrepresent yourself to the insurance company, that in itself may be grounds for cancellation of your policy; perhaps dismissal of any claims you may have. You could even be subject to a fraud suit.

There are some other clinkers to consider. Some policies won't reimburse you if your camera is damaged or destroyed by confiscation under government quarantine or customs regulations. For example, if a customs agent takes your camera apart looking for contraband, you may be left with a box of camera parts and no insurance to have them reassembled or replaced.

You may also find no coverage for damage to your equipment from "hostile or warlike actions," whatever that may mean. This is one reason why it's important to understand what your policy covers and what it excludes.

If your camera equipment is lost, stolen, or damaged, it is imperative that you report the incident to the police. Get a copy of the report that is filed, including the file or claim number. Report that to your insurance company immediately. When your claim is filed, the adjuster usually has a basic formula from which to determine your reimbursement. For example, new cameras are considered to have a life of twenty years (although many photographers will laugh at that) and depreciate 5 percent annually. Used equipment is computed similarly.

We would like to pass on some tips that police and law-enforcement officials have given us with respect to the most common types of camera theft. Camera thieves are especially hip to the aluminized shopping cases and the big, flashy camera bags that many professionals favor. These people hang out at transport terminals and hotel lobbies and they will follow the owner until they get a chance to pluck the bags. The dinner hour is prime time for thieves to slip into your hotel room and relieve you of your equipment. Crowded places give the lifter a superb opportunity to snip the strap on your bag and disappear into the scenery.

According to our police friends, here are some preventive measures you can take:

1. *Don't* leave your equipment in a car, hotel room, or similar place. Lock it away where it is secure. Use your hotel's safe or, if you're out in no-man's land and you have to keep it in your car, lock it in the trunk.

2. *Don't* show the whole world that you have lots of expensive photography gear. Drape an old army surplus bag over your regular bag. Keep it close at hand.

From the standpoint of the insurance company, *don't* play mailman by shlepping your camera through rain, sleet, hail, or snow. Your stuff won't last long nor will your policy if you keep making claims to replace damaged equipment.

Finally, let's briefly touch one area about which more and more photographers are concerned: what happens to prints left with galleries or museums? How are they protected by insurance?

Most galleries have a comprehensive policy of insurance coverage for almost every potential hazard short of World War III. Most of these policies contain valuation clauses by which the insurance company can determine how much it can pay for a work that is damaged.

The market value of a work is determined by an independent, qualified appraiser. This appraiser's determination forms the basis of the settlement of a claim. However, it should be noted that works of art may increase in value from one year to the next; accordingly, appraisals should be updated at least once a year.

Some policies contain what is known as a "coinsurance clause," which states that the gallery must carry insurance on 100 percent of the value of all items on its premises. If it doesn't, then any claim will be proportionately reduced. For example, a gallery may have a blanket coverage of $1 million but at the time of a claim its works are valued at $1.6 million. The entire claim would automatically be reduced by three-eights or 37.5 percent. Thus, it would be advisable for a gallery with a coinsurance clause to make regular inventories and report all changes to its insurance company.

TO SUMMARIZE

Camera insurance is not unnecessarily complicated, nor is equipment insurance or any of the other types we mentioned in this chapter. Our objective is to give you an overview of what insurance is available for what purposes.

The best advice comes from an insurance company or agent. Discuss exactly what protection you currently have and what you may want. Don't procrastinate—it's too important.

Taxes

How did Ben Franklin put it? "But in this world nothing can be said to be certain, except death and taxes."

It is an understatement to say that before you enter into any agreement or transaction, it is wise to consider the tax implications. Once your photography business becomes operational, regardless of the business form you choose, the first step toward proper tax management is the computation of what will be deemed taxable. This is known as taxable income, meaning the amount of income subject to tax at the applicable rate.

Let's understand something at the very beginning. You'll have taxes to pay—all sorts of taxes—and primarily you will pay tax on everything except those items which are deemed excluded under the provisions of the Internal Revenue Code. Sounds simple enough, right? Is this code, which governs and sets the rules for what is and isn't taxable or deductible, very complicated? Not really.

The title page is easily understood. From there on, it is all down hill. For example, the code starts with Section 1. From that point to Section 58, you get what is known as the "prelims." Then, from Section 61, it begins to get wild and doesn't end until Section 9042, if you're still around by that time.

There is an old adage about what is and what is not considered income for purposes of taxes. Ask the IRS "why is that included as income?" and the answer you'll get back is, "because it's not excluded."

Let's try and simplify this. First, the monies that come in are termed gross income. You name it, it's gross income. If you are supposed to pay taxes on that, you have what is known as taxable income.

TAXABLE INCOME

For the most part, all receipts of cash are deemed taxable (unless specifically exempted, such as gifts, repayments of loans, life-insurance proceeds, and contributions to the capital of a partnership or corporation). To put this in perspective, the following are the common items which are considered income and are therefore subject to tax:

1. Income derived from a business (your income).

2. Income for services rendered, whether it be salaries, commissions, or fees.

3. Gains from the disposition of business assets.

4. Interest and dividends.

5. Rents and royalties.

6. Shares of profit from a partnership or corporation.

As you can see, it includes just about everything.

You the taxpayer must compute your taxable income and file your income-tax return each year. This is generally done on the basis of a period of time called the tax year. A tax year is considered twelve consecutive months. You've heard the terms calendar year and fiscal year. To explain: a calendar year is twelve consecutive months ending on December 31; a fiscal year is twelve consecutive months ending on the last day of any month but December.

If you're a new taxpayer, you can have either a calendar year or fiscal year. If you're an oldie and want to change from one tax-year computation to another, permission is required from the IRS. If you're the sole proprietor in the business (see Chapter 4), then you must report your business income on an individual tax return, and your business tax year is generally the calendar year.

If you're in a partnership, then you must use the tax year of the principal partners, meaning those having at least a 50 percent interest in the profits of the group. Partnerships are usually on the calendar-year basis.

A corporation, though, is another matter. Its tax year may be either calendar or fiscal, with certain options open to it. Careful planning by a corporation as to the selection of a particular tax year is important. The so-called tax-option corporation can defer income for corporate benefit. For example, inasmuch as the usual distributive shares of income from such a corporation are included in the income of its shareholders for the particular corporate tax year, deferral of income is possible for fiscal-year corporations owned by

calendar-year shareholders. Thus, the undistributed shares of income from a tax-option corporation with a fiscal year ending January 31, 1981, will not be reported until a calendar-year individual shareholder files his 1981 tax return.

Keep in mind that the tax year used by a taxpayer also determines the filing date for his income-tax return. However, employers' quarterly tax returns have to be filed on a calendar year.

Thus taxable income must be computed for the specific year according to a set of rules which determine the time and manner of reporting income and, of course, deductions. That brings us to the next step.

ACCOUNTING METHOD

The accounting method selected must be used consistently; as we have said, permission is required for any change. Suppose a taxpayer does not use a regular method of accounting, or the method he uses does not clearly reflect his income. The IRS has the right to compute the taxable income based upon its own method. Taxpayers may use the cash method, the accrual method, or a combination of both.

The cash method includes all income and expenses as they are received or paid. If you receive property for services rendered, then you must report it at its fair-market value.

By the same token, cash disbursements for prepaid expenses such as interest and insurance must be apportioned to the applicable periods, notwithstanding the accounting method used. Since the receipt of cash or other property governs the time for reporting the income under the cash method of accounting, the taxpayer may defer his income at year's end by avoiding actual or constructive receipt of it.

Likewise, he may accelerate the payment of expenses to increase his deductions. Smaller businesses are usually the ones using the cash method.

The accrual method is different. Taxpayers report income when it is earned, regardless of when payment is received. Thus, acts which determine a photographer's income determine the time of reporting.

Similarly, expenses are deducted when they are incurred, even though they are not paid in the same tax year. Such taxpayers can, however, defer income by delivering and billing as little as possible

during the closing days of a taxable year. Likewise, they can accelerate expenses by ordering and requesting billing of supplies before the end of the year.

It is well established that in order to be tax deductible, expenses must be necessary and directly connected to the taxpayer's business. Deductions for unpaid expenses between related entities (such as a corporation and a shareholder) will not be allowed if they remain unpaid for more than a certain period after the close of the taxable year of the party paying the tax. Accrued salaries and bonuses fall into this area.

A taxpayer who carries a lot of inventory must use the accrual method in accounting for purchases and sales. If the inventory is not substantial, then he can use the cash method. Note that a taxpayer is required to account for inventory if the purchase, production, or manufacture of items that he holds for resale is an important part of his business.

In this regard, most large photographic studios are required to account for inventory. Stocks of film, paper, chemicals, picture frames, albums, mounts, and so on, are all considered items subject to inventory. Studios that purchase these items but maintain no stock on hand are usually not required to account for them as inventory.

Let's turn to the studio that is required to account for inventory in computing its profits.

The computation of what is known as gross profit is essential in order to determine taxable income for those taxpayers using the inventory method. Inventory covers all materials you are holding for resale. It also includes works in progress and whatever supplies become part of the finished product. In fact, even merchandise to which you hold title, such as exhibited works, is included. Goods shipped C.O.D. are part of this, too, at least until payment is received. Inventory is computed by putting a value on the foregoing materials.

We will now take a brief look at the kinds of expenditures that might qualify as deductions.

DEDUCTIONS

As you might expect, we are not going to delve into areas such as medical or dental deductions, contributions to charities, and the like. Instead, we're reviewing some of the business-oriented deduc-

tions that have particular relevance to you, the photographer. For example, the assets of a business refer to the amounts spent for capital expenditures or for improvements to the property which has more than a year's life.

If these expenditures do not qualify as capital, they are deemed deductible expenses when paid or incurred. Examples are such small equipment accessories as batteries, color enlarging filters, and others that last hardly a year.

Once you have determined that your expenditures are for long-lived business assets, you can then determine the tax rate.

Depreciation (which is deductible) can apply to the cost of buildings and other such property. Depreciation is a decrease in the value of property through wear, deterioration, or obsolescence.

Once the depreciable item is determined, the next step in computing actual depreciation is to find out the life expectancy of the particular property. This depends on a number of variables, including age, frequency of use, and repairs. The life expectancy of an item is usually determined by experience. An item's increase in price is not considered. The determination of what will last is the subject of debate, but you should be familiar with what is deemed by many to be the norm with respect to photographic equipment:

Subject	Life Expectancy (in years)
Cameras (hand-held)	4–6
Cameras (view)	6–10
Lenses	5–8
Tripods	5–8
Camera accessories	3–5
Studio lighting	3–6
Electronic flash equipment	3–5
Enlargers	6–10
Projectors	3–5
Miscellaneous darkroom equipment	3–5
Camera bags and cases	2–4

Let's look at some other aspects of taxation with which you may be more familiar. We mentioned the use of a Subchapter S corporation in Chapter 4, and we said that there are tax benefits in this.

A Subchapter S corporation is a domestic corporation that elects to be taxed under the Subchapter S provisions of the Internal Revenue Code. A corporation electing Subchapter S status is *not* subject to federal tax on its income. However, its income or losses are considered the income or losses of all its shareholders in direct propor-

tion to their percentage of ownership. Thus, the income of the corporation is included in the gross income of the shareholders during the taxable year in which the Subchapter S corporate year ends.

A Subchapter S corporation is similar in some respects to a partnership in that it files a return each year with the Internal Revenue Service, but pays no federal income tax. The return is for information purposes only. A corporation elects to be a Subchapter S corporation by filing with the IRS a document signed by the president of the corporation and all of its shareholders during the first seventy-five days of the corporation's taxable year. Once this is decided, the corporation becomes bound for that calendar year unless its status is terminated by the IRS. However, its status can be terminated for subsequent years. In the event it is so terminated, the corporation cannot pick up the Subchapter S status for a period of five years thereafter.

To qualify for Subchapter S status, the corporation must meet certain requirements. First, it must be a domestic corporation with only one class of stock and fifteen or fewer shareholders. (Stock owned by husband and wife, whether together or separately, is considered as stock owned by one person.) Second, the corporation cannot be a member of any group affiliated with other corporations. Third, all of its shareholders must be either individuals, estates, grantor trusts, or voting trusts. Fourth, corporations or types of trusts other than those enumerated above are not allowed as shareholders. Fifth, all shareholders must be residents of the United States.

In addition to the above requirements, the corporation cannot derive more than 80 percent of its gross receipts in any taxable year from sources outside the United States. It also cannot derive more than 20 percent of its gross receipts from rents, dividends, interest, annuities, royalties, sales, or exchange of securities or similar forms. Therefore, Subchapter S status cannot be taken for a corporation whose purpose is to own and lease real estate.

A Subchapter S corporation has distinct advantages. For example, all of the advantages of a corporation (listed in Chapter 4) over other forms of business exist, including the ability to provide fringe benefits to employees, such as medical-reimbursement plans, group-term life insurance, and deferred compensation plans. In addition, losses of the corporation may be used by the shareholders as an offset against their other income.

The advantages of Subchapter S status merits careful consider-

ation. We suggest you discuss it with your accountant or other financial planner.

While you're at it, review some of the following topics:

INDEPENDENT CONTRACTOR STATUS

If you're an employer and you can categorize those working for you as independent contractors rather than employees, you can avoid withholding income and social security taxes, and not have to pay unemployment taxes and your employer share of social security. In some respects, independent contractor status may be advantageous to the worker, too. Business deductions are allowed to self-employed persons who are not employees.

Who is an independent contractor? An individual is generally considered one if he renders his services without the direct and complete control of the party retaining him. An individual is usually deemed an employee if his actions are completely controlled by another.

Of course, it is not all cut and dry. There may be overlapping, but an employee is usually considered an individual who is hired and supervised, who is given a salary with taxes deducted, perhaps medical insurance is offered, and who functions in every capacity under the direction and control of another.

One element characteristic of an employer is the furnishing of a place to work. Naturally, this does not hold true in all instances. It's simply a quick-reference rule of thumb.

The IRS has already determined that a studio which employs freelance portrait photographers taking portraits subject to the studio's direction (such as time, place, pose, and so forth) and which also supplies the film, is treated as an employer. However, if you can show facts different from the above (relating to control and direction), you can have independent contractor status as a freelancer.

ENTERTAINMENT EXPENSES

Generally, these are allowed as a tax deduction if they are directly related to the active conduct of your business. Expenses which are incurred to maintain or to create a business, or continue the good will of one, are also deductible if they are associated with the business itself. But be careful. Deductions made for entertainment facilities such as country clubs and resort hotels are frowned upon by

the IRS and the result is usually an audit of your tax return. The key to a successful deduction of entertainment expenses lies in proper documentation. You must substantiate everything.

Keep records indicating the time date, place, purpose, and party you entertained. *Don't rely on your memory.* Get it in writing. Keep a diary. Save all those bills and receipts, all those cancelled checks and other evidence. The failure to retain and maintain adequate records may mean a disallowance of what could otherwise be deductible expenses.

TRAVEL EXPENSES

These are the necessary expenses incurred while traveling away from your place of residence for your business. However, commuting expenses are not usually deductible.

Corporations and partnerships may adopt plans to reimburse their employees for travel expenses incurred in pursuit of business for the company. Such expenses would not be considered employees' income unless the reimbursements exceed the expenses. Remember that unreimbursed expenses can be deducted by employees, and the reimbursements themselves are deductible by the employer.

ORGANIZATIONAL EXPENSES

A corporation may depreciate certain organizational expenses incurred, but it must elect to do so when it files its return for the first tax year. Such expenses include payment of temporary directors and expenses for organizational meetings, fees paid to the state in order to incorporate, and accounting and legal fees for the preparing of the charter, by-laws, and such.

Only corporations may amortize organizational expenditures; partnerships may only deduct such expenditures for the year the partnership is terminated.

PENSION ARRANGEMENTS

In 1974, federal pension legislation was enacted affecting practically every private retirement plan in the United States. The beauty of pension and retirement plans lies in the fact that contributions are deductible, and the tax-exempt status of those contributions apply until retirement age.

Corporate pension plans usually provide for a maximum of 25 percent of a participant's annual compensation (up to $100,000) as a contribution to a plan in any one tax year. Higher limits may also be applicable.

For self-employed persons, contributions can be made to retirement plans under the Keogh or HR 10 arrangement. This legislation also offers a new plan, known as Individual Retirement Accounts (IRA), for employees and other self-employed individuals not participating in a qualified pension or other retirement plan. These accounts can be established in the form of cash deposits at banks or other financial institutions, or in bonds issued by the U.S. Treasury.

We recommend you consult an accountant or attorney before starting one of these plans.

Before we leave this aggravating subject of taxes, let's look at a particular problem that has arisen.

SALES AND USE TAXES

Many tax audits have recently been made in New York state of the books and records of photographers. Most of these audits were of photographers working primarily in the advertising field. As a result, many of them have had to pay huge sums of money to New York state.

The problem was not limited to New York. Audits were also being conducted in Massachusetts and California. What seemed to be happening was that the state tax bureaus were saying that a photographer using props or wardrobe was the ultimate consumer of those items (they did not transfer the props to their customers) and, therefore, had to pay sales tax when such items were bought or rented *and* had to bill the advertising agency for such items with the applicable tax. This, the photographers screamed, amounted to double taxation.

The tax experts, however, maintained that the client must pay the sales tax on the rental of props, since they are not actually transferred to their customers.

The American Society of Magazine Photographers, the leading voice in professional photography, retained the services of a noted tax attorney, David Lopez of New York City, to research the matter. Mr. Lopez, at the time this section was being written, had just handed down a forty-two-page report detailing the application of New York state sales and use taxes to commercial photographers.

In particular, he looked at the problem of double taxation in connection with the purchase of supplies and services necessary to a photographer in creating his product.

Basically, the report says that unless there is a specific statutory exemption, every sale of a photograph—or of a photographic service—is subject to a sales tax and a local tax. The amount upon which the tax is to be levied includes the photographer's fee or his charge for services, or even the flat price charged for the finished product. It also includes the cost of any props, models, supplies, or services purchased by the photographer and rebilled to the customer. Included are any sales taxes paid by the photographer in acquiring such goods or services. However, it would not apply if the materials are physically transferred to the customer in the form in which purchased or as a physical component part of the end product.

There are five exemptions to the above.

1. Sales intended for resale by the purchaser.

2. Sales where delivery of photographs is made outside the state for use outside the state.

3. Sales to exempt organizations.

4. Sales to a person holding a direct payment permit issued by the state department of taxation and finance.

5. Under a grant of right to reproduce a photograph where the photograph is in no way altered or retouched and remains the property of the photographer.

If a customer claims any of the first four of these exemptions, then the customer must deliver to the photographer a signed certificate (in form approved by the state) attesting to the exemption. If the photographer does not receive such a certificate and does not display it at the time of an audit, then the photographer will be held liable to payment of the tax, notwithstanding the fact that the photographer may not have collected it.

If you're wondering what an exempt organization is, consider these.

1. New York state and its agencies, instrumentalities, public corporations, or political subdivisions.

2. The United States, its agencies and instrumentalities, *except* national banks or federal savings and loan associations and federal credit unions.

3. The United Nations or any international organization of which the United States is a member.

4. Nonprofit organizations organized and operating exclusively for religious, charitable, scientific, testing, or public safety, literary or educational purposes, or for the prevention of cruelty to children or animals.

5. War veterans' posts or organizations organized in New York, no part of the net earnings of which inure to the benefit of any private shareholder or individual.

6. Certain Indian nations or tribes residing in New York state.

Such organizations must deliver to the photographer an exempt organization certificate, as set forth on the following page.

The Lopez report also explains how purchases of photographic supplies may be effected tax free through delivery by the photographer to his supplier of a resale certificate, but only if the supply being purchased will be physically transferred to the customer either in the form purchased or as a physical component of the end product. A resale certificate is included on pages 81 and 82.

Note that machinery and equipment (including cameras and lights) may be purchased tax free through delivery of a resale certificate.

There is another certificate that is used, called the exempt use certificate (see pp. 83–84), in which the purchaser advises that the material purchased is exempt from applicable taxes and submits this certificate to the vendor.

Mr. Lopez offers some basic suggestions. He says that every photographer making retail sales of his product should register with the state department of taxation, obtain a sales tax collection number, collect all appropriate sales tax, file regular reports with the state commission, and pay over such collected sales taxes.

He also feels strongly that every photographer must maintain books and records of sales and income for a minimum of three years following the submission of a tax return.

Mr. Lopez also notes that "although a seller of tangible personal property is made an involuntary agent of the Department of Taxation and Finance for collections, we should not lose sight of the fact that sales tax is primarily a tax levied on purchasers." Thus, Mr. Lopez feels that any photographer "who consistently bills and requires payment from his customers *unless* he has first had delivered to him a purchaser's certificate of exemption is unlikely to run afoul of a significant deficiency assessment."

Appendix A of this book offers a full listing, prepared by the New York State Technical Services Bureau, of the taxable status of sup-

ST-119.1 (1/80)

State of New York - Department of Taxation and Finance - Taxpayer Services Division

New York State and Local Sales and Use Tax

EXEMPT ORGANIZATION CERTIFICATION

VENDOR		EXEMPT ORGANIZATION MAKING PURCHASES
	NAME	
	AND	
	ADDRESS	

THIS CERTIFICATION IS ACCEPTABLE IF THE PURCHASER HAS ENTERED ALL INFORMATION REQUIRED.	CERTIFICATE NUMBER **EX-**

THE UNDERSIGNED HEREBY CERTIFIES THAT THE ORGANIZATION NAMED ABOVE HAS RECEIVED AN EXEMPT ORGANIZATION CERTIFICATE AND IS EXEMPT FROM STATE AND LOCAL SALES TAXES ON ALL ITS PURCHASES.

SIGNATURE OF OFFICER OF ORGANIZATION	TITLE	DATE PREPARED

 Exempt Organization Certifications (ST-119.1) may be used only when an exempt organization is the direct purchaser and payer of record.

 An Exempt Organization Certification must be given to each vendor at the time of the first purchase from that vendor. A separate certification is not necessary for each subsequent purchase provided the exempt organization's name, address, and certificate number appear on the sales slip or billing invoice. The certification is considered part of each order given to the vendor and remains in force unless revoked.

 Vendors must retain the Exempt Organization Certification for at least three years after the date of the last exempt sale substantiated by the certification.

Additional copies of this form (ST-119.1) can be obtained from any State District Tax Office or from the main office of the Taxpayer Assistance Bureau, State Campus, Albany, New York 12227. This form may be reproduced without prior permission from the Department of Taxation and Finance.

ST-120 (6/79) State of New York - Department of Taxation and Finance - Taxpayer Services Division

New York State and Local Sales and Use Tax

<table>
<tr><td>To be completed by purchaser and given to and retained by vendor.

Read Instructions on back of this certificate.</td><td># RESALE CERTIFICATE</td><td>The vendor must collect the tax on a sale of taxable property or services unless the purchaser gives him a properly completed resale certificate or exemption certificate.</td></tr>
</table>

NAME OF VENDOR	DATE
STREET ADDRESS	*Check Applicable Box*
	☐ Single Purchase Certificate
CITY STATE ZIP CODE	☐ Blanket Certificate

The undersigned hereby certifies that he:

holds a valid Certificate of Authority to collect New York State and local sales and use tax.

is principally engaged in *(indicate nature of business)*..

...

intends that the *(check applicable box or boxes)*

A. ☐ tangible personal property is for resale in its present form or as a component part of tangible personal property.

B. ☐ tangible personal property is for use in performing taxable services where such property becomes a component part of the tangible personal property upon which the services are performed or will be actually transferred to the purchaser of the service in conjunction with the performance of the service.

C. ☐ service is for resale.

understands that this certificate may not be used to make tax free purchases of items or services which are not for resale and that he will pay the use tax on tangible personal property or services purchased pursuant to this certificate and subsequently used or consumed in a taxable manner, and that any erroneous or false use of this certificate will subject him to payment of tax plus penalties and interest.

SIGNATURE OF OWNER, PARTNER, OFFICER OF CORPORATION, ETC.	NAME OF PURCHASER
TITLE	STREET ADDRESS
Certificate of Authority Identification Number of Purchaser	CITY STATE ZIP CODE

81

INSTRUCTIONS

A Resale Certificate may be used only to claim exemption from tax on purchases of tangible personal property or services to tangible personal property which will be resold or transferred to a customer (as stated in paragraph A, B or C on the front).

NOTE: Since September 1, 1969, contractors have to

1. Pay the sales tax at the time of purchase.

or

2. Issue a Contractor Exempt Purchase Certificate (ST-120.1) if the tangible property purchased will be used in the manner specified by such certificate.

or

3. Issue a Resale Certificate (ST-120) if the tangible property purchased will be resold without installation.

When property or services are intended for resale and purchased tax exempt with a Resale Certificate, but later used or consumed rather than resold, the purchaser must pay a use tax on the purchase price. In addition, use of any item of tangible personal property manufactured, processed or assembled by the user is taxed on the basis of the price at which other property of the same kind is offered for sale by the user in the regular course of business.

A Resale Certificate in proper form must have all required entries completed by the purchaser. Vendors are protected from liability for failure to collect sales tax when they have a properly completed exemption certificate on file. Failure by a vendor to collect tax, as a result of his acceptance of an improperly completed Resale Certificate, makes him personally liable for the tax, plus penalties and interest. Misuse of a Resale Certificate by a purchaser subjects him to penalties and interest in addition to the tax.

A blanket Resale Certificate may be filed with the vendor by a purchaser to cover additional purchases of the same general type of property or service. However, each subsequent sales slip or purchase invoice, based on such blanket Resale Certificate, must show the purchaser's name, address and Certificate of Authority Identification Number for purposes of verification.

82

ST-121 (8/77)

State of New York - Department of Taxation and Finance

New York State and Local Sales and Use Tax

The vendor must collect the tax on a sale of taxable property or services unless the purchaser gives him a properly completed exemption certificate.

EXEMPT USE CERTIFICATE

NAME OF VENDOR			NAME OF PURCHASER		
STREET ADDRESS			STREET ADDRESS		
CITY	STATE	ZIP CODE	CITY	STATE	ZIP CODE
CHECK APPLICABLE BOX:	☐ SINGLE PURCHASE CERTIFICATE ☐ BLANKET CERTIFICATE		PURCHASER'S CERTIFICATE OF AUTHORITY ID #		

Unless this is marked above as Single Purchase Certificate, it shall be considered part of any order given to you and shall remain in force until revoked by written notice to you.

The undersigned hereby certifies that it is exempt from the applicable Statewide and local sales and use tax as indicated below on purchases to be made from you because the property or services are to be used for an exempt purpose as follows:
(Check appropriate box or boxes)

EXEMPT FROM ALL SALES AND USE TAX

[a] Tangible personal property for use or consumption directly and predominantly in research and development in the experimental or laboratory sense.

[b] Gas, electricity, refrigeration or steam for use or consumption directly and exclusively in research and development in the experimental or laboratory sense.

[c] Cartons, containers, and wrapping and packaging materials and supplies, and components thereof for use and consumption by a vendor in packaging or packing tangible personal property for sale, and actually transferred by the vendor to the purchaser.

[d] Fuel sold to an airline for use in its airplanes.

[e] OTHER (Describe exempt use and section of Tax Law covering this exemption)

SUBJECT TO THE STATEWIDE AND NEW YORK CITY TAX, BUT EXEMPT FROM ALL OTHER LOCAL SALES AND USE TAX

* [f] Tangible personal property other than fuel, gas, electricity, refrigeration or steam for use or consumption in the same way as described in paragraph g below. This exemption includes parts with a useful life of one year or less, supplies used in connection with exempt machinery and equipment, and tools used directly and predominantly in production. See reverse side for the definition of "tools".

SUBJECT TO THE NEW YORK CITY TAX, BUT EXEMPT FROM STATEWIDE AND ALL OTHER LOCAL SALES AND USE TAX

* [g] Machinery or equipment for use or consumption directly and predominantly in the production of tangible personal property, gas, electricity, refrigeration or steam for sale, or telephone central office equipment or station apparatus or comparable telegraph equipment for use directly and predominantly in receiving at destination or initiating and switching telephone or telegraph communication. This exemption includes parts with a useful life of more than one year for such machinery or equipment.

[h] Fuel, gas, electricity, refrigeration or steam for use or consumption directly and exclusively in the production of tangible personal property, gas, electricity, refrigeration or steam for sale.

* NOTE: This certificate can not be used to exempt charges covering installation of production machinery and equipment.

No exemption is allowable for labor charges covering repairs to production machinery and equipment. However, the charge for parts used in such a repair job may be exempt under either paragraph f or g above, provided this charge is separately stated and the parts are incorporated into the machinery or equipment.

_____ _____ _____
Signature of owner, partner, officer Title Date
of purchasing corporation, etc.

83

Instructions to Vendors Concerning Exempt Use Certificate

You may accept this certificate as a basis for exempting sales to the purchaser providing:

a. The Certificate of Authority Identification Number, showing that the purchaser is a registered vendor, is entered on the form.
b. The purchaser has entered all other information required and checked the appropriate items.

A blanket Exempt Use Certificate may be filed with you by a purchaser to cover additional purchases of the same general type of property or service. However, each subsequent sales slip or purchase invoice (excluding utility bills) based on such blanket Exempt Use Certificate, must show the purchaser's name, address and Certificate of Authority Identification Number for purposes of verification.

All sales which are not supported by a properly executed exemption certificate shall be deemed retail sales and the burden of proving the sale is not at retail is upon you as the vendor.

Special Instructions To Purchasers on the Use of this Certificate for Purchases of Fuel, Gas, Electricity, Refrigeration or Steam

If you produce tangible personal property or gas, electricity, refrigeration or steam for sale, you may use this certificate to purchase fuel, gas, electricity, refrigeration or steam without payment of tax to the vendor except for New York City's 4% tax providing:

a. All or part of your purchases of such fuel or utility service qualifies for the exemption described in item h on the front of the form, and
b. *You assume full liability for any state and local tax due on any part of purchases used for other than the exempt purposes described in item h on the front of this form. The taxable portion of these purchases is to be reported by you as a "Purchase Subject to Use Tax" on your Sales Tax Return (Form ST-100 or Form ST-101).*

Definition of "Tools"

As applied to the sales and use tax, the term "tools" refers to hand tools such as are used by carpenters and machinists and does not include parts, attachments or devices which are affixed to a machine in connection with the performance of its functions. Such tools are not exempt under paragraph f on the reverse side unless used in performing direct production functions, such as tightening a nut on a machine being produced for sale.

Special Instructions for Printers and Publishers of Shopping Papers (Chapter 884, Laws of 1977 Effective September 1, 1977)

a. Paper, ink and any other tangible personal property purchased for use in the publication of a shopping paper are exempt from both the statewide and local sales and use taxes if such tangible personal property becomes a physical component part of the shopping paper.

When claiming exemption on the purchase of these items, the purchaser should check Box e, "Others," on the face of this form and enter "for use in producing a shopping paper, Tax Law Section 1115(a)(20)" in the space provided as an explanation of the exemption claimed.

b. The retail sale of a shopping paper to the publisher and the sale of printing services performed in publishing the shopping paper are exempt from the statewide and local sales and use tax.

A publisher claiming exemption on his purchase of the printed shopping papers or the printing service should check Box e, "Other," on the face of this form and enter "purchase of a shopping paper for distribution, Tax Law Section 1115(i)" as an explanation of the exemption claimed.

Definition of a "Shopping Paper"

A "shopping paper" is defined as a community publication variously known as a consumer paper, pennysaver, shopping guide, town crier, dollar stretcher and other similar publications distributed to the public without consideration for purposes of advertising and public information.

To qualify as a shopping paper for the purpose of exemption, the publication must also:

1. Be distributed to the public on a community-wide basis;
2. Be published at stated intervals at least fifty times a year;
3. Have continuity as to title and general nature of content from issue to issue;
4. Contain in each issue news of general or community interest and community notices or editorial comment or articles by different authors;
5. Not constitute a book, either singly or when successive issues are put together;
6. Contain in each issue advertisements from numerous unrelated advertisers;
7. Be independently owned in that the publication is not owned by or under the control of the owner or lessees of a shopping center or a merchants association or similar entity or a business which sells property or services (other than advertising) and the advertisements in such publication are not predominantly for the property or services sold by such business;
8. The advertisements in such publication do not exceed ninety percent (90%) of the printed area of each issue.

The term "shopping paper" does not include mail order and other catalogs, advertising fliers, travel brochures, house organs, theatre programs, telephone directories, shipping and restaurants guides, racing tip and form sheets, shopping center advertising sheets and similar publications.

plies used by photofinishers. This listing will show what items are deemed transferred to the final product and therefore not subject to state and local taxes.

The Lopez report may be obtained by contacting the American Society of Magazine Photographers, 205 Lexington Avenue, New York, NY 10016.

TO SUMMARIZE

This chapter is intended to give you an overview of what is involved in taxation. Certainly, we suggest that you sit down with your accountant and explore your particular situation.

If you're interested in reading further on the subject, we recommend Everything You Always Wanted to Know about Taxes, but Didn't Know How to Ask *by Michael Savage (Dial Press, 1979).*

Legal and Accounting Needs

Should you have an accountant *or* an attorney? Should you have an accountant *and* an attorney? Should you have neither? What you should be able to do is to make your own decision based on the facts at hand. For example, we have already seen the way an attorney fits into the picture. Are you incorporationg? Are you going into a sole proprietorship? Are you leasing space? Are you buying a loft? By now, you should have the answers to those questions regarding your photography business.

As for accountants, we have reviewed the tax and insurance areas. We have looked at record keeping. You should know at this time whether you need the services of an accountant. Remember, unless you have considerable knowledge about taxes and insurance, you should have at your disposal a professional objective enough to advise you about what you are doing and to plan the various elements of your business.

How important is an accountant or financial planner? According to a survey conducted by the American Bar Association in 1977, the highest proportion of lawyer use was in the area of estate planning: a fat 790 consultations per 1,000 people. Thus, people use lawyers, tax attorneys, and other financial experts in estate planning and wills more often than in any other area. This reflects how important the financial aspect of our everyday life is. Keep in mind that the largest single factor in accounting practice concerns taxes. That thoroughly affects the meat and potatoes of your business.

As we have said, an accountant helps set up the records and books and assists in the administration and planning of various insurance and other requirements, from tax filing to pension arrangements.

Should you have an accountant? We strongly suggest you do (unless you really know what to do about these things yourself), and we also recommend that you find someone experienced in the field of photography. This area is getting more and more specialized and is already highly complicated. Make sure you have someone competent in the photographic field.

Now we turn to the attorney. Here you may get a wide range of opinion. There are photographers who swear by attorneys and there are those who swear at them.

To understand better how lawyers fit in, we think it is important to give you an overview of what problems arise with respect to photographers and the law.

The following is a summary of the laws which apply to the photographer. One caution, though: this section is a short and rather sketchy analysis of a highly complex subject. *It is not to be used as a substitute for a lawyer.* If you want something with more body, we immodestly refer you to our book, *Photography: What's the Law?* (revised edition; Crown Publishers, 1979).

In order to digest this a little easier, let's consider the key problems. First of all, how do the laws apply to you, the photographer?

TAKING THE PHOTOGRAPH

For the most part, you can take whatever you want. In other words, you can walk down the street and snap shot after shot. However, keep in mind the following:

1. Don't trespass.

2. Make sure you obey local ordinances. For instance, if your city requires a permit before you can set up a tripod in the park, obtain that permit.

3. Don't be a nudnik. Nobody likes to be harassed.

4. Understand that the law has certain rigid standards as to courtrooms, theaters, museums, and other public places. (For a closer look at this area, see Chapter 12.)

5. The law has certain guidelines regarding money, stamps, securities, flags, seals, etc. When in doubt, consult someone knowledgeable about this field.

Therefore, except for specific limitations, you can pretty much

shoot what you want. How you use that shot involves many more restrictions.

OWNING THE PHOTOGRAPH

We have a new copyright law on the books, and it has changed the complexion of the photographic world more than anything else in the last decade.

Under the old copyright law of 1909, a copyright was considered a single bundle of exclusive rights. The old law regarded copyright as an indivisible entity, which meant that a transfer of less than the entire package of rights to a work was merely a license allowing a holder to use the work in a specific way but did not permit him to exercise any right of ownership. Unless there was a specific agreement signed to the contrary, the one who hired the photographer was deemed the copyright owner.

The new law, which went into effect on January 1, 1978, contains the first explicit statutory recognition of the principle of divisibility of copyright ownership in U.S. law. Its impact is that any of the exclusive rights that make up a copyright can now be transferred and separately owned. This divisibility applies whether or not the transfer is limited in time or place of effect.

In brief, we have the following situation with respect to copyright: under the old law, in the absence of an agreement to the contrary, the person or entity who hired the photographer to take the picture owned it *and* the copyright; under the new law, the shoe is generally on the other foot. The photographer can divest his ownership only by signing an agreement to that effect.

The bottom line is, once you shoot it, you own it! You can give all or part of it away only by a signed agreement. In most transactions you may license a right rather than give away ownership.

USING THE PHOTOGRAPH

When we talk about using a photograph, we find ourselves in the area of releases. Do you need a release? When do you need one? What kind of release do you need? Keep the following in the forefront of your mind: use of photographs in the news and educational areas generally does *not* require a release. Use of photographs in advertising and for purposes of trade *does* require a release.

The best rule is to acquire a release, if possible, under all circumstances. You may not know precisely what use will be made of the photograph, and you want to insure as wide protection as possible. (We include sample forms of releases on p. 94–96.)

When you utilize a photograph without a release—which pretty much means without authorization—you may find yourself hit with a hefty lawsuit for invasion of privacy. Let's differentiate a few terms. Invasion of privacy is an injury to one's right to be left alone. Libel is deemed an injury to one's reputation; for example, when you read or see something false about someone. (Slander is the same as libel—injury to one's reputation—but it is via the spoken word.)

As you can see, libel and invasion of privacy frequently join hands in the same action, and you could find yourself on the receiving end of a million-dollar lawsuit if you haven't protected yourself sufficiently.

The best way to protect yourself from liability for libel is to caption every photograph and print that you make. Then, if the ultimate user of the photograph miscaptions or deletes your caption and adds his own, he will be solely responsible for any libel which may eventually occur.

These are the grounds on which most photographers are sued. To advise you to be careful is a gross understatement.

Be aware that you, the photographer, must understand that it is the manner and context of the use of a person's photograph that will determine whether that person's privacy has been invaded. It is not always the nature of the photograph itself. If you don't know the ultimate purpose of the photograph, then get a written release, making sure it's the proper form for the purpose.

COPYRIGHTING THE PHOTOGRAPH

We mentioned having certain items on every print that goes out of your shop. Immediately upon having the film processed, make sure that a copyright legend is placed on the back of every black-and-white negative and on the mount of every transparency. Every print, too, should have the legend. This way, you will prevent any dedication to the public (the public domain), and you will have served notice to the world that the work is owned by you.

What is a copyright legend? "Copyright © 1980 by Peter Photographer. All rights reserved."

There is plenty more to learn about copyright, such as term of copyright, assignment, fair use, reproduction, and more. For a greater exposure to this highly important subject, you can check our book or you can write to the Register of Copyrights, Library of Congress, Washington, DC 20559 and ask for the materials on the new copyright law. You will receive free of charge a large gray manila folder chock-full of forms, circulars, and suggested ways of protecting your work. Every photographer should have this material on hand.

Remember that only you, the photographer, has the copyright in what you create and only you, the photographer, can determine how you will dispose of it.

OBSCENE PHOTOGRAPHS

The problems of defining and controlling obscenity—whether in the electronic or print media or in motion pictures—are among the most tangled in all of American law. Most of the time, the target is the vendor, the distributor of the material. Bear in mind that it is not the taking of the photograph which is of prime importance; it is its distribution. In other words, how it is being used.

Basically, it has been left to the states to determine what is obscene within their particular communities. The biggest problem is in determining what the phrase "community standards" means. Is North Carolina like South Carolina? Would West Virginia agree with Virginia? Would Albany, New York, have the same values as New York City? And what is a community anyway? Would Kentucky have 120 community standards because it has 120 counties? After all, the same legal entanglements which closed *Deep Throat* in New York City might be used to censor Fielding's *Tom Jones* in Omaha or Hermann Hesse's *Narcissus and Goldmund* in Key Biscayne. (For a look at some of the latest legislation, see Chapter 12.)

LOSS OF THE PHOTOGRAPH

What happens when you send photographs to someone else? For one thing, they can be bought. That's good. For another, they can be lost. That's bad. They can also be damaged, they can be retained for too long a period, and they can be used without your consent and without payment. That's very bad.

Most photographers, as well as users of photography, have been completely ignorant of what value photographs and transparencies have, and what rights the parties have as to liability.

Each photograph stands on its own. It is immaterial whether it is part of a sequence or not. A photograph is an accounting of a specific time and place. Therefore, the first and foremost rule is for the photographer never to send something out of his shop without proper papers attached to it. We have already mentioned the copyright notice, and later we will show you the actual piece of paper suggested when a photograph puts on its traveling sneakers. For now, understand two concepts relating to liability and damages.

First, under the law, a customer will be held liable for those materials he has asked to be sent to him, since he has had an opportunity to reject the materials or the document that may have been attached to same. Instead, he chose to keep them. There are variables here, but the basic premise is, "Where the offeree takes or retains possession of property which has been offered to him, such taking or retention in the absence of other circumstances is an acceptance." (Williston, *A Treatise on the Law of Contracts*, third edition, Section 91, pages 319–22.)

What kind of liability applies? What we are talking about is the value of a photograph. There are certain ways in which this can be determined. One is the actual value of the photograph in question, which can be determined by its prior use, the leasing fees commanded, and the extent of usage.

In the absence of market value, we have what is known as intrinsic value. Intrinsic value can be determined by showing the nature of the property, the cost of obtaining the photographs, the purpose for which they were procured, and the difficulty of replacing them. In other words, you could take into consideration the value of the property to you.

The final way to determine value is by the stipulated damage provision. This means the compensation which the parties agreed in advance would be paid for loss or damage to a property. This is the kind of clause you put in a contract and its purpose is apparent: to permit the parties to look to the future, anticipate that there may be a breach, and arrange for a settlement in advance. The courts have dealt with loss or damage to transparencies and we have detailed some of those cases in *Photography: What's the Law?* (Also, check Chapter 12 of this book for additional information.)

What you must consider is that liability is generally determined

by the contractual arrangements between the parties. Absence of a contract relegates the photographer to other areas of the law for collection purposes.

THE TRUTH OF YOUR PHOTOGRAPH

In Chapter 3, we discussed briefly the question of truth-in-advertising, particularly as it applied to food photography. Generally, it should be noted that the photographer will not be held liable for deception if he did not know anything about it.

But even then, the photographer must watch himself carefully. He must learn to protect himself against any claims of fraud as a participant to deception. The consequences are evident. The general rule is this: if the subject matter to be photographed is clearly misleading in size, content, or form, beware. A way to protect yourself contractually is by using a release or indemnification form. Here are some of the ways, in living black and white, that you can protect yourself contractually.

PUT IT IN WRITING

The forms we are including here are simply those that have been developed from talking to photographers and seeing which provisions are used in the industry. You could say that these forms are pretty much standard terms and conditions based on custom and usage in the trade. Naturally, should you require something additional or need to modify a particular provision based on your own needs, feel free to do so. Everything should be tailor-made to your own requirements. These forms are intended to give you a starting point from which to build.

RELEASES

You are out shooting people. They are adults. You don't know for what purpose the shots will be used. Thus, you have the adults sign the following:

ADULT RELEASE

In consideration of my engagement as a model, upon the terms hereinafter stated, I hereby grant , his legal representatives and assigns, those for whom he is acting, and those acting with his authority and permission, the absolute right and permission to copyright and use, reuse and publish, and republish photographic portraits or pictures of me or in which I may be included, in whole or in part, or composite or distorted in character or form, without restriction as to changes or alterations from time to time, in conjunction with my own or a fictitious name, or reproductions thereof in color or otherwise made through any media at his studios or elsewhere for art, advertising, trade, or any other purpose whatsoever.

I also consent to the use of any printed matter in conjunction therewith.

I hereby waive any right that I may have to inspect or approve the finished product or products or the advertising copy or printed matter that may be used in connection therewith or the use to which it may be applied.

I hereby release, discharge, and agree to save harmless , his legal representatives or assigns, and all persons acting under his permission or authority or those for whom he is acting, from any liability by virtue of any blurring, distortion, alteration, optical illusion, or use in composite form, whether intentional or otherwise, that may occur or be produced in the taking of said picture or in any subsequent processing thereof, as well as any publication thereof even though it may subject me to ridicule, scandal, reproach, scorn, and indignity.

I hereby warrant that I am of full age and have every right to contract in my own name in the above regard. I state further that I have read the above authorization, release, and agreement, prior to its execution, and that I am fully familiar with the contents thereof.

_____ _____(L.S.)

 Date

 (Address)

 Witness

Wait a minute! There's a child in the frame. You better get a release signed which applies to a minor. Use the following form:

MINOR RELEASE

In consideration of the engagement as a model of the minor named below and upon the terms hereinafter stated, I hereby grant his legal representatives and assigns, those for whom he is acting and those acting with his authority and permission, the absolute right and permission to copyright and use, reuse and publish and republish photographic portraits or pictures of the infant or in which the infant may be included, in whole or in part, or composite or distorted in character or form, without restriction as to changes or alterations from time to time, in conjunction with the infant's own or a fictitious name, or reproductions thereof in color or otherwise made through any media at his studios or elsewhere for art, advertising, trade, or any other purpose whatsoever.

I also consent to the use of any printed matter in conjunction therewith.

I hereby waive any right that I or the infant may have to inspect or approve the finished product or products or the advertising copy or printed matter that may be used in connection therewith or the use to which it may be applied.

I hereby release, discharge, and agree to save harmless , his legal representatives or assigns, and all persons acting under his permission or authority or those for whom he is acting, from any liability by virtue of any blurring, distortion, alteration, optical illusion, or use in composite form, whether intentional or otherwise, that may occur or be produced in the taking of said picture or in any subsequent processing thereof, as well as any publication thereof even though it may subject the infant to ridicule, scandal, reproach, scorn, and indignity.

I hereby warrant that I am of full age and have every right to contract for the infant in the above regard. I state further that I have read the above authorization, release, and agreement, prior to its execution, and that I am fully familiar with the contents thereof.

_____	_____(L.S.)
Date	(Father) (Mother) (Guardian)
_____	_____
(Minor's Name)	(Address)
_____	_____
(Minor's Address)	(Witness)

You're not through as yet. There's a nice building to shoot, and here's a nice property release to use:

PROPERTY RELEASE

For good and valuable consideration herein acknowledged as received, the undersigned being the legal owner of, or having the right to permit the taking and use of photographs of certain property designated as _____

does grant to _____ , his agents, or assigns, the full rights to use such photographs and copyright same, in advertising, trade, or for any purpose.

I also consent to the use of any printed matter in conjunction therewith.

I hereby waive any right that I may have to inspect or approve the finished product or products or the advertising copy or printed matter that may be used in connection therewith or the use to which it may be applied.

I hereby release, discharge, and agree to save harmless _____ , his legal representatives or assigns, and all persons acting under his permission or authority or those for whom he is acting, from any liability by virtue of any blurring, distortion, alteration, optical illusion, or use in composite form, whether intentional or otherwise, that may occur or be produced in the taking of said picture or in any subsequent processing thereof, as well as any publication thereof even though it may subject me to ridicule, scandal, reproach, scorn, and indignity.

I hereby warrant that I am of full age and have every right to contract in my own name in the above regard. I state further that I have read the above authorization, release and agreement, prior to its execution, and that I am fully familiar with the contents thereof.

_____ _____

Date

_____ _____

Witness (Address)

You now have a batch of marketable photos and an interested party, so you prepare the photos for submission. Off they go, *but* with a delivery memo accompanying them. Here's what that delivery memo will say:

Delivery Memo

To:

Attention:
Phone no.:

Delivery no.:
Date:
Total color:
Total B&W:
Subject:

Please contact us before using these photos. Photos incorrectly credited are subject to a 50% penalty.

The materials listed above must be returned to us in the same condition as delivered. The terms and conditions set forth on the reverse side are deemed incorporated herein and made a part thereof.

SUBJECT TO TERMS BELOW

Terms Relative to Submission

1. Photographs or transparencies (hereafter "photographs") may be held for fourteen (14) days approval. Unless a longer period is requested and granted by us, in writing, a holding fee of Five ($5.00) Dollars per week per color transparency and One ($1.00) Dollar per week for black-and-white positive will be charged after such fourteen-day period and up to the time of return.

2. Photographs may not be used in any way, including layouts, sketches or photostats, until submission of an invoice indicating Recipient's right to use same, or indicating purchase of the photographs outright, which shall be only on terms of use hereinafter specified.

3. Recipient is responsible for loss or damage to the photographs delivered to it, from time of receipt until their return to us. Recipient shall be responsible for safe delivery and return of photographs to us and shall indemnify us against any loss or damage to photographs in transit or while in the possession of Recipient. This agreement is not considered a bailment and is specifically conditioned upon the item so delivered being returned to us in the same condition as delivered. Projection of transparencies is not permitted. Recipient assumes an insurer's liability herein for the safe and undamaged return of the photographs to us. Such photographs are to be returned by bonded messenger or by registered mail (return receipt requested,) prepaid and fully insured.

4. The monetary damage for loss or damage of an original transparency or photograph shall be determined by the value of each individual photograph. Recipient agrees, however, that the reasonable minimum value of such lost or damaged photograph or transparency shall be no less than Fifteen Hundred ($1500) Dollars. We agree to the delivery of the goods herein only upon the express covenant and understanding by Recipient that the terms contained in this Paragraph 4 are material to this agreement. Recipient assumes full liability for its employees, agents, assigns, messengers, and freelance researchers for the loss, damage, or misuse of the photographs.

Terms as to use

5(a). Unless otherwise specifically stated, photographs and transparencies (hereafter "photographs") remain our property or the particular photographers. Upon submission of an invoice by us, a license only is granted to use the photographs for the use

specified on the invoice and for no other purpose, unless such photographs are purchased outright. Such use is granted for the United States only, unless otherwise specified. Recipient does not acquire any right, title, or interest in or to any photograph, including, without limitation, any electronic reproduction or promotional rights, or the right to reproduce the photograph by any means or in any form, and will not make, authorize, or permit any use of the particular photograph(s) or plate(s) made therefrom other than as specified herein.

(b). Photographs are to be returned within four (4) months after date of invoice, except in cases of outright purchase. Recipient agrees to pay, as reasonable charges, the sum of Five ($5.00) Dollars per week per photograph after such four-month period to date of return.

6. Recipient is solely responsible for loss or damage to photographs and will indemnify us against any loss or damage, commencing with receipt by Recipient of such photographs until their return to, and receipt by us. In this connection, Recipient assumes an insurer's liability herein for the safe and undamaged return of the photographs to us. Such photographs are to be returned either by bonded messenger or by registered mail (return receipt requested,) prepaid and fully insured.

7. The monetary damage for loss or damage of an original color transparency or photograph shall be determined by the value of each individual photograph. Recipient agrees, however, that the reasonable minimum value of such lost or damaged photograph or transparency shall be no less than Fifteen Hundred ($1500) Dollars. We agree to the delivery of the goods herein only upon the express covenant and understanding by Recipient that the terms contained in this Paragraph 7 are material to this agreement. Recipient assumes full liability for its employees, agents, assigns, messengers, and freelance researchers for the loss, damage, or misuse of the photographs.

8. No model releases or other releases exist on any photographs unless the existence of such release is specified in writing by us. Recipient shall indemnify us against all claims arising out of the use of any photographs where the existence of such release has not been specified in writing by us. In any event, the limit of our liability shall be the sum paid to it per the invoice for the use of the particular photograph involved.

9. This agreement is not assignable or transferable on the part of the Recipient.

10. Only the terms of use herein set forth shall be binding upon us. No purported waiver of any of the terms herein shall be binding on us unless subscribed to in writing by us.

11. Time is of the essence in the performance by Recipient of its obligations for payments and return of photographs hereunder. No rights are granted until payment is made to us even though Recipient has received an invoice.

12. Payment herein is to be net thirty (30) days. A service charge of two (2%) percent per month on any unpaid balance will be charged thereafter. Any claims for adjustment or rejection of terms must be made to us within ten (10) days after receipt of invoice. In the event that any photographs are used by Recipient in publications, then Recipient shall send to us on a semiannual basis (June 30 and December 31), a certified statement setting forth the total number of sales, sublicenses, adaptations, translations, and any other uses. Recipient shall provide us with two (2) free copies of such publication immediately upon printing.

13. Photographs used editorially should bear a credit line as indicated by us. Recipient shall provide copyright protection to the photograph. Such copyright shall be immediately assigned to us upon request, without charge.

14. All rights not specifically granted herein to Recipient are reserved for our use and disposition without any limitations whatsoever.

15. Recipient agrees that the above terms are made pursuant to Article 2 of the Uniform Commercial Code and agrees to be bound by same, including specifically the clause to arbitrate disputes.

Disputes or Claims Arising Out of Submission and/or Use
16. Any and all disputes arising out of, under or in connection with this agreement, including, without limitation, the validity, interpretation, performance and breach hereof, shall be settled by arbitration in New York City, New York, pursuant to the rules of the American Arbitration Association. Judgment upon the award rendered may be entered in the highest court of the Forum, State or Federal, having jurisdiction. This agreement, its validity and effect, shall be interpreted under and governed by the laws of the State of New York.

You figure that the client may want to retain some photos at this time for further consideration. Or, perhaps he's ready to buy or license something. You're going to be fully prepared. You have a confirmation memo included, which gives the client directions as to what he is receiving and how to proceed.

The agreement which covers this aspect follows:

Confirmation Memo

Please Complete and Return This Form to Us

Dear Client:

For your convenience and protection please follow directions below:

1. Check this delivery to make sure it includes all photos listed on the attached Delivery Memo.
2. Keep the Delivery Memo for your records.
3. List in the space provided below serial numbers of color, subject description, and photographer's name of b&w prints. Check the appropriate boxes, date, sign, and return this form to us.

MATERIALS MUST BE RETURNED TO US IN THE SAME CONDITION AS DELIVERED

List Below Only the Photos You Are Holding

_____Bill Us for_____
_____Bill Us for Service Fee
_____Bill Us for Layout
_____Bill Us for Presentation
_____Bill Us for Artist Reference
_____Holding for Consideration
_____Holding for Use
_____None Used/All Returned
_____Purchase Order Enclosed
_____Will Send Purchase Order
_____Photostated for Possible Use

Total Photos Being Held:
B&W_____Color_____

Remarks:

Company: _____ Our Delivery No.: _____
 _____ Delivery Date: _____
 _____ Date of Return: _____

Person Requesting Photos: _____ _____
 Signature of Person Returning
 Photos

The terms and conditions set forth on the reverse side are deemed incorporated herein and made a part thereof

SUBJECT TO TERMS BELOW
(See pp. 98–100)

Also, keep your own log of what is happening. Use the following control form.

Delivery Follow Form

Name of Company: _____ Our Leasing Memo No. ____
Person Sent to: _____ Date Leased: _____
Phone Number: _____

Date	Person Spoken to	Remarks

You're clicking right along. And when the client calls you up and tells you that he's decided to take *everything* you've submitted, you are ready with the next form. Out comes the invoice, the self-explanatory invoice. You fill in the numbers, naturally.

Invoice

To: _____ Our Invoice No.: _____
 _____ Our Delivery Memo: _____
 _____ Your P.O. No.: _____
 _____ Your Job No.: _____
Date of Billing: _____ Your Client/Product:_____

Description and Number	Amount

The materials listed above must be returned to us in the same condition as delivered. Service charge of 2% per month will be added on all balances over 30 days past due. The terms and conditions set forth on the reverse side are deemed incorporated herein and made a part thereof.

SUBJECT TO TERMS BELOW
(See pp. 98–100)

Suppose a client calls you up and wants you to do an assignment; in other words, to go out and shoot something specific.

The first thing you want to do is to make certain you understand everything that is involved. Many photographers make the tragic

mistake of just saying "yes" and grabbing their knapsack and taking off. Slow down. Start acting like a professional. The first thing you do is to detail, in writing, what it is you are to be doing, when you are to be doing it, what you are being paid, when you are being paid, who is getting what and when and how.

To aid you in this time of distress, we recommend that you immediately put to use an assignment confirmation memo which sets forth all of the elements we just mentioned, and many more. In this way, the deal is clear and unambiguous. Everyone understands, or should understand, what is expected of the parties and when. This saves a lot of aggravation later on.

Assignment Confirmation Form

To: _____ Date: _____

You hereby engage the undersigned to render photographic services for you as follows:

1. Nature of services: _____
2. Length of services: _____
3. Date to commence: _____
4. Fee to be paid _____
5. Color_____ Quantity _____
6. B&W_____ Quantity _____

7. Expenses to Be Paid:
 Assistants _____
 Film and processing _____
 Per diem _____
 Special equipment _____
 Studio rental _____
 Telephone and messengers

 Travel _____
 Other (specify) _____

8. Fee Paid According to:
 Day rate _____
 Page rate _____
 Cover rate _____
 Per photo used _____
 Other _____

9. Size and Location of Use:
 Cover _____
 Inside _____
 Sizes of use _____

10. Amount of Rights Granted:
 One-Time Nonexclusive _____
 One-Time Exclusive _____
 First-Time Rights _____
 Specify Period _____
 Other _____

11. Type of Rights Granted:
 Promotional _____
 Catalog _____
 Corporate report _____
 Annual report _____
 Slide film _____
 Internal organ _____
 Brochure _____
 AMOUNT _____
 Direct mail _____
 AMOUNT _____
 Records _____
 Cover _____
 Inside _____
 Magazine _____

Cover _____

Inside _____

Newspaper _____

Trade book _____

Textbook _____

Encyclopedia _____

Calendar _____

Posters _____

Trade ads _____

Specify _____

Other (specify) _____

12. Areas of Distribution:

U.S. solely _____

North America _____

English-language countries

Other foreign _____

Specify _____

World rights _____

13. Assignment Interruption:

Cancellation fee _____

Postponement fee _____

14. Return of Material:

Accepted material
returnable within _____

Rejected material
returnable within _____

SUBJECT TO TERMS ON REVERSE SIDE. ALL TERMS APPLY UNLESS OBJECTED TO IN WRITING WITHIN TEN (10) DAYS.

_____ _____

Photographer Client

TERMS AND CONDITIONS

1. All transparencies and photographs (herein collectively called "photographs") remain my property and, except as specifically set forth on the reverse side hereof, you do not acquire any other right, title, or interest in or to any photograph. Photographs may not be used in any way until submission of an Invoice indicating sale of right to use the same.

2. You are solely responsible for loss or damage to photographs and will indemnify me against any loss or damage, commencing with receipt by you of such photographs until their return to, and receipt by, me. In this connection, you assume an insurer's liability herein for the safe and undamaged return of the photographs to me. Such photographs are only to be returned either by bonded messenger or by registered mail (return receipt requested,) prepaid and fully insured.

3. The monetary damage for loss or damage of a photograph shall be determined by the value of such photograph. If the pho-

tograph so lost or damaged has no market value in that there has been no prior use, then in the absence of market value, the monetary damage shall be determined by the intrinsic value of such photograph. You shall be liable for all acts of your employees, agents, assigns, messengers, and freelance researchers for all loss, damage, or misuse of the photographs.

4. Photographs used editorially shall bear a credit line to me. If there is a failure to provide such a credit line, then I shall be entitled to twice the fee set forth on the reverse side hereof. You shall provide copyright protection to the photograph granted to you. Such copyright shall be immediately assigned to me, upon my request, without charge.

5. If requested, I shall provide model releases on any photographs delivered to you provided such photographs warrant such releases. You shall indemnify me against all claims arising out of the use of any photographs where the existence of such release has not been requested in writing by you. In any event, the limit of my liability shall be the sum paid to me pursuant to this agreement for the use of the particular photograph involved.

6. This agreement is not assignable or transferable on your part.

7. Time is of the essence in the performance by you of your obligations for payments hereunder. All payments must be made within thirty (30) days from the date hereof.

8. Only the terms herein set forth shall be binding upon me. No purported waiver of any of the terms herein shall be binding on me unless subscribed in writing by me.

9. All rights not specifically granted herein to you are reserved for my use and disposition without any limitation whatsoever.

10. Any and all disputes arising out of, under, or in connection with this agreement, including without limitation, the validity, interpretation, performance, and breach hereof, shall be settled by arbitration in New York, New York, pursuant to the rules of the American Arbitration Association. Judgment upon the award rendered may be entered in the highest court of the Forum, State or Federal, having jurisdiction. This agreement, its validity and effect shall be interpreted under and governed by the laws of the State of New York. You shall pay all costs of arbitration, plus legal interest on any award.

11. Time is of the essence in the performance by you of your obligations for return of materials.

12. You agree that the above terms are made pursuant to Article 2 of the Uniform Commercial Code and you agree to be bound by same.

You remember that we used an invoice for photos that were submitted to a client. There is no difference in the assignment; an invoice should still be submitted. For instance, this one:

Assignment Invoice

Invoice No._____
Date:_____

Amount of Rights Granted:

Type of Rights Granted:

Description of Photographs:

COLOR	BLACK-AND-WHITE	FEE

Expenses: EXPENSE REIMBURSEMENT

Total_____

SUBJECT TO TERMS ON REVERSE SIDE PURSUANT TO ARTICLE 2, UNIFORM COMMERCIAL CODE.

TERMS AND CONDITIONS OF USE

1.(a) Photographs remain the property of (" "), or the particular photographers. User does not acquire any right, title, or interest in or to any photograph, including, without limitation, any electronic or promotional right, and will not make, authorize, or permit any use of the particular photograph(s) or plate(s) made therefrom, other than as specified herein. All photographs are to be returned within four (4) months after date of this Invoice, except in cases of outright purchase.

(b) User agrees to pay as reasonable charges, the sum of Five ($5.00) Dollars per week per color transparency and One ($1.00) Dollar per week per black-and-white positive to after such four (4) month period, to date of return.

2. User is solely responsible for loss or damage to photographs and will indemnify against any loss or damage, commencing with receipt by User of such photograph until its return to, and receipt by . In this connection, User assumes an insurer's liability herein for the safe and undamaged return of the photographs to . Such photographs are only to be returned either by bonded messenger or by registered mail (return receipt requested,) prepaid and fully insured.

3. The monetary damage for loss or damage of a photograph shall be determined by the value of such photograph. User agrees that the reasonable minimum value of such lost or damaged photograph shall be no less than Fifteen Hundred ($1500.00) Dollars for a color transparency or black-and-white negative. User acknowledges that this clause is essential and material to the making of this agreement. User shall be liable for all acts of its employees, agents, assigns, messengers, and freelance researchers for all loss, damage, or misuse of the photographs.

4. Photographs used editorially shall bear a credit line as indicated by . User shall provide copyright protection to the photograph granted to it. Such copyright shall be immediately assigned to , upon his request, without charge.

5. No model releases or other releases exist on any photographs unless the existence of such release is specified, in writing, by . User shall indemnify against all claims arising out of the use of any photographs where the existence of such release has not been specified in writing by . In any event, the limit of liability of shall be the sum paid to him pursuant to this Invoice for the use of the particular photograph involved.

6. This agreement is not assignable or transferable on the part of User.

7. Time is of the essence in the performance by User of its ob-

ligations for payments and return of photographs hereunder. No rights are granted until payment is made to even though User has received this Invoice.

8. Only the terms of use herein set forth shall be binding upon . No purported waiver of any of the terms herein shall be binding on unless subscribed in writing by

9. Payment herein for such use is to be net ten (10) days. A service charge of one-and-one-half (1½%) percent per month on any unpaid balance will be charged thereafter. Any claims for adjustment or rejection of terms must be made to within ten (10) days after receipt of this Invoice. In the event that any photographs are used by User in publications, then User shall send to on a semiannual basis (June 30 and December 31) a certified statement setting forth the total number of sales, sublicenses, adaptations, translations, and any other uses. User shall provide with two (2) free copies of each publication immediately upon printing.

10. All rights not specifically granted herein to User are reserved for 's use and disposition without any limitations whatsoever.

Disputes or Claims Arising out of Use

11. Any and all disputes arising out of, under or in connection with this agreement, including without limitation, the validity, interpretation, performance, and breach hereof, shall be settled by arbitration in New York, New York, pursuant to the rules of the American Arbitration Association. Judgment upon the award rendered may be entered in the highest court of the Forum, State or Federal, having jurisdiction. This agreement, its validity and effect shall be interpreted under and governed by the laws of the State of New York. The User shall pay all costs of arbitration, plus legal interest on any award.

12. No electronic reproduction rights or promotional rights are granted herein unless specifically stated.

13. User agrees that the above terms are made pursuant to Article 2 of the Uniform Commercial Code and agrees to be bound by same.

If you're not completely form-weary by now, we have one more for you to consider. Most of the professional photographers in this country are generalists; they do everything. Many of these photographers have studios and do a wide variety of work, ranging from bar mitzvahs to portraits to food shots, and so on. A photographer working in a specialized field needs a special kind of contract, one in tune to his particular needs and the customs that apply.

Take a look at the following. It may just serve your needs.

Bar Mitzvahs	Commercial	Weddings	Confirmations	Movies

The undersigned hereby engages _____ Studio to take color photographs as set forth below:

Name Of Place	Address	Date	Time

Name: Name:

Address: Address:

City: Zip: City: Zip:

Phone: Phone:

Job Description	Quantity of Prints	Type of Album	Approx. Size	Price	Extras	Remarks
Movies						

Remarks:			Cover Information
	Portraits		
	Heavy Oil		Design #
	T/Y Cards		Color
	Other		Date
	Contract Total		

Deposit on Contract	Date Rec'd.
Additional Payment Date of Affair	Day of Affair
Final Payment on Selection (but no later	
than)	
Tax	

_____ _____
Customer's Signature Studio

TERMS AND CONDITIONS OF USE

1. All negatives and proofs remain the sole and exclusive property of Studio. The customer shall have the right, subject to the approval of Studio, to order future prints or albums at the prevailing rate at the time of the reorder.

2. Time is of the essence with regard to payment and a service charge at the rate of two (2%) percent per month on any unpaid balance will be charged thereafter. The customer agrees to pay all collection costs, plus reasonable attorneys' fees for collection.

3. If the customer fails to make payments, as set forth, all obligations of Studio shall cease and the customer shall have no recourse.

4. Studio agrees only to deliver proofs or prints reasonably acceptable in the industry. Failure of the customer to object, in writing, to Studio within ten (10) days after receipt of proofs, prints, or albums, shall constitute a waiver.

5. Studio, its employees or assigns, shall not be liable for nonperformance if caused by illness, accident, or other unavoidable cause, such as acts of God, strikes, threats, force majeure, or due to any cause beyond its control; nor for loss or destruction of prints or proofs in transit or in developing; nor for any acts or omissions unless caused by 's gross negligence. In any event, the limit of 's liability, or that of its employees or assigns, shall be no more than the contract price.

6. No trade, custom, or usage shall affect the agreement and the terms thereof.

7. Color fidelity of prints shall be that which is applicable in the industry. No warranty is made as to color fidelity.

8. Acceptance of prints or albums constitutes a release of all claims against Studio, its employees, agents, or assigns.

9. This agreement is not to be construed as an employment contract, but rather Studio is an independent contractor.

10. No change, addition, or erasure of any portion of this agreement (except the filling in of blank lines) shall be valid or binding. There are no oral agreements or representations between the parties and this written agreement supersedes all prior agreements.

11. This contract is to be interpreted solely by the laws of the State of New York. Any litigation arising out of this agreement must be conducted in the State of New York.

12. The customer agrees that Studio may display or publish any of the prints taken pursuant to this agreement and the customer consents to same.

13. There shall be no refunds of any monies paid if affair is cancelled; and full sum is owed when affair is photographed, regardless of selection or not.

Suppose you use all the forms and you still get burned. Suppose you enter into a contract to supply someone with two photos from your stock library; the photos are supplied and you render your bill for $500 and it goes unpaid for six months. Calls and letters to the client fall on the floor. It is time to take action. What do you do?

Obviously, the simplest way to settle any dispute is to get the party to sit down at the bargaining table with you over a glass of Perrier. However, if that doesn't work, then you have to resort to legal action. This can take the form of suing in the applicable court or bringing the matter into arbitration.

We have no intention of turning this into a law book, but you should understand some aspects of what's involved if you decide to sue somebody.

By and large, the United States has fifty-one court systems: one at the federal level and one for each state. You can only go into federal court if the matter involves federal taxes, patents, treason, and other national concerns, or you are appealing a lower court decision which has been adverse to you. In addition, under the new copy-

right law, actions involving copyright matters (such as infringement of copyright) can only be brought in the federal court.

The state court is something else. Each state has its own court system and the jurisdiction of the state courts is generally dictated by the state's laws. The state court system is pretty much broken down into various aspects as for example, criminal, family, probate, and traffic courts.

A third level of the court system, and the one that many photographers use, is small claims court. This court is perhaps the most misunderstood and underused system of them all; yet, people who have used it found it to be quick, fair, and inexpensive.

The purpose of this court is to handle a case as expeditiously as possible. Each state (and many times, areas within a state) has its own set of rules, but the basic procedures are pretty much the same. For example, in New York, if you have a claim for under $1,000, you can bring your suit in small claims court without a lawyer. The clerk of the court will help you fill out the necessary forms and will take care of serving the other party with the summons and complaint.

The court then sets a date for the matter to be heard. You show up at that time and tell your troubles to the judge. That's it. The judge will hear the other side, too, and render a decision.

To aid you somewhat, we have included as Appendix B a state-by-state listing of the basic rules pertaining to small claims actions. A caveat: these rules can become outdated rather quickly. Therefore, always double-check with the clerk of the court in your jurisdiction for any changes.

Another way to bring an action is through arbitration. You use the American Arbitration Association (known as the AAA, but with no connection to the automobile people). In order to commence arbitration, both parties must consent to this forum.

Basically, arbitration is an informal proceeding by which the parties select their own judges and have the controversy heard within a relatively short time.

The AAA does have stringent rules that apply to such a proceeding, and these must be adhered to. We include in Appendix C the addresses and telephone numbers of the American Arbitration Association's regional offices. By contacting the office in your area, you can receive information as to the procedure to be followed for commencing an arbitration.

The arbitration itself usually takes place around a table. It is an informal gathering and the strict rules of courtroom procedure are

generally dispensed with. After the hearing, the arbitrator or arbitrators will render an award. It sometimes takes thirty days for an award to come down; rarely longer.

Obviously, the single largest appeal of this forum for settling disputes is its civility. Look into it wherever you can.

TO SUMMARIZE

In this chapter, you have seen various ways to protect yourself by the use of paper. It is vitally important that you understand what it means to get things in writing. A lot of time, energy, aggravation, and money can be spent trying to prove something belongs to you or someone owes you something or the arrangement was not what you "told me over the phone."

Use contract forms. It is the professional way. It is the only way.

III

CONDUCTING THE BUSINESS OF PHOTOGRAPHY

Tools of the Trade

You should now have a fairly good idea of what you need in order to operate your photography business successfully. As you must have realized, just having equipment is not enough. The legal forms, copyright stamps, account ledgers, and the other items we've discussed are all part and parcel of good, sound business management.

It would be ridiculous to say that equipment is not necessary and we would be derelict in our duty if we did not mention something, however brief, about this aspect. A caveat: anything we say must be tempered by the facts that this is not a technical book and that there are infinitely better books on the market dealing with the kinds of equipment photographers might want to have at their disposal.

What we will do is give you a capsule view of what equipment you should consider. This is all based on information furnished to us by professional photographers. Keep in mind, though, that what is good for one person may not be good for another. And there is also the question of preference; that's why Howard Johnson's has twenty-eight flavors.

Everybody has a different opinion about what you should have in your knapsack. Ask one batch of photographers and you'll be told to keep things down to the "bare essentials." Ask another group and you'll get the opposite advice: get as much as you can.

The fact is that you need certain tools depending on what you are doing—and they must be the right ones. You open a can with a can opener, not a bottle opener. And quality, not quantity, is also important. You want equipment that will last and give you reliable service with the best results attainable.

In addition, make sure you have enough of what you need. You wouldn't want to be in Antarctica and run out of film, or find yourself deep in the bush of Africa without proper lenses or filters.

Finally, it is recommended that you buy only what you really can use. Most pros don't use too many fancy gadgets. They're for amateurs. Remember, you're not in business to keep photography suppliers solvent. You're in business for yourself.

Now, let's try to organize this.

A while back we used the term generalist. Most of you may well fall into this category. The general photographer is the individual who can do almost anything, whether in the studio or out on location. He is sometimes called the media or "anything" photographer. This photographer lives out of his hat; he carries most of his equipment around with him. He pulls up to the cliff, opens the trunk of his Datsun 280Z and there's his office. He is ready for just about anything.

ACTION NEWS

You are driving down Main Street and see a two-ton pickup plow into a small Volkswagen. The truck overturns while the beetle continues straight ahead. You should have with you at least two cameras (35mm, of course), with neck straps. You should also have at least two medium-wide-angle lenses, one macro lens (55 to 65mm) and a medium telephoto lens. And don't forget a shoulder bag in which to carry the film and optional equipment. This is the basic stuff. Remember, you want to carry things that are light in weight, small in bulk, and high in versatility. Depending on how quickly you act, one of your cameras should get a readily publishable shot.

SPORTS NEWS

You are at Soldiers Field in Chicago. The Bears are kicking off to the Eagles. You will be either on the sidelines or in the stands. A telephoto lens is essential. In this situation, you will need two cameras (both operable), an extreme telephoto lens (250 to 300mm), a medium telephoto lens (90 to 200mm), and a medium-wide-angle lens. You might also want to consider having your camera equipped with either an auto-winder or be motor-driven. Keep in mind that sports action is not going to stop or slow down for you to advance the film by hand. When Walter Payton cracks the line and takes off on a 55-yard gallop, he won't be waiting around for you to get ready.

TRAVEL

It goes without saying that passports, visas, carnets (for equipment), and the like are a necessity in travel photography, as are the releases, copyright assignment and other forms. If you live in Chicago and are photographing in Sri Lanka, it makes things a trifle difficult to run back home for something you forgot. Therefore, when taking equipment with you, consider two cameras and two lenses (35mm and 90mm). That's basically it. You might want to think of taking a small strobe with you, but the key is to travel as lightly as possible with the fewest complications. Travel means going from one place to another. Accordingly, you want to move with as great flexibility and freedom as possible.

And for God's sake, make sure that everything is in working order *before* you start out.

ON LOCATION

We have purposely separated this section from the preceding ones because advertising or similar assignment work is not the same as witnessing that smash-up on Main Street. If you have received an assignment to shoot something outside your own premises (on location), you can take a little more time in assembling what you need. You can also take a little bit more equipment. What you need may depend a great deal on what it is you are shooting. Telling you about the kinds of cameras or lenses to be packed would be like advising you what to wear in a certain locale without knowing its weather. However, there are a few points you should keep in the forefront of your mind.

First, it is mandatory that you research the project carefully. Although location photography is more expensive than studio work because travel to and from the location already means longer days, plus scouting time required and extra personnel, it may still be less costly than building a huge set or sets in your studio. Every aspect of the whys, wheres, and hows of location photography should be examined closely.

For example, when a particular location must be scouted, there are several ways to go about it: you can find the spot yourself and then take your client out there for approval, the client can accompany you to look for a location, or you hire someone to do it for you.

Next, check out the permits and licenses that may be required. If you happen to be shooting on private property, you better get

permission of the owner . . . and that doesn't mean the kid delivering the newspaper.

Insofar as equipment is concerned, it should be tough. You may be in the jungle or in the desert. Go with the best you can find. The client is not spending good money for a job that may be flubbed because of cheap, undependable equipment.

If you're thinking of artificial lighting, don't forget a generator. We've been told that a 3K generator is usually sufficient to operate a couple of 2,000-watt strobes. We've also been told that more powerful generators are available (up to 40K) for use on trailers.

Also, how about those other juicy items, such as reflectors, scrims, silks, and the ever-popular gobos?

One photographer advised us that many of his contemporaries forget about filters. In effect, they become so accustomed to shooting inside that the possibility of enhancing the shot with filtration doesn't occur to them. The nature of the shoot will, of course, dictate what is essential. For example, if vehicles are being photographed, a compressor to raise and lower tires plus a jack to move the vehicle into correct position are needed. And if you're dealing with mountain terrain, consider a four-wheel drive for towing purposes, especially out of that mudhole your Buick LeSabre has found.

Then there's food. Anybody want a soggy tuna-fish sandwich and a warm can of beer? A van equipped with a kitchen, bathroom, and storage area is mandatory for some types of work. If you are shooting in the desert, don't forget to take plenty of liquid refreshment.

As long as we're on the subject of sand, what about shooting down at the beach? Sandbags may be necessary for keeping things from taking off into the wild blue yonder. Also, consider items such as nails, hammers, wires, shovels, brooms, and cleaning rags.

See what we mean? It's like packing for a Sunday at the shore with your spouse and four kids. Practically everything in the house is shoved into the back of the station wagon.

Let's get out of the sun and go indoors for a spell.

INTERIORS

Again, the type of equipment you have may depend on what kind of shooting you do. Is fashion photography that much different from portrait photography? Is food photography similar to shooting nudes?

Consider these basics. You can obviously add and subtract to fit your needs.

1. Two cameras. (Some suggest a 4 × 5 and a 5 × 7 view-type.)
2. Tripod.
3. Cable release.
4. Extreme wide-angle lens (say, 16 to 21mm for 35mm; 40mm for $2\frac{1}{4}$ × $2\frac{1}{4}$).
5. Normal or slight telephoto lens (preferably macro) with 55 to 85mm for 35mm; 100 to 150mm for $2\frac{1}{4}$ × $2\frac{1}{4}$. You use this for closeup and detail work.
6. 800–1,200-watt-second power pack.
7. Two heads with umbrellas.
8. Two light stands.

And there is plenty of optional equipment. You can have a veritable field day purchasing Polaroid cameras, flash or strobe meters, fisheye lenses, PC lenses, and on and on.

We have not even touched the studio itself. What about the darkroom with its sinks and tanks for processing? What about a finishing room for mounting? What about backdrops?

The foregoing gave you a bird's-eye view of some primary areas. To cover a little more ground, here are some specialized fields.

AERIAL PHOTOGRAPHY

It has been said many times by the powers that be that the best camera to use for aerial photography is the one you are most familiar with. Nevertheless, a medium-format camera such as a 120/200 roll-film or a camera with a 70mm roll-film back has been highly recommended. The advantage is that these cameras are easy to handle in the confined spaces of a plane. And, almost any size enlargement can be made.

An interesting sidelight: it is a federal offense to drop anything from an aircraft. Therefore, make certain that you carry the camera securely, preferably with a neck or wrist strap.

As far as lenses are concerned, most photographers claim that aerial photographs can be taken with normal-focal-length lenses, although many advocate bringing along a wide-angle lens. This latter lens provides two distinct advantages: motion is reduced so that the picture will appear sharper, and the picture can be shot from a lower altitude. This usually improves the image contrast.

ARCHITECTURAL PHOTOGRAPHY

Serious architectural photographers demand a view camera equipped with both full front and back movements. In addition, it should be capable of taking film sizes up to 4 × 5. It is noted that a 35mm camera is particularly useful for slides and for some kinds of detail work, especially under difficult conditions such as construction sites.

Don't forget a tripod. Architectural photographs are usually shot at extremely small apertures in order to achieve maximum depth of field. Consequently, long exposure is considered the rule rather than the exception.

Most assignments in this field require the use of more than one lens. For instance, wide-angle lenses will be most often used for interior work, although they will frequently be called on for exteriors as well. It has been said that all lenses should be of good quality achromatism with a wide circle of coverage to permit the maximum use of camera movement. A lens hood is essential for exterior work.

Photographers say the use of a spot meter will overcome the problem of obtaining accurate luminance readings when the camera is a good distance from the subject (the building).

We haven't discussed film because of personal tastes, and also because it is much too large a field for this book. For example, consider this statement when dealing with architectural photography: fast films are seldom used or required. The basic reason: the subject rarely moves. Enough said!

MEDICAL PHOTOGRAPHY

Medical photography is as broad and diverse as medicine itself. And the equipment used is just as broad and diverse. For example, in special techniques, you can go from ultraviolet photography involving fluorescent work to induced fluorescence to infrared, where wavelengths can penetrate the skin to a depth of 3mm.

The types of equipment used and the ways they are used are mind-boggling. And there are countless procedures to follow which never crop up in fashion photography or photojournalism. When cameras and other equipment are used for photographing autopsies or for photographing pathological specimens, the equipment may become accidentally contaminated. Therefore, the photographer must bear in mind the precautions to be taken. These include wear-

ing masks, gowns, and rubber gloves. Did you know that most cameras, even with film in them, can be sterilized? They should be.

UNDERWATER PHOTOGRAPHY

It may seem downright silly to say the obvious: all photographic equipment going underwater should be protected and tough. The materials partially account for the high cost of equipment.

It is possible to buy protective housings for almost every type of photographic equipment needed underwater. As off-the-shelf items, reliable housings are available for simple cameras, 35mm cameras, roll-film cameras, movie cameras, and flash units.

However, let's take a fast look at the basic camera used by most underwater specialists. That's the Nikonos, also known as the Calypso/Nikkor. It is a self-contained underwater 35mm camera that needs no housing to protect it from the water. It is compact and reportedly very easy to use. Thus, it has become the standard against which all other underwater equipment is measured. It has four interchangeable lenses and a number of accessories including flash units, viewfinders, close-up lenses, extension tubes, brackets, and connectors.

We're not saying that this is the only camera to be used; it's just the most famous. In any event, underwater photography is tricky business and a host of materials from filters to film must be seriously considered. Add to these factors environment, behavior of light underwater, exposure, auxiliary lighting, diving with equipment, maintenance of equipment, and a wide range of safety factors, and you have a lot to consider before you jump off the gangplank.

TO SUMMARIZE

The kind of equipment you use depends on what you are doing. Check with other professionals working in your discipline to determine what might be best. Check the technical books. Make sure you have what you need.

And don't forget about the business aspects. Watch those delivery memos, invoices, assignment confirmation forms, and copyright legends. Also, what about the releases? When in doubt, whip it out.

These are the tools of the trade. They're the difference between being in the business and being out of it.

How to Sell Your Work

After nine chapters of telling you how to construct your accounting ledgers, prepare your invoices, draw your agreements, deal with taxes, and other sundry items, it is now time to start doing something to recoup some of the money and energy expended. You have to sell your work.

Selling what you produce involves many approaches, because there are various ways to accomplish it. You can sell your work on an assignment basis, you can sell it via the speculative route, or you can have third parties do it for you.

ASSIGNMENT SALE

This is exactly what it says: you are appointed to render a service, to complete a task. Someone calls you up and asks that you do something for them. For example, "Peter Photographer? This is Arnold Aardvark. I need a picture of my pet snail, Sam. Can you do the job for me? I'll pay $1,798.43 for two 8 × 10 glossies."

You grab the satchel with your equipment and set out for Arnold's house to complete the assignment. You shoot the pictures, deliver the two glossies and get your money. Clean and neat. That's the assignment sale.

Assignment work can apply to any number of areas. A magazine can call you to do something for them; an advertising agency may ask you to shoot a product of theirs; a department store may need shots of luscious women lounging in lingerie or macho men making their beds. The range is wide.

SPECULATIVE SALE

These are the photographs that you do without a specific assignment. In other words, you do something in the hopes of later selling it. For instance, suppose you are on vacation in Alaska and you come across a herd of penguins en route to a bar mitzvah. They are all in a long line, 753 of them. You decide right on the spot that this is a great story. Without further ado, you whip out your Nikon and begin shooting.

What you have is a picture story of a particular episode. You can then try to sell this to a magazine, newspaper, or book publisher, or, in fact, to anyone else who might have an interest in such a photograph.

In effect, you have created your own assignment. The key in speculative photography is to try and do those things that would be salable. Certainly, 753 penguins marching to the strains of "Hava Nagela" would have a market, as opposed to 753 penguins sleeping.

Let's go a little deeper into the selling of your work to various customers. Take the magazine field. There is an enormous array of magazines on the market and you must be able to choose which ones best fit what you have produced. If you are a writer and work in the sports area, writing articles about a baseball, football, or tennis star, it wouldn't serve your interests to submit those articles to *National Geographic*. By the same token, if you are a political writer, what are you doing sending your stuff to *Jack and Jill*?

The same applies to photography. It is mandatory that you familiarize yourself with the magazines so that you have a thorough grounding in the kinds of photography each magazine publishes.

Also, bear in mind that when hard news is involved, you don't have the luxury of creating a story over a long period of time. The penguin exposé can be developed with considerable care because there is no sense of urgency in getting it published, although you don't want to dawdle too long lest another photographer visit Alaska the following Saturday and see the same procession. The pressure is not as great as shooting an explosion at an atomic plant. That shot is a current newsworthy event, with emphasis on current.

Thus, if you come across a hard news shot, take it, get it developed as quickly as possible and sell it to the magazine or newspaper that can best use it. Generally, the newspaper and the weekly newsmagazine are your best bets.

Speed is important, for some publications believe in buying the

first photo they see rather than the best one. And don't forget that each magazine has its own lead time. This refers to the time the magazine closes or cuts off the submission of all material and the date it actually publishes. Most magazines in the non–news area have a lead time of between two and three months. You must be aware of the fact that a photo story submitted to one of these magazines in January may not be published until March. Will your story be outdated by then?

Let's look at what we have so far: a client can call you for an assignment, or you can pop right out and do the work on spec.

There have been a plethora of books, articles, and other printed information on how to sell your work in the assignment or speculative field. In fact, entire books have been written solely on how to present the best portfolio of your work to a magazine or newspaper editor. There have even been books on how to handle an assignment. Our intention is not to repeat what has already been memorialized in black and white. Instead, our thrust is to try to simplify the procedure in order to make you more aware of the key elements involved.

Perhaps the most important feature of selling your work is to keep in mind what it is you are trying to do. And the word is *sell*. Whether you get an assignment or you do it on spec with the hope of getting it published, your intention must be to do those things which will sell what it is you have produced and thereby bring in the money to pay your bills. After all, you are in business (you have taken the risk), and although photography is considered an art and you want to be as creative as possible, don't let the artsy side confuse the business side. Unless you are independently wealthy or can live on a few dollars a month, you *must* treat your career as a business. And that means to effectuate all those things to enhance and perpetuate the business. The area of assignment work serves as a prime example.

ASSIGNMENT PHOTOGRAPHY

To repeat what you read a few chapters back, if someone calls you for an assignment, you must keep in mind some simple points: understand what the assignment is, agree on what you are being paid, determine what it is you have to deliver and when, and *get it all in writing*. This is the umpteenth time you may have heard this, but it is crucial. Don't take an assignment over the phone, grab

your bag and run off to shoot the sunset over the Wabash. You're a professional. Act like one. To elucidate, try these two scenarios:

Scenario One:
"Hello, is this Priscilla Photographer?"
"Yes it is."
"This is *Tall Tails* magazine. We have an assignment for you. We need to have three color shots of the tails of elephants grazing in the green, green grass. Can you do this for us? We need it yesterday."
"Of course I can do it for you. In fact, I'm on my way."
Click! Over and out.
Scenario Two:
"Hello, is this Priscilla Photographer?"
"Yes it is."
"This is *Tall Tails* magazine. We have an assignment for you. We need to have three color shots of the tails of elephants grazing in the green, green grass. Can you do it for us? We need it yesterday."
"I believe I can. But I need some information. First of all, what are you paying for these shots? Second, when will you be paying for them? Third, what use do you wish to make of them? And fourth, when exactly do you need them?"

See the difference?

The majority of the complaints that come in from photographers have to do with the rights being sold or licensed and the money being paid. It is best, therefore, to get as much of the assignment detailed up-front as possible. There is nothing that is of such urgency that a few additional questions cannot be asked. Once you have the information, send an assignment-confirmation form (as detailed in Chapter 8). If time is of the essence, then send a confirming telegram, letter, or some other writing explaining what it is you have been assigned to do, how much and when you are being paid, and what rights are passing hands.

The two tales above dealt with assignment work from a magazine. The usage made of the photographs was primarily editorial. However, what happens when you are dealing in the advertising field, where the assignment comes from an advertising agency?

Most companies of any size have their own advertising departments that regularly buy or assign photography. By and large, most photography used in advertising is purchased through a separate agency. Thus, it is this entity—the advertising agency—that generally doles out the assignments for advertising work.

The basic function of an agency is to develop advertising ideas for its client. This cuts across the board, whether it be for television, radio, billboards, magazines, newspapers, catalogs, or brochures. Insofar as you, the photographer, are concerned, the heart of the agency is its art director. The art director is like the picture editor at a magazine or newspaper. This individual decides what photographer gets what assignment. The art director and his staff create those visual ideas which are assigned to you, the photographer, to execute.

As you will see from some sample rates set forth below, the work can be quite rewarding. However, in order to secure an assignment from an art director, you must show him your work. Obviously, the art director looks for something he can use. Nevertheless, he is not looking for a specific picture. He is concentrating on what you have already done in order to determine whether you can do what he has in mind. It's as simple as that. Therefore, what you must give the art director is your best work, arranged in a logical manner for your utmost advantage.

In that regard, consider these two points:

1. Have a good physical presentation. Your work should be presented in a first-class binder with proper captioning (if necessary). Remember those rules from the old contest days: "Neatness, clarity, and aptness of thought, in twenty-five words or less."

2. It is useless to show an art director a portfolio of air-disaster shots when he is looking for someone to shoot an airline campaign.

The portfolio may be *the* most important item in your presentation. If you need help in assembling one, then seek it. There are plenty of people who can guide and counsel in this respect. Don't underestimate its value.

Insofar as rates are concerned, there are plenty of books to tell you about the current prices for assignment work. The following is a capsule view of the rates governing a few of the areas relating to assignment photography throughout the country. By and large, the figures represent the per-day rate.

Magazines

Advertising	$1,500–3,000+	(national)
	700–2,000+	(local)
Editorial	250–700+	(news)
	300–700+	(travel, geographic)

Brochures

Advertising	1,000–3,000+	(national)
	500–1,500+	(local)
Corporate	400–1,500+	

Annual Reports	500–1,500+

Publicity/Public Relations

Press kits	300–1,000+
Portraits	300–1,500+

Miscellaneous

Record covers	500–2,000+	
Corporate publications	350–700+	
Billboards	1,500–3,000+	(national)
	700–1,500+	(local)

One source that we are partial to (and rightly so) is the ASMP, which has published a survey of the latest rates in assignment photography. For a fuller explanation of those rates and how they apply, we refer you to ASMP's *Professional Business Practices in Photography,* which can be purchased from the society.

There is another area of assignment photography you should consider, although you can work on spec here, too.

BOOK PUBLISHING

A number of photographers have struck gold in the lucrative field of publishing. If you check the spring and fall announcement lists in *Publishers Weekly,* a magazine for the publishing community, you will see a vast array of picture books being published. The key to picture-book publishing is to come up with an idea that will capture the fancy of the publisher *and* the customer. In the trade, they call this a hook.

How do you go about selling your hook? It's rather simple.

First, put together a presentation. This means an outline of some ten pages explaining what the book is about. Include your biography and perhaps write up the first chapter so that the publisher has an idea where you're heading. Include some representative photographs and interweave both picture and text to tell the story. If you are not a writer, then get somebody who can string words together to help you; if you don't know anybody who can write, put some idea of the book down on paper, even in its briefest terms. And watch out for misspellings; they drive publishers crazie!

When you're ready to submit your proposal, find out which houses publish picture books. Write an introductory letter to the editor-in-chief explaining your project and ask whether he or she would like to take a look at it. Where do you find out which publishing houses do what? Get a copy of *Literary Market Place (LMP)* from R. R. Bowker Co., 1180 Avenue of the Americas, New York, NY 10036, or from your local public library. *LMP* lists all publishers and the fields in which they primarily work.

Should you be fortunate enough to elicit interest from the publisher and, most importantly, a contract, you must understand what you are getting ready to sign. In *Photography: What's the Law?* we delved into the area of book publishing. Here are the highlights to keep in mind, and a good sample contract.

1. Grant of Rights. Is the publisher to have worldwide rights, or are they to be limited? What do you want to retain? How long a grant?

2. Delivery of materials. When? How? What? Who's responsible if transparencies are lost or damaged? When do they get returned to you?

3. Warranties. You, the photographer, can only represent that to the best of your knowledge, the photographs submitted are free and clear and that you have the right to enter into this contract with the publisher. Similarly, the publisher must represent and indemnify you against any actions arising from matters inserted in the book without your approval.

4. Copyright. This should be in your name. If there is text written by somebody else, there's nothing wrong with having the text copyrighted in the writer's name and the photographs copyrighted in the photographer's name.

5. Approval. Do you have any rights of approval? Certainly, you should have a say in any cropping or the addition of titles and captions.

6. Money. You should be paid an advance plus a percentage of the profits, known as royalties. Royalties generally work on a sliding scale; for example, 10 percent of the suggested retail list price on the first 5,000 copies sold, 12.5 percent on the next 5,000 copies, and 15 percent thereafter. (Naturally, these are suggestions; certain established people may obtain better terms, while some types of books earn less.)

While we're on the subject, it is important for you to tie in what you give the publisher in the way of rights as against what you receive in royalty payments. In short, you must be paid for every right exercised by the publisher.

Let's take a look at a standard contract from the photographer's point of view. We're not saying that this is the only contract you can sign; however, you might want to keep this handy as the basis for any "reasonable" deal. The publisher has its contract; you now have yours.

CONTRACT

AGREEMENT made this day of , 198__, between (hereinafter referred to as "the Photographer") and , a corporation (hereinafter referred to as "the Publisher").

WITNESSETH:

The Photographer hereby grants to the Publisher and the Publisher hereby accepts, a limited license to reproduce, publish and vend, hardcover edition of a book presently entitled (hereinafter referred to as "said Book"), containing certain photographs by the Photographer (hereinafter referred to as "said photographs"), upon the following terms and conditions:

1. The Photographer shall submit to the Publisher photographs (whether black-and-white, color, or any combination) not later than . The Publisher shall then have months from receipt of said photographs to select those to be used in said Book. The photographs not selected will be returned to the Photographer immediately. A list of such photographs to be used shall be incorporated in this agreement by reference hereto.

All photographs not selected and thereafter returned to the Photographer shall be deemed excluded from the scope of this agreement, and the Photographer shall have the right to use such photographs in any manner whatsoever without restriction of any kind. All photographs so selected by the Publisher for use in said Book will be returned to the Photographer no later than two (2) months after plates are made, which shall be done no later than . Said Book is to be published no later than .

It is understood that the Publisher shall not acquire any right, title, or interest in or to said photographs, and shall not make, authorize, or permit any use of said photographs other than as specified herein. Without limiting the generality of the foregoing, said photographs may not be used in any way, including, without limitation, layouts, sketches, photostats, and Xeroxes, except on terms specified herein. Projection of photographs is specifically not permitted.

2. The Publisher shall be responsible for the safe return of all photographs to the Photographer and shall indemnify the Pho-

tographer against any loss or damage to such photographs (including those not selected for use in said Book) whether in transit or while in possession of the Publisher, its printer, agents, employees, messengers, or assigns. The Publisher assumes an insurer's liability herein for the safe and undamaged return of all photographs to the Photographer; it being agreed that said photographs are to be returned by bonded messenger or by registered mail, return receipt requested, prepaid, and fully insured.

The monetary figure for the loss or damage of an original color transparency or photograph shall be determined by the value of each individual photograph. However, the Publisher acknowledges that the agreed and reasonable minimum value of such a lost or damaged transparency shall be no less than Fifteen Hundred Dollars ($1500). The Publisher shall be liable for all acts of its printers, employees, agents, assigns, messengers and freelance researchers, for all loss, damage, or misuse of the materials submitted by the Photographer hereunder. Any such payment shall not, however, be construed to transfer to the Publisher any right, title, or interest in or to said materials so lost, damaged, or misused.

3. The Publisher's rights hereunder shall be for a period commencing and ending , unless sooner terminated as provided herein. The Photographer represents and warrants that the photographs are original and that the Photographer is the sole author thereof. In addition, the Photographer represents that to the best of Photographer's knowledge, the photographs do not infringe upon any rights of others and that the Photographer has the full power and authority to enter into this agreement.

4. The license granted to the Publisher hereunder is solely for the Publisher's hardcover edition of said Book. The license granted is for a one-time, nonexclusive, reproduction use of said photographs in language editions throughout the . The Publisher shall have the right to arrange for the publication of a cheap edition of said Book by another firm, or for publication of said Book in a set or omnibus volume. The Photographer shall receive fifty (50%) percent of the gross amount received by the Publisher. Royalties on any cheap edition issued under the Publisher's own imprint shall be fixed by agreement between the parties. There shall be no cheap edition of said Book for a period of one year after publication of the hardcover edition without the Photographer's prior written consent.

5. Prior to publication, said Book shall be submitted in its entirety to the Photographer, including, without limitation, the text, its title, its photographs, and the contents of its covers, and said Book shall only be published in the form approved by the Photographer. The Photographer shall receive credit on the cover

of said Book, on the title page as well as in the interior, all in size, type, and prominence not less than that afforded any other person or party appearing thereon, and all subject to the Photographer's absolute approval.

It is a material part of this agreement that no books or other matter be issued without the Photographer's credit as approved by him. Any approval by the Photographer, however, shall not in any way limit, negate or affect the provisions of paragraph 12 hereunder.

6. The Publisher shall pay to the Photographer, or his duly authorized representative, the following unreturnable advances in the following manner:

(a) $ upon the execution of this agreement; and
(b) $ upon the acceptance of the materials by the Publisher hereunder.

The foregoing advance shall be repaid to the Publisher in the event the Photographer fails to deliver the photographs hereunder or same are deemed unacceptable.

The Publisher shall also pay to the Photographer the following percentages (after recoupment of the advances previously paid to the Photographer) based on the Publisher's suggested retail list price:

(a) Ten Percent of the retail price on the first 5,000 copies sold;
(b) Twelve-and-One-Half Percent on the next 5,000 copies sold;
(c) Fifteen Percent on all copies in excess of 10,000.

The suggested retail list price shall be $ for the purpose of computing the royalties to be paid hereunder. No royalty shall be paid on copies sold at or below cost or furnished gratis to the Photographer, or for review, advertising, sample, or like purposes.

7. Payment of such royalties, accompanied by detailed statements of sales, licenses, accrued royalties, and deductions, will be made to the Photographer on a semi-annual basis, within thirty (30) days after June 30 and December 31 of each calendar year. The Photographer, or his duly authorized representative, shall have the right at any time and without limitation, to check, inspect, and audit the Publisher's books, records, and accounts relating to the Book in order to verify or clarify any and all such statements, accountings, and payments. The expense of such examination shall be borne by the Photographer unless errors amounting to five (5%) percent or more of the total sums paid or payable to the Photographer shall be found to his disadvantage, in which event the expense of such examination shall be borne by the Publisher.

Notwithstanding anything to the contrary contained herein, any sum of One Thousand ($1,000) Dollars or more which may become due to the Photographer shall be paid by the Publisher to

the Photographer not later than the fifteenth of the month in which the Publisher shall have received such sum.

The Publisher shall keep books of accounts containing true and accurate records of all transactions involving the subject matter of this agreement and of all sums received and disbursed in connection therewith. The Photographer may at any time contest the accuracy of any such accounting statement and the propriety of any items included therein.

8. Said Book shall be published with due notice of copyright of the photographs in the name of the Photographer and shall be duly registered in the Copyright Office of the United States of America. Without limiting the foregoing, all copyrights under the Berne Convention, the Universal Copyright Convention, and the Buenos Aires Treaty, will be secured; it being specifically understood that in no event shall said Book be published without a copyright of the photographs in the name of the Photographer. The Publisher shall take all steps necessary, without cost to the Photographer, to effect such copyrights, incuding any renewal copyrights, if applicable, as well as to prosecute or defend any infringement of copyright actions.

9. The Publisher agrees to furnish the Photographer with twelve (12) copies of the published book, free of any cost or charge to the Photographer whatsoever, for the Photographer's own use. If the Photographer requires copies in addition to the twelve (12), the Publisher agrees to furnish such additional copies to the Photographer at a discount of forty (40%) percent from the retail selling price.

10. All notices which either party may desire to or be required to send to the other shall be sent by prepaid registered mail and addressed to the parties as follows:

Publisher: _____

Photographer: _____

11. If, after the initial printing and distribution of said Book, the Publisher decides to discontinue any further publication of said Book, it shall give immediate notice of same to the Photographer and the latter shall have the option of purchasing from the Publisher the plates for said Book at one-fourth ($\frac{1}{4}$) of the original cost, including the original compositions and the Publishers stock at one-quarter ($\frac{1}{4}$) of the list price thereof. If the Photographer shall not purchase said plates, engravings, illustrations, and copies of said Book (or any of them) within ninety (90) days, then the Publisher shall destroy the plates and shall furnish the Photographer with a Certificate of Destruction thereof. In any event, the Publisher's obligation for payments hereunder to the Photographer shall nevertheless continue.

For purposes of this agreement, said Book shall be deemed to be in print only when copies are available and offered for sale in the U.S. through normal retail channels and are listed in the catalog issued to the trade by the Publisher. Said Book shall not be deemed in print by virtue of the reproduction of copies by reprographic processes or if it is available by any media or means other than the hardcover edition referred to above.

If the Publisher fails to keep said Book in print, the Photographer may at any time thereafter serve a request on the Publisher that said Book be placed in print. Within sixty (60) days from receipt of such request, the Publisher shall notify the Photographer, in writing, whether it intends to comply with said request. If the Publisher fails to give such notice or, having done so, fails to place said Book in print as specified within six (6) months after receipt of said request by the Photographer, then, in either event, this agreement shall terminate automatically and all rights granted to the Publisher shall revert to the Photographer.

12. The Publisher's acceptance hereof shall indicate its agreement and understanding that the Photographer makes no warranty, expressed or implied, and that the Publisher will and hereby agrees to indemnify, defend, save, and hold the Photographer, his successors and assigns, harmless against any and all claims, losses, expenses, damages, or costs (including reasonable legal fees), which may accrue or be asserted against the Photographer or his successors and assigns, of any others, by reason of the use of said photographs hereunder or other conduct by the Publisher in connection with any rights granted by the Photographer hereby. Similarly, the Photographer hereby agrees to indemnify and hold the Publisher harmless from any loss or damage that it may suffer as a result of the breach of any of Photographer's representations and warranties hereunder.

13. If there is an infringement of any rights granted to the Publisher, the Photographer and the Publisher shall have the right to participate jointly in an action for such infringement. If both participate, they shall share the expenses of the action equally and shall recoup such expenses from any sums recovered in the action. The balance of the proceeds shall be equally divided between them. Each party will notify the other of infringements coming to its attention. If the Photographer declines to participate in such action, the Publisher will proceed and will bear all costs and expenses which shall be recouped from any damages recovered from the infringement; the balance of such damages shall be divided equally between the parties.

14. Any controversy or claim arising out of or relating to this agreement or the breach thereof, shall be settled by arbitration in , in accordance with the rules then obtaining of the

American Arbitration Association, and judgment upon the award rendered by the Arbitrator(s) may be entered in any court having jurisdiction thereof.

15. (a) Nothing contained in this agreement shall be deemed to constitute the Publisher and the Photographer as partners, joint venturers, or fiduciaries, or to give to the Publisher a property interest, whether of a legal or equitable nature, in any of the Photographer's assets.

(b) A waiver by either party of any of the terms and conditions of this agreement shall not be deemed or construed to be a waiver of such terms or conditions for the future, or of any subsequent breach thereof. All remedies, rights, undertakings, obligations, and agreements contained in this agreement, shall be cumulative and none of them shall be in limitation of any other remedy, right, undertaking, obligation, or agreement of either party.

(c) All rights not specifically granted herein to the Publisher are reserved for the Photographer's use and disposition without any limitations whatsoever. This includes, without limitation, all individual uses of the photographs hereunder.

(d) In case of bankruptcy, receivership or assignment for the benefit of creditors, the right of publication shall revert to the Photographer.

(e) This agreement and all of its terms, conditions, and provisions, and all rights herein, shall inure to the benefit of, and shall bind the parties hereto, and their respective successors and assigns.

(f) This agreement may not be assigned by the Publisher, either voluntarily or by operation of law, without the prior written consent of the Photographer. Any such assignment, if consented to by the Photographer shall not relieve the Publisher of its obligations hereunder.

(g) Time is of the essence in the performance by the Publisher of its obligations for payments hereunder. If the Publisher fails to promptly pay the royalties hereunder or if the Publisher fails to conform or comply with any other terms or conditions hereunder, the Photographer shall have the right, either personally or by his duly-authorized representative, to advise the Publisher of such default and if fourteen (14) days elapse after the sending of such notice without the default having been rectified, this license shall terminate without affecting the Photographer's rights to compensation or damages in connection with any claims or causes of action the Photographer may have.

(h) This agreement and all matters or issues collateral thereof, shall be interpreted under, and governed by, the laws of the State of . This agreement constitutes the entire agreement between the parties hereto and cannot be changed or terminated

orally, and no changes, amendments, or assignments thereof shall be binding except in writing signed by both parties.

IN WITNESS WHEREOF, the parties hereto have executed this agreement as of the day and year first above written.

(Publisher)

By:_____

Its:_____
(Photographer)

We now turn to the third area of selling.

STOCK SALES

Stock photography is a highly lucrative field, and if you are not already building up your stock file, you ought to take another look at what you are doing.

Whenever you go out with that camera of yours, make certain you shoot something for your file. Although a number of photographers sell their stock photos themselves, an equal number (maybe even more) use a stock-picture agency.

Picture agencies are companies that supply photographs to editors, publishers, art directors, and other buyers of photographs. In effect, they are a clearing-house for their clients. Here's the way it works in its simplest terms. Say twenty photographers each have 500 transparencies. The subjects are varied. The twenty photographers turn their work over to a picture agency. The agency catalogs the transparencies, putting all the shots of animals in one drawer, all photographs of the Statue of Liberty in another, and so forth. The agency maintains a library of pictures.

A magazine publisher calls and needs a shot of the Statue of Liberty. The agency culls from its drawer those transparencies it has of the statue and sends them to the magazine. The magazine selects the one it wishes to use and returns the rest. The agency and the magazine then reach an agreement on the price to be paid. The magazine pays the money and the agency splits the payment with the photographer.

As you can see, the picture agency represents you (and many other photographers) in selling your work. However, understand that agencies have different areas of interest: some specialize in wildlife, others in news stories, others in historical photographs; some do a

little of everything: you have to make sure that you have the right agency working for you.

What are the questions about picture agencies and your relationship with them? What do you need to know in dealing with them?

How do you go about finding one? We've made that a lot easier for you. In Appendix D we have included a list (albeit not a complete one) of most of the major picture agencies in the country. There are lots more, to be sure, but this will give you a start.

How do you contact them? Simple. Call them up, arrange an appointment to show them your work. Hear what they have to say. See what their operation looks like. There are some agencies that require the submission of hundreds of transparencies. There are some that require far fewer. Remember, the agency is simply acting as your agent to help sell your pictures.

The key to a successful stock-agency representation is a combination of quantity and quality. Obviously, the greater number of good pictures you leave with them, the better off you will be. And don't forget that the agency will be representing a number of other photographers with similar photographs, so that when a magazine asks for that shot of the Statue of Liberty, you may be one of many photographers whose works are being submitted. You want to increase your chances of being the one selected.

Do you have to sign a contract? You better believe it. Any agency worth its salt will have you sign an agreement which details what they are holding, what rights are being placed with them and how much they are splitting with you. Rates vary; some agencies will split 50/50 with the photographer; some will give a 60/40 split in favor of the photographer; some will go 70/30. Try to arrange the best deal possible.

To afford you a clearer look at what many agencies demand, we are including a sample form of agency contract to give you an idea of what you may be up against.

PHOTOGRAPHER'S EXCLUSIVE AGENCY AGREEMENT

1. I, the undersigned, certify and warrant that I am the sole and exclusive owner of all negatives, prints, positives, original color transparencies, duplicates, stories, motion picture films, text information, and other photographic materials delivered to you, now and in the future. I appoint you as my sole and exclusive Agent and representative in respect of the leasing and sale of said materials throughout the world. All negotiations shall be at your

discretion without prior consultation with me, except when outright purchase of originals is to be negotiated.

2. The compensation for your services shall be fifty (50%) percent of the total sum billed and collected by you. In the event of cancellation by your client after payment has been made to me, I authorize you to deduct an equal amount from future sales of my materials.

3. In the event of damage, destruction, loss, or the unauthorized use of original color transparencies, negatives, prints, or motion picture films by your client, I give you full and complete authority to make claims or institute suit, in your name if necessary, without further permission from me. All recovery made therein shall be apportioned fifty (50%) percent to you and fifty (50%) percent to me after deductions for collection fees, legal fees, and other expenses incurred by you in your efforts to resolve said claims. Any settlement is at your sole discretion.

4. I agree to refrain from actively soliciting or selling my photographs, directly or through another person or agent, to clients to whom you have introduced me and to whom my photographs have been sold by you. In the event of such sales I agree to pay you your fifty (50%) percent of the total amount billed.

5. I agree during the term herein not to place with any agent, agency or library "similars" or duplicates of those photographs which I have submitted to you and which you have accepted.

6. I agree to supply you with captioned photographs in protective sleeves and to enter them on the description sheet supplied to me; and to indicate on all my photographs if I have model releases in my possession. If you should be required to caption, mount or enter my transparencies on said description sheets, I authorize you to deduct the cost from sums due me from the sales of my photographs and to hold all my photographs until said costs are paid in full.

7. I understand and agree that you shall not be liable to me, my heirs or assigns for any loss or damage to the transparencies or photographs submitted to you by me during the term hereof, unless caused by your gross and willful negligence.

8. I warrant that I have the right to sell the photographs and the rights thereto, and I warrant that there are no claims by anyone, including the subjects of the photographs, all necessary permissions having been secured.

9. In view of the circumstances that, at any one time, some photographs will be in foreign countries with affiliated or other sales agents or clients, some will be in the hands of prospective clients in distant parts of the United States, some will be in the Agency's

files on the Agency's premises, and some will be in transit, it is here contemplated that recall of any photograph may be extremely burdensome, time-consuming, and costly in clerical labor and effort. Accordingly, black-and-white prints left with you for sales purposes are not returnable; it being our mutual understanding that I have negatives of each and can make duplicate prints if necessary at far less cost than that involved in your retrieval of them.

10. I agree that original color transparencies previously, now, or hereinafter submitted to you for sale shall remain with the Agency for five (5) years from this date and that, if subsequently recalled by me, three (3) years from date of requested return shall be deemed a reasonable time for their reassembly and redelivery to me. The Agency agrees that, if for some special reason I should require a speedier retrieval, you will assign special clerical help to the retrieval task, the specific out-of-pocket expense for such special help to be borne by me in consideration of your special retrieval efforts.

11. I agree to assume full responsibility for all claims resulting from erroneous and inaccurate information supplied to you by me regarding ownership, caption information, and model releases for all photographs and other photographic materials deposited with you for sale now and in the future. I agree to give you copies of all original model releases obtained by me on all my photographs deposited with you for sale, now and in the future.

12. If a copyright notice is not affixed to my photographs, I hereby authorize you, if you deem it necessary, to affix a copyright notice in my name.

13. I agree to give you full assistance to help you in locating and removing from your files all my photographs at the termination of this agreement.

14. I agree that I shall continue to shoot and to contribute new photographs to you on a regular basis in order to keep my file up to date. I further agree to follow your ideas and suggestions with regard to producing photographs that are salable. Failing to do so, a file maintenance charge will be made against my account. I agree to replace all black-and-white prints sold by you.

15. This agreement shall be for five (5) years from the date signed and it shall renew itself for a like period automatically at each expiration date unless terminated in writing by either party sixty (60) days before any expiration date.

16. You shall be entitled to your regular commission on any resale of my materials sold by you even after the expiration of the term herein.

17. I understand and agree that transparencies or prints may in time be lost, damaged, or fade through normal usage. Being aware of this, I agree that if at the termination of this agreement a full return of my material is not made by you because of the above events occurring, you shall not be liable for such non-return.

18. In the event of my death, my estate shall be bound by the terms of this agreement and my estate shall receive the payments which would otherwise have accrued to me.

19. It is understood and agreed that this agreement does not constitute an employment agreement between me and you, and that my status is that of an independent contractor.

20. This agreement shall not be modified, amended, or changed in any respect unless the change is reduced to writing and signed by each of the parties.

21. No trade, custom, or usage shall affect this agreement or the terms and conditions of it.

22. This agreement incorporates our entire understanding.

23. This agreement shall be binding upon the Photographer, the Agency, and their heirs, executors, administrators, successors, and assigns.

24. Any and all controversies are to be litigated solely in the City and State of New York. This agreement is to be interpreted solely according to the laws of the State of New York and no amendments or changes in the terms are to be had unless signed by the party to be charged.

Photographer's Name

Photographer's Signature

Address

Phone Number

Social Security Number

AGREED TO AND ACCEPTED:

By: _____

Date: _____

Most reputable agencies will negotiate the agreement to mutual satisfaction. To aid you somewhat, consider these points when you do deal with a stock house:

1. Are you authorizing the agency to sell as well as to lease your work? In other words, are you willing to sell outright all reproduction rights?

2. A 50/50 split is the minimum you should accept. If you've got a hot hand, you may go for a 60/40 or 70/30 arrangement. It's all negotiable. Don't forget to nail home when you are to receive your share. You don't want the agency to hold your money for an unreasonable length of time.

3. What happens when your work is lost or damaged by either the agency or the client? Who's responsible and under what conditions?

4. How long is the agreement?

5. When, and under what circumstances, can you terminate the agreement and get your work back?

6. Are there any charges by the agency? Some agencies may charge a photographer for providing captions and mounts if they are not already included.

7. Make sure you receive credit, and remember to have your copyright legend affixed to everything that goes out.

8. What happens if the agency goes bankrupt or changes ownership?

For a more detailed study of the photographer-agent relationship, we refer you to the ASMP's *Business Practices*.

Can you have one person represent only you? Sure. These are known as personal representatives. They work solely for you, or at least they're supposed to. Most photographers in the advertising field have personal reps. Unlike the stock-agency field, where you leave your pictures and let the agency do the rest, the personal rep works for you on a constant basis, selling each and every day if need be. Remember, while an agency may draw on the output of a number of photographers, perhaps 50 to 100, a personal representative depends on the one or two or three individual photographers with whom he is associated.

The one value you should keep in mind with respect to stock photography is that it is an extremely lucrative field. As we said before, whenever you are shooting, always think in terms of shooting extra photographs for your stock file. These photographs can become an annuity for you. We know of one photographer who can count on almost $30,000 of his annual income from stock sales alone. He con-

tinuously replenishes his stock agency with photographs and every three months another big check rolls in.

Having thousands, even millions, of photographs in your stock library, is not out of the ordinary. It's money in the bank. How so? Take a look at the latest survey of rates in the stock field:

Magazines

Advertising	$1,250–3,000+	(color/national)
	750–1,500+	(B&W/national)
Editorial	2,000 for cover	(color/national)
	1,000 for cover	(B&W/national)
	800 for full page	(color/national)
	300 for full page	(B&W/national)
Brochures	500–1,500+	(color/1 million print run)
	400–750+	(B&W/1 million print run)

Books

Trade	250	(full page/color)
	150	(full page/B&W)
Encyclopedia	250	(full page/color)
	150	(full page/B&W)
Annual Reports	500–2,000+	(color/cover)
	400–1,000+	(B&W/cover)
	350–800+	(color/page)
	250–600+	(B&W/page)

Miscellaneous

Record covers	400–1,500+	(color)
	250–750+	(B&W)
Posters	500–1,500+	(color)
	300–500+	(B&W)
Greeting cards	250–600	

Again, see ASMP for further rates.

There are a few other possibilities in selling photographs that you might want to consider. For example, contests. Trying to sell photographs through this medium entails an enormous risk. Why? Because your photographs may never be returned. Also, you may not win. You give away your photographs and more often than not you receive nothing in return. That's not good business.

Follow this cardinal rule: *Don't give away anything for nothing!* Sure, you may win the contest and get a gift certificate to some men's shop. Maybe you'll even be lucky and see your name in print somewhere.

There are, of course, a number of different areas in which your photographs can be sold without your being a charitable institution. You can photograph for record albums, you can sell to galleries, you can shoot for greeting cards, you can make educational film strips, you can illustrate for T-shirts. If you can't come up with ten items where photographs can be used in a ten-second walk out your front door, then you are in big trouble. You can tap almost any market. In fact, we'll give you the latest one: how about photography for business decor?

In a recent study done by Eastman Kodak with the Fortune 500 list, it was found that corporations, both large and small, are interested in decorating with photographic art. Kodak found that the interest exists in all segments of the business world. This means quite clearly that there is a market for professional photography to decorate business. And it's a huge market.

The survey points out that nearly every town has a doctor, lawyer, real-estate firm and other professionals whose offices can be decorated with photographic art. Additionally, many businesspeople may be interested in displaying your photography—especially if it relates to their businesses, their products, or their locale.

If you would like further information on how you can become involved in decorating with photographic art, we suggest you contact the Professional and Finishing Markets Division of Eastman Kodak Company, 343 State Street, Rochester, NY 14650.

TO SUMMARIZE

Selling photographs has many options open to you. You must be thoroughly familiar with the markets and their prices, and you must understand what the particular market can bear. Once you do, you can develop your own skills for the specific area.

A word of caution: the rates enumerated in this chapter are as of the date this book was written. They should be outdated quickly; that is, they should get higher.

You must function as a businessperson. Don't use your skills without reward and certainly don't give anything away. Realize what it is you are trying to sell and to whom; then go ahead and sell it.

The Marketplace

Don't be deceived by the title: this is not a repeat of the preceding chapter. In that one, we discussed ways in which you can sell your work. Of course, that's a marketplace. In this section, we will be looking into another marketplace. Rather than selling what it is you have produced (your photographs), let's talk about you personally.

What happens when you get tired of toting that heavy bag of equipment, or suppose you just decide that taking pictures is not satisfactory enough, whether at the beginning of your career or later on?

There are a number of photography-related career opportunities to consider. Here are a few of the possibilities:

Archivist
Audiovisual programmer
Camera repair
Colorist
Curator
Darkroom supervisor
Director of photo services
Editor of photo magazine
Gallery director
Laboratory technician
Manager, photographic equip-
 ment
Photo editor
Photo equipment technician
Photo researcher
Photographer's agent

Photographic processor
Photographic technician
Photography director
Photography librarian
Printer
Retoucher
Sales
Studio manager
Stylist
Teacher
Technical representative
Video cameraman
Video engineer
Video technician
Videotape editor

As you can see, there is a wide range here. Many a photographer has moved into these other areas, primarily on the technical side, such as photofinishing, retouching, and other laboratory work. Photofinishing itself is an up-and-coming area. There has been an increased demand for photofinishing services, especially in color photography. This means that jobs are opening constantly for qualified technicians.

There are companies today that specialize in the quality of photofinishing required by professional photographers. Processing labs numbering in the thousands in the United States include photofinishers and retouching specialists.

There are also people who make film, cameras, and other equipment, and they need first-class technicians such as engineers, machinists, and chemists. In fact, many a research worker has been trained as a physicist, chemist, or mathematician. Whether they are good photographers, or even photographers at all, doesn't matter. Their work lies in the fields known as pure and applied science. Jobs in these areas usually wind up in the laps of those persons who can offer the necessary skills to produce certain items for the photographer.

On the other side, you have the salesperson, who has the knowledge to translate the technical work into the professional photographer's language. As a salesperson, you're supposed to have a thorough grounding in what you are selling coupled with the ability to sell it. A recent report shows that there are more than 15,000 retail shops selling photographic goods in the United States, with more than 60,000 drugstores alone selling photo products. A good living can be had here.

The number of people employed in various kinds of photographic positions is a significant one. The largest concentration is employed in the audiovisual or nontheatrical field. This is the group that produces (and distributes) motion-picture films for education, business, industry, government, and the like. Here there are opportunities for technicians in film production and laboratory work as well as personnel for distribution of such films.

In the medical field, many people may work as X-ray technicians and perform similar duties dealing with photography of one sort or another.

We are talking about the behind-the-scenes, organizational, and production work of photography, although many areas are actually in the vanguard of the profession, like teaching.

Interestingly enough, some of the biggest challenges can be had

in teaching. You can teach in junior and community colleges, secondary schools, universities, private institutions, vocational schools, or workshops. The instruction can go from solely the technical to a combination of technical and creative. One famous school in New York City tries to teach more than just the f-stop aspects of photography. It concentrates on teaching students how to develop original concepts; in short, to push the student's creativity to the utmost. It can be most rewarding.

Just shooting pretty pictures is only one part of the complete spectrum that is photography. To aid you further, consider some additional opportunities.

In the business area, you can sell equipment, provide storage information services, be involved in document reproduction, cataloging, public relations, publications, reporting, sales, administration, managing.

In the printing field, there is photoengraving, photomechanics, photolithography, rotogravure, stripping.

In medicine, you have photomacrography, pathology, X-ray, laboratory research, photomicrography.

You like public health? How about detection, reporting, identification work?

Transportation your bag? There's photomapping, traffic control, instrumentation, public relations.

This is only the surface of what's available.

TO SUMMARIZE

Remember, photography doesn't stop with the taking of the picture. There's an enormous world out there.

For more in-depth information on careers in photography, you can obtain booklets issued by the Eastman Kodak Company, the U.S. Government Printing Office, and the U.S. Department of Labor. Also, we recommend Photography Market Place, *edited by Fred McDarrah and published by R. R. Bowker Co.*

Don't forget those educational institutions we listed in the opening chapter. There is also information available from the various photographic societies; see Chapter 13.

Current and Proposed Legislation Affecting the Business

Each working day, the authors of this book handle on the average of fifty phone calls from photographers and others connected with photography. Most of the questions we are asked have to do with some phase of the business which easily leads to a bout with a lawyer.

"I've just completed a shoot for XYZ advertising agency. They say they own the copyright in everything I took. Is that true?"

"I sent my film to KDK laboratory for processing. They were shots of nudes. The lab won't return them. They say the pictures are obscene and they could get into trouble if they sent them to me."

"I've got a great shot of this little boy on a beach. A magazine here in New York wants to use that photo in an essay about polluted beaches in a particular country. I have no release. Can I give them the photo?"

The questions go on and on. Many years ago, we adopted a specific procedure: we list all phone calls as to date, time, the person calling, and the subject matter of the call. In this way, the main concerns of the photographer can be easily discerned.

Here are the major trouble areas, what the current legislation says, and a peek at the horizon.

COPYRIGHT

The new copyright law went into effect on January 1, 1978. Instead of telling you everything you didn't want to know about the law and its effect on photography, let's reestablish the key elements.

First, the law provides a term of copyright which lasts the photographer's life plus fifty years. Second, the law specifically confirms a principle known as "fair use," which sets limitations on the exclusive rights of copyright owners. (We'll be discussing that in greater detail a little later.) Third, the law lists how libraries and archives may make single copies of works for noncommercial purposes. Fourth, the law created a Copyright Royalty Tribunal whose job is to determine what rates are reasonable in certain categories. (We'll discuss that in a few pages hence.) Fifth, under this new law, certain graphic works are deemed subject to a compulsory license with respect to public broadcasting.

Let's take these sections one by one.

Fair use A party may utilize a photograph which is owned by you for such purposes as criticism, news reporting, teaching, scholarship, or research. This is known as fair use and no permission or other authorization is necessary to accomplish it. However, in determining whether the use is considered fair, the following factors are taken into consideration:

1. The purpose and character of the use, including whether such use is for commercial or nonprofit educational purposes.

2. The nature of the copyrighted work.

3. The amount and substantiality of the portion used in relation to the copyrighted work as a whole.

4. The effect of the use upon the potential market value of the copyrighted work.

Thus, if your photograph is being used without your permission, you should first establish whether or not the use might be considered fair use. The above criteria should then be reviewed. However, because of the complexity of this matter, we strongly suggest that you seek out the advice of a competent attorney well-versed in copyright law to determine if the fair use section is applicable.

Library and archival copying Under the law, limited reproduction by libraries and archives is permitted provided the reproduction is not made for commercial purposes. Therefore, if a library is open to the public or to outside researchers and the reproduction of your photograph is being made for a noncommercial purpose such as for research work, then no permission is required from you. Again, you have to make sure that no one is reproducing your work, hanging it on the wall, charging an admission and then selling 8 x 10 prints of same. That's not permitted under the new law.

Public broadcasting The law provides that noncommercial transmissions by public broadcasters of copyrighted published

graphic works (such as photographs) are subject to a compulsory license, and that if the copyright owners cannot agree on the terms of the license, the newly arranged Copyright Royalty Tribunal can fix the royalties. Let's explain this in greater detail.

Under a section of the law, educational television stations were able to use published photographs without permission of the copyright owner. The station paid a fee as determined by the Copyright Royalty Tribunal and that was that. These fees were considered extremely low by many photographers. They ranged from a low of $15 for background and montage display to a high of $60 for use of a work on program identification. This was nothing to write home about.

Last year, two guilds, the American Society of Magazine Photographers and the Graphic Artists Guild, filed a brief before the Copyright Royalty Tribunal, arguing that the record of use by the Public Broadcasting System (PBS) of photographic works demonstrated that there was no reason for such a compulsory license. The guilds pointed out that only 7 percent of the educational stations made any use of the license and that PBS itself utilized it in less than 2 percent of its programming.

The societies claimed that the only just conclusion was for the photographer to be free to negotiate individually for the use of a work and to bargain for the price to be received, "just as Western Electric or any supplier of electronic equipment to public broadcasters is entitled to do."

In addition, the groups said that there is "no compulsion for public broadcasters to use the work of any single photographer . . . and their own record as reported by themselves, indicates a complete absence of any need for a compulsory license."

PBS didn't sit idly by. They filed a massive report arguing that the present law was of significant benefit to public broadcasting and that considerable visual uses were just not being reported on cue sheets since "many uses are either public domain uses, fair uses, exempt uses, etc." They said that in future years there may be a greater application of this particular section of the copyright law because a larger number of visual works will be subject to copyright protection. The bottom line was that it was much too early to make any determination as to what modifications, if any, were appropriate with respect to this regulation.

As you might gather, the guilds saw things a bit differently. They said that they had seen enough and that "photographers . . . have no need for such licensing. They are essentially all entrepreneurs who

deal directly with the customers for their works, and their traditional way of business has been and is to license their works individually."

The tribunal agreed with this position and stated in its decision: "On the basis of the experience to date, the Tribunal must conclude that the limited use made of the compulsory license for visual works cannot justify interference with the traditional operation of the copyright system, the freedom of the marketplace, and the artistic freedom of the creators of visual works."

The tribunal went on to say, "The copyright system can advance the constitutional objectives only if the exclusive rights of authors and copyright proprietors are preserved." It then concluded that compulsory licensing was not necessary for the efficient operation of public broadcasting and recommended that Congress reconsider such a license.

As of this writing, a bill is being introduced to modify the compulsory license section of the new copyright law.

What happens when a person does use your copyrighted photograph without your permission and the use neither falls under the fair use provision nor the compulsory license section? The law is quite specific on this. Anyone who violates your exclusive rights is deemed an infringer.

What can you do about it? You can sue. What are your remedies? Simple.

1. The infringing copies may be impounded and subsequently destroyed.

2. The infringer will be liable for any profits made by his use of your work plus your actual damages, including those set forth under the statute.

3. The infringer will be liable for costs and attorney's fees.

You must get your lawsuit started within three years after your claim accrues. That's what is known as the statute of limitations. If you don't file your action within the prescribed time, you will be precluded, under the law, from doing so later on.

Should anyone ask, it is a *criminal* offense to infringe a copyright willfully and for purposes of commercial advantage or financial gain. It is also a criminal offense to affix a fraudulent copyright notice, to remove a copyright notice, or to make a false statement in a copyright registration application.

The Copyright Office in Washington, D.C., is primarily a place of record where claimants may register their copyright materials. The office does not furnish legal advice in any way except to explain the

copyright law itself as well as to report on various facts which it has on record. In order to sue someone for copyright infringement, you must first register your work in the Copyright Office.

In a prior chapter, we told you where you could write for the copyright kit. We suggest you do so.

INVASION OF PRIVACY

This is the area where most photographers are sued. Here is where you better watch your step every inch of the way.

To recap something that we advised you previously: whenever a living person's picture is used without his written consent, the question of a possible invasion-of-privacy action arises. And the lawsuits which have been brought against the photographers have not been skimpy: one million, one million five, two million . . . and we're talking about dollars.

There is no simple way to determine whether a person's privacy has been invaded. It all depends on the circumstances, and these range widely. However, there are a few basic rules to which the courts have consistently looked.

First, if a living person's picture is used as part of a purely factual account relating to a matter of legitimate public interest, then there are no grounds to complain, even if a written release was not obtained. "Legitimate public interest" means primarily general news information.

Second, if the picture is being used without authorization for what is known as "purposes of trade" or for advertising a product or service, then the privacy is deemed invaded. The basic aim of any right-of-privacy law is to prevent a commercial use of a living person's picture.

With respect to the law in this area, there are four jurisdictions to consider.

1. Certain states, like New York, Utah, and Virginia, have what is known as right-of-privacy statutes. In New York, the statute is quite clear: no use for advertising or for purposes of trade.

2. Certain states recognize right-of-privacy based upon legal precedent or case law in that particular state.

3. Certain states, such as Texas, Nebraska, and Rhode Island, don't have such statutes and refuse to recognize the right of privacy.

4. Certain states have taken no position whatsoever, one way or the other.

Keep in mind that it is the purpose or intention of the use of a picture that determines whether a party's privacy has been invaded. Generally, if your intention is simply to convey some general news information, you are on safe grounds. If you're looking for money and a commercial exploitation, you'd better have a written release in hand.

We should mention that the term general news information is not crystal clear. For example, what is considered factual, what is considered truthful, and what is considered exploitation may overlap. Let us give you an example. Suppose you have taken a photograph of a person who is born only two inches tall. His name is Yoda and eventually, he becomes the star of a motion picture. If the photograph winds up on the front page of your local newspaper, that's considered factual and truthful and certainly under the aegis of general news information.

However, if you decide to take that photograph and start running it on T-shirts, calendars, and the like, or perhaps just simply selling it—under the guise of general information—you may be guilty of exploiting that person and thereby invading his privacy. Forty-seven states now permit parties to sue for breach of privacy.

Consider this actual case. A small girl was hit by an automobile. A photographer on hand took the girl's picture. It showed her face in great pain, her dress ripped. It was published the following day in the newspaper as general news information.

Almost two years later, a magazine published an article on traffic accidents. It was called "They Ask to Be Killed," and it showed how pedestrians were very careless, leading to their own accidents. The picture of the child was used.

The little girl sued, and she won. The court held that even though the press privilege protected the first publication in the newspaper, the magazine had no right to use the picture in its publication with respect to an article on traffic accidents. In other words, according to the court, the magazine had gone beyond the bounds of press privilege and the law when it turned the girl into a "pictorial, frightened example of pedestrian carelessness." The court felt that the use of the photograph was exploitation of someone's misfortune. (Leverton v. Curtis Pub. Co., 192 F2d 974.)

There is one question that pops up at least once a week. Does the photographer have the right to follow a public figure in order to get a photograph? The answer is an obvious one. Yes, provided the photographer is not trespassing or does not become a nuisance. Ah, there's the rub. What is nuisance?

This case is a famous one. A professional photographer made a career of taking photographs of a beautiful woman who also happened to be a former president's widow. When her Secret Service agents started interfering, the photographer sued, claiming that he wasn't able to make a living because of this interference. The former first lady countersued for harassment.

The trial was a sensational one and there were almost 5,000 pages of transcripts involved. In a 130-page opinion, the court ruled that the photographer had indeed invaded the woman's privacy, and he was enjoined from getting too close to her to take her picture and, as a sidelight, the court prevented the photographer from using any photographs of her for advertising or trade purposes. This included self-promotion. (The photographer was using her picture on a self-promotion postcard.)

You may be saying to yourself, what about freedom of the press? What did the court say about that?

Recognizing that the case presented a direct confrontation between right of privacy and freedom of the press, the court ruled that the First Amendment of the Constitution did not automatically give the photographer the freedom to trespass nor to maintain "surveillance" over the former first lady. And that's still the law today. (Galella v. Onassis, 353 F. Supp. 196.)

There are two other major cases which are of interest to photographers and which are worth recalling here. One concerns a fellow named Murray who used to sell newspapers in New York. On St. Patrick's Day he attended the parade dressed in a green hat, green bow tie, green buttons on his green jacket and waving a green flag. The only clinker was that Murray was not Irish. Now, while watching the parade, he was photographed, and that photograph appeared on the front cover of a popular magazine below the title "The Last of the Irish Immigrants."

Murray sued for breach of his right of privacy but the magazine was deemed not liable. The court pointed out four things.

1. The article concerned itself with an event of public interest.

2. The photograph was used to spotlight the event.

3. Murray was photographed only because his presence constituted a visual participation in an event of special importance.

4. His photograph was related to the subject of the article. (Murray v. *New York* Magazine, 27 NY 2d 406.)

The second one of interest concerns Joe Namath, the ex-football player. His photograph was used in connection with an article in *Sports Illustrated* magazine. Some time later, it appeared in adver-

tisements promoting subscriptions to the magazine, but it was published without his permission. The court ruled that the use of the photograph to promote subscriptions was simply an "incidental" use and that its reproduction was intended to illustrate the quality and content of the periodical in which Namath had earlier been properly and fairly depicted. (Namath v. *Sports Illustrated,* 48 AD 2d 487.)

The bottom line is that you must pay strict attention to the law of your state. When in doubt, make sure you are protected by the use of a release—see the form we provided in this book.

We have received a few phone calls from photographers asking whether permission is necessary to photograph on Indian reservations in the United States. Apparently, a large number of photographers do work in these areas. The U.S. Department of the Interior, Bureau of Indian Affairs, in Washington, D.C., advises that if you intend to take photographs on any Indian reservation, or make a film or television production, that you first have the permission of the proper tribal authorities. You must observe any conditions attached to that permission.

The bureau says that you are traveling as a guest on Indian-owned lands, and therefore the usual courtesies of guest-host relationships will be your guide.

OBSCENITY

Try a couple of these on for size.

1. Two photographs of a nude man embracing a nude woman published in a newspaper. Not obscene.

2. A man publishes pornographic books that other people prepare. He's convicted.

Inconsistent? Let's see. In Georgia, it was held that mere possession of obscene matter could not be constitutionally punished on the basis that a person has "the right to satisfy his intellectual and emotional needs in the privacy of his own home." And the United States courts have found no constitutional violation in the seizure of photographs that a customs agent deemed obscene. But recent decisions have begun to show that certain jurisdictions can deem certain matters obscene if they so wish.

We have already delved into this subject in an earlier chapter. The point to keep in mind is that obscenity today is determined by applying "contemporary community standards" and not "national standards."

There is one type of censorship, though, that seems to be disturbing everyone, and that concerns the U.S. mails. Sections 4006 and 4007 of 39 U.S. Code permits the postmaster general to stop anyone from using the mails for transmitting obscene materials. However, pursuant to a court decision, the burden of proving obscenity was placed on the censor. With this in mind, many companies have begun to question the use of the mails for sending what could be construed as obscene materials. A major film producer, Kodak, has been the latest to be so charged in a lawsuit.

As of this writing, *Penthouse* magazine has instituted a lawsuit against Kodak for their failure to return a number of photographs. Apparently, Kodak has refused to return materials sent to it for developing on the basis that the film is obscene. Kodak's rationalization for not returning the film is not quite clear. The company cited court rulings in Georgia and Texas to show that the firm might be held criminally liable for distributing or sending through the mails sexually explicit photographs.

Penthouse, of course, claims that its suit raises basic First Amendment rights. It feels that a company which contracts to develop film simply does not have the expertise to judge what is and what is not obscene. Kodak's response is that if it returned the film, it might subject itself to criminal prosecution under state and federal obscenity statutes.

What seems to have developed from all this is that each area will be its own judge and jury. Accordingly, a photograph may be considered obscene in one state and not obscene in another. To say that this will create all sorts of problems for both the creator and the distributor of material is an understatement.

What will happen? We don't know. It certainly seems that until some kind of definition can be found (and it may be that we are trying to define something that is undefinable), the courts will have to deal with the problem on a case-by-case basis.

While we're at it, let's look at what's happening in the courts.

THE COURTROOM

There is no question but that whenever the interests of society come into conflict with those of the individual, there's going to be a clash, unless some sort of balance is obtained. The area becomes gray and the line between the two quite thin. When does the individual give away his rights to society, and vice versa?

One of the areas that many photographers have been fighting to-

day has to do with the courtroom itself. Photographers consider that the first and most important bastion. In a major case of fifteen years ago, the court said that "It is obvious that the introduction of television and news cameras into a criminal trial invites many serious constitutional hazards. The very presence of photographers and television cameramen plying their trade in a courtroom might be so completely and thoroughly disruptive and distracting as to make a fair trial impossible." (Estes v. Texas, 381 U.S. 532.)

Two years later, in the matter of Seymour v. United States, 373 F2d 629, it was stated that a rule of a federal court in Texas prohibiting "the taking of photographs . . . in connection with any judicial proceeding on or from the same floor of the building on which the courtrooms are located" is deemed upheld as against a constitutional challenge by a television news photographer.

What comes to mind quickly is where the media fit in with respect to the First Amendment. Is there a constitutional right of access to the media? Does the First Amendment protect the public's right to know as well as the right of the media to do their job?

Enough waves were made over the years so that recently many states have begun liberalizing their rules in certain key areas. One of those is the courtroom heretofore barred to photographers.

It has been the rule for the longest while that the taking of photographs in a courtroom at any time, whether or not the court is in session, is prohibited unless permission is first obtained. In New York, this is specifically set forth in the rules of the Administrative Board of the Judicial Conference of the state. What the board had in mind, obviously, was the dignity of the courtroom.

Now, things are beginning to change, slowly but surely. For example, the California Judicial Council adopted new rules authorizing electronic and photographic coverage of court proceedings. This is a one-year pilot program which started on June 1, 1980, under which photographic coverage of court proceedings is now permitted subject to the discretion of the judges. Certain guidelines concerning type, number, and placement of equipment have been drawn up.

In Nevada the Supreme Court authorized a one-year experimental program, commencing April 6, 1980, to permit electronic media and still photographic coverage of public judicial proceedings in trial and appellate courts, subject to the approval of the judges and to certain court-adopted rules of procedure and technology.

For instance, looking at the still photography situation in this state, the new law provides that the still photographer would be po-

sitioned in locations in the court designated by the judge. The photographer would then assume a fixed position within the designated area and once the photographer is so positioned, he could not move about in any way which might attract attention.

In Iowa, too, a one-year pilot program was started on January 1, 1980. In this state, still cameras are to be standard professional-quality single-lens reflex or rangefinder 35mm, or twin-lens reflex 120mm in good condition. Motor-driven film advances and autowinders on still cameras are not allowed. In addition, not more than two photographers, each using not more than two camera bodies and two lenses, are to be permitted at any one time.

Oklahoma adopted a similar rule, as did North Dakota. In the latter state, photographers must notify the court seventy-two hours in advance of any planned coverage, with the court reserving the right to prohibit coverage of certain proceedings. In North Dakota, the entire coverage of a court proceeding is limited to one audio system for radio broadcasts, a single television camera, and one still photographer.

In New Jersey, there was a one-day experiment and the court is now considering this experimental coverage in determining whether to relax the state's current ban on cameras in the courtroom.

What do we think about this? It's all to the good. We have always found a marked inconsistency in courtroom proceedings. If artists' sketches can be made of a trial and these are then telecast that very evening, what is the problem about a nonclicking, nonflashing camera?

If cameras were allowed, we fail to see the concern. Would knowledge that photographs were being taken change the performance in the courtroom any more than those in the Senate or House Judiciary hearings which are televised before the world?

Perhaps the courts are concerned about publicity, especially adverse publicity, or the publication of photographed materials and personages. Perhaps the answer might be to hold publication of sensitive materials until after the trial is complete. We don't know, but we must continue to work to improve the situation.

Our personal hope is that the changes we described here do continue. The world can't be closed forever.

LEGISLATION

There has been much going on in the legislatures around the country, some of importance and some not.

For example, a bill was introduced recently in the state of North Carolina which says that the customer will own all photographs unless there is a written agreement to the contrary. Whatever happened to the copyright law, which is a federal law? We contacted the general counsel for the Copyright Office at the Library of Congress.

According to the response from the Copyright Office, the new copyright law has extended the scope of its operations so that the states are no longer free to create either statutory or decisional law equivalent to the legal rights under the federal law regarding works that come within the subject matter of copyright.

The Copyright Office does say that states retain certain authority concerning contractual disputes and even the interpretation of contracts. However, a state court will have to apply the federal Copyright Act, where relevant, in interpreting the contracts, as well as the particular state law of contracts. In other words, the states cannot enact any legislation or do anything that conflicts with the federal law.

In New York, a bill has been introduced that would safeguard the rights of artists when reproductions of their works are sold. The term work of art as defined in the bill means any work of visual or graphic art of any medium, and that includes photography. The artist's rights legislation is designed to protect artists' ownership rights to their works and to aid them in concluding reproduction contracts.

The bill would establish that when reproduction rights are sold, the artist remains the legal owner of the physical artwork unless ownership is explicitly transferred through a written and signed agreement. The measure also mandates that contractual ambiguities involving the nature and extent of an artist's rights be resolved in favor of the artist.

The sponsor of the bill, Assemblyman John C. Dearie of the Bronx, says that "Federal law covers an artist's copyrights, but does not preempt or resolve ownership issues relating to the ownership of the physical artwork when reproduction rights are transferred. For example, royalties from pictures of our Winter Olympic hockey team may be lost to photographers because of continuing interest in the team's victory. Photos sold on a one-time reproduction basis to a newspaper may be used later in books or other publications on the American triumph and the photographers would lose reimbursement for these subsequent publications. This bill would clarify the photographers' and other visual artists' rights and help ensure that they receive compensation for their work."

We're all for it.

From the sublime to the ridiculous. A bill has been introduced in the state of New Jersey under which photographers would have to be licensed to practice in that state by meeting certain stringent conditions. Check some of these out.

1. No person shall engage in the practice of photography for financial compensation unless such person is duly licensed.

2. A board made up of five members will establish an examination fee, license fee, and annual license renewal fee.

3. The board, in addition to all sorts of other record-keeping duties, will conduct examinations and issue licenses. Each written examination will be supplemented by an oral examination as the board determines.

Can you see it now? An advertising photographer who receives an assignment for a major ad campaign to be shot in New Jersey would be required to obtain a license pursuant to the requirements and procedures spelled out in the proposed bill. The time alone involved in obtaining such a license would rule out the possibility of that photographer's carrying out the assignment, not to mention the potential loss of revenue not only for the photographer but for the state in making it next to impossible for companies to function within the state on that basis.

By the same token, a photojournalist covering a story for a magazine or newspaper, where time is of the essence, would be precluded from fulfilling the assignment because of such a licensing restriction.

Where does this bill now stand? It's still in committee and a number of companies (both within and out of New Jersey) have been writing to the New Jersey Assembly voicing opposition to the bill. As of this writing, one sponsor even changed his mind. He wrote saying that originally the bill was presented as a "consumer protection" device; "However, I can see from your letter that such legislation quite oversteps the bounds of propriety in this area. From your description, A-1737 would seem comparable to throwing out the baby with the dirty bath water. Please be assured that I have withdrawn my cosponsorship.... Further, should the bill be released from committee, I shall cast my vote in the negative."

What's the chances of its getting out of committee? Those we asked said no chance. We couldn't be more pleased.

We cannot cover all the states; we are just pointing out those which have recently seen volatile changes. In California, the so-called Jackie Coogan law covers photographing minors. In its present form, the law puts all sorts of restrictions on the professional

photographer. One of them is the fact that if a shoot is for more than two and a half hours, a social worker must be hired through a teacher's union at a cost of $144. On any shoot of two and a half hours or less, the same procedure takes place at a cost of $60. The social worker is empowered to stop the shoot at any time if it is believed to be appropriate for the best interests of the minor.

The ASMP has been negotiating for a change in this child-labor law. It recommends that:

1. On any shoot that is for two hours or less, and which does not affect the school day (i.e., outside school hours or on weekends or holidays), there should be no requirement for the presence of a social worker.

2. On any shoot that is for more than two hours, or less than two hours but which interferes with school, then the present interpretation of the law would apply.

3. If the minor is a casual model (defined as a person being photographed one time only), having never been photographed before, there should be no requirements as are presently being enforced due to the obvious financial considerations which make the use of a casual model prohibitive.

The society felt that these small changes would not be considered radical and that they would gain support not only from the modeling agencies but from the parents whose minors are pursuing professional careers.

And finally, as long as we're in California, photographers should take note of this little-used but important law. There is a print statute in the state dealing with artworks which says, among other things, that no fine print is to be offered for sale unless a written invoice or receipt for the purchase price or a certificate furnished to the purchaser clearly discloses all of the relevant informative details.

AIRPORT SECURITY AND THE X-RAY MACHINE

Nothing seems to get the traveling photographer's goat more than the X-ray machines at the airports. Airport security is okay, but it does get to the point of absurdity. The problem, as most photographers know, is that X-rays ruin film.

We queried the Federal Aviation Administration Security Office at the Department of Transportation in Washington. The FAA's position was that all requests for physical inspection of film and photographic materials *must* be honored without exception. The FAA

says that signs are posted at each checkpoint in the U.S. utilizing X-ray systems. Accordingly, they recommend that persons carrying film request a physical search in lieu of X-ray inspection.

That seems clear enough.

We also contacted a number of international airlines such as Lufthansa, KLM, Icelandic, Sabena, Alitalia, and Air France, and were advised that the same procedure was available at most of the airports they service. However—and here's the fly in the ointment—the security measures taken at the individual airports are *not* administered by the airlines but by an independent security force appointed in many cases by the government. Therefore, procedures vary from one country to another.

What do you do? Recognize what you are dealing with and whom, and try to make the adjustments as best you can. You can be sure that all carry-on luggage will be searched and you simply must insist on a visual inspection.

The FAA tells us that luggage consigned to the cargo area is usually not X-rayed; however, this could vary from airline to airline.

If you run across problems in the United States, your best bet would be to contact the FAA. If you're traveling abroad, try to persuade the authorities to conduct a visual search ... and put on a healthy smile.

TO SUMMARIZE

It's no secret that there's a lot going on in the world of law, legislation, and the courtrooms pertaining to what you do as a photographer.

The intention of this section is to familiarize you with some of the key matters which trouble photographers. How does that saying go? Knowledge is 90 percent of the law.

Photography Guilds and Organizations

Whether in the business for decades or just starting out, most photographers join some sort of guild, club, or association. The reason is obvious: they want to learn more about their profession, they want to exchange ideas, they want to reap the benefits that organizations offer.

There are enough different photographic organizations in this country to choke the proverbial horse. The big question then is what does each offer. We couldn't possibly detail all that in this section, but we can explain what differences exist among various kinds of societies.

We have included in Appendix E a list of some of the organizations involved with photography ... not all, just a few. These are primarily the major ones. We couldn't list every camera club in every area, simply because we don't know all of them and there are so many that you would need a wheelbarrow to get this book home. For more information, write to those groups that interest you and you will be deluged with literature.

Now, let's look at some basic organizations; how are they different from one another and how could one be of greater benefit to you than another?

Most of the organizations that exist in this country are known as trade associations. There are probably more of these in the United States than there are any other type of organization. They range from the American Association of Nurserymen to the American Industrial Hygiene Association to the American Bottled Water Association. Most people, however, are bewildered as to the difference between a union, a guild, and an association.

A union is an organization made up of members who deal with

management on matters such as wages and working conditions. Its members are employees toiling in a particular company or field and the organization negotiates with employers for standard rates and rights. For example, if you are an actor doing a film television commercial, you would be a member of the Screen Actors Guild (SAG) and, as such, your employer has to abide by certain rules and regulations which it and SAG negotiated in a collective-bargaining agreement.

Is the Screen Actors Guild the same as, say, the Authors Guild?

No. Although they share the word *guild* in common, the Authors Guild is not a labor union. It is a trade association, which is defined as a group of people belonging to the same class and engaged in similar pursuits. Naturally, this description can easily apply to SAG. The difference is that the Authors Guild is comprised of independent writers (primarily authors of books), not employees.

The key to whether a particular organization is a union or a trade association (and put the word *guild* away for, as you can see, its use can be misleading) is what its members do. A union functions on behalf of the employee and has agreements with the employer which cover rates and conditions of employment. A trade association (or nonunion, for our purposes here) is generally an association of people who are not, for the most part, employed, but rather who work as independent contractors. Thus, there is no collective-bargaining agreement in effect.

The Authors Guild serves to protect and promote the professional interests of its members by disseminating information on subjects which are of importance to its group. This can range from copyright to taxes to freedom of expression. They have been most effective. You don't have to be a union to obtain results.

For instance, the Authors Guild fought for the implementation of a new copyright law which would protect the creator. It succeeded. The society issues all sorts of guidelines to aid its members in the writing profession, including surveys on what advances and royalties different publishers pay. It files legal briefs as amicus curiae (friend of the court) in matters pertaining to legislation which would affect its members. It organizes contract clinics and engages in many projects to help authors understand more about their profession.

With all this business about unions and associations, there is considerable confusion today. The feeling exists that many unions, as we know them in the communications industry, aren't unions at all . . . or, at least, shouldn't be.

The Directors Guild of America (DGA) is a union whose members work in the television and motion-picture fields. Years ago a director was signed to a studio such as Paramount Pictures for a certain number of films. He was employed by Paramount and given a contract reflecting the employer-employee relationship. The DGA represented that director, and collective-bargaining agreements were initiated between Paramount and the DGA.

Today, the director is not quite an employee. In many instances, the director (especially one of any stature) has his own corporation, which furnishes his services to the particular motion-picture company as an independent contractor, not as an employee. The director is an employee of his own company. If the director is not an employee of the studio, how does he come under the scope of the DGA?

It would seem to these authors that in a number of areas such as writing, directing, and choreography, the employer-employee relationship as we used to know it no longer exists. We think the day will eventually come, depending on who pushes whom the hardest, when the motion-picture company will resist standard rates and conditions as set by the unions on the basis that union jurisdiction is not applicable. With creative elements being furnished through their own companies, we may see more trade associations than unions springing up in the communications fields.

What can a trade association do? The best example, impartially of course, is the American Society of Magazine Photographers.

The ASMP is similar in many respects to the Authors Guild. It is a trade association, a society whose members are united by mutual interests for a common purpose. To go through exactly what ASMP has done over the years would take up most of this book, but let us backtrack for just a moment.

In 1944, a number of magazine photographers met with the idea of organizing. Many problems existed at that time. There was no minimum day rate. There was constant bickering over fees and expenses; many assignments, in fact, were done on speculation. By the end of that year, the Society of Magazine Photographers had been formed and incorporated in the state of New York. Under its original constitution, which still stands today, the organization's objectives were "To safeguard and promote the interests of photographers, to maintain and promote high professional standards and ethics in photography and to cultivate friendship and mutual understanding among professional photographers."

The ASMP was formed as a not-for-profit membership corpora-

tion, or a trade association. Interestingly, seven years later the organization was granted a charter by the state of New York to operate as a labor union. That charter is still in effect. In 1951 the Board of Standards and Appeals approved making ASMP a membership corporation licensed to act as a labor union.

The ASMP is in a unique position. Its members are the cream of the professional photography world. However, in many cases, the typical ASMP member is a freelance, freewheeling, independent professional who does not like to have strings attached and who generally functions in a highly creative atmosphere with little or no control by the client. He does not receive employee benefits and is a private contractor doing what he has to do and wants to do. Of course, if 51 percent of the ASMP membership decided to function as employees, then it could (in the proper situation) probably function as a labor union pursuant to its charter. This could happen.

What ASMP does as a trade association is establish an industry-wide level of professionalism. For example, it originated a stock picture code in 1952. It initiated legal precedents in various aspects of law, including the establishment of the value of exposed but undeveloped film. It worked out a code of ethics and standards and over the years negotiated with most of the major publishers on rights and rates. In fact, its negotiations with Time Inc. are legendary. One battle (of many) revolved around the residual uses of photographs. The ASMP members stood fast, and as a result, Time recognized for the first time the photographers' ownership rights to their photographs. It also established credit lines for photographers.

Additionally, the ASMP helped to clarify the relationships between photographers and representatives, agencies, and users of photography. In 1973 it published *Business Practices in Photography*, a book that quickly became a standard reference work for the communications industry.

The facts are simply the tip of the iceberg. In the past year alone, membership has increased by 400; it now stands at 2,500 of the world's finest professional photographers in not only the magazine field but in every area of the visual media, from journalism to advertising to corporate to television to motion pictures. Furthermore, the scope of ASMP is being felt across the country. The society now has nineteen chapters in major cities in the United States and a new national headquarters in New York.

Enough of ASMP. It should be noted that the manner in which trade associations effectively serve its members is through vigorous

action and information exchange in the areas of rights, ethics, and standards. The function of a trade association is to educate. The feeling exists that awareness would change many of the attitudes and methods of operation prevalent in the industry today. Many of the organizations went about increasing their own involvement in a number of new facets of the communications field.

For one, a number of societies have taken the lead with respect to the new copyright law. As we have said, this law changed completely the rights of the photographer. Under the old law, the client usually owned the photographs which were made under assignments unless there was an agreement to the contrary. Under the new act, the photographer owns the work unless he signs an agreement otherwise.

However, the law itself didn't produce the changes now going on in the industry. It was up to these trade organizations to implement that change. They had to explain to the photographer that at the instant he clicked the shutter his work was protected by federal law and remained so until he chose, if ever, to give it away.

Most clients, as well as photographers, were stunned by the reversal in ownership. After all, they were used to doing business in a certain way since 1909. A committee of fifteen trade associations then drafted a position paper which was sent to all users of photography in order to explore ways of benefiting from the new copyright law.

Also, a number of trade associations try to act on members' problems wherever possible. Some have filed briefs with the court as amicus curiae in tax matters; some have helped with the establishment of various legal precedents in the field; some provide seminars on a wide range of subjects, from negotiating the editorial or advertising assignment to selling stock photographs; some have established closer liaison with suppliers such as Kodak and Polaroid; and some (like the ASMP) have done all of the above.

There is also a new insurance program being developed for the industry, as we mentioned in Chapter 6. For the first time, coverage will be available for the cost of reshooting a job. Equipment, faulty stock, and negative liability insurance have been combined in one package that has become a first not only in the photographic industry but in the insurance industry as well. It's called Photo Pac. Look for it.

As the photographer's interests widen, so do the trade association's of which he is a member. Years ago, the photographer was

limited in scope. He was first a portrait photographer, then branched into commercial work, did assignments and advertisements, and then into the news media, magazines, and allied fields. Today, he is all over the place doing many things.

It would be an understatement to say that photography is the medium of the future. It is now being raised to heights never dreamed of before. Who thought that when an organization like ASMP was founded thirty-six years ago, we would today have advanced to self-developing photographs, three-dimensional prints, or holography? The changes will continue to be made, and the photographer should and must recognize that he is just as much a part of these changes as anyone.

That's exactly why organizations such as ASMP thrive. It is through them and the people who comprise and work with them that the photography field can move ahead even more dramatically than in the past.

The role of a trade association? Look at what they do. That's the real test.

Aside from the trade associations, there is also a multitude of camera clubs which you might want to consider.

Most camera clubs are begun because photographers want to exchange news and other information, and learn about what is going on in photography. They also like to show each other their photos and discuss in depth what they are doing and how they are doing it.

A camera club is quite different from a trade association. Most clubs are started by beginning photographers who desire a social contact and a place to exhibit what they are doing. Don't misunderstand us; this is not a knock. However, the fact remains that most of these clubs are primarily interested in the creative and technical ends of photography rather than the business side. This is perfectly fine. A program on how to shoot wedding pictures or the correct filters to use in desert shooting may be of invaluable aid to all photographers, whether amateurs or hardened professionals. Generally, though, camera clubs require participation by all their members. For example, if in a particular area there are ten photographers who shoot weddings, these ten might want to band together to form a camera club which would offer programs on new technology in wedding photography or creative ideas on any other matter of mutual interest.

Of course, the success of the club will depend on how willing each of the ten photographers is to exchange whatever information he

has with the other photographers who are, after all, his competition.

But camera clubs don't have to be professionally oriented, and most aren't. A group of people who love to shoot rolls and rolls of film while on vacation might form their own travel camera club where once a month a member shows slides of his recent vacation. Slides of someone's three-week trip to a resort hotel in the Poconos may be boring to most people, but may be terribly interesting to the guy who just came back from his own three-week trip to a mountain resort.

In the recently published *Encyclopedia of Practical Photography* (AmPhoto, Kodak), there is a marvelous section on camera clubs. In it, there is a breakdown on what kinds of programs evoke the greatest response, especially from amateur photographers. Apparently, most people are interested in the following topics:

How to photograph babies
How to take vacation pictures
How to photograph weddings
How to light for home movies
How to edit home movies
How to make simple home portraits
How to photograph hobby activities
How to make sports pictures
How to expose color film
How to photograph children
How to photograph flowers

At the risk of sounding chauvinistic, but keeping in mind what we have seen from a great number of professional photographers (both male and female), we would like to add one other topic which may be the most interesting of all. You guessed it: how to photograph the nude.

TO SUMMARIZE

There is a plethora of photographic organizations of all sorts with which you can become associated. They can be a valuable forum for the exchange of information, and information is what it's all about. Keep up to date with what's going on in your chosen field. Learn about the newest techniques, understand the latest business principles, stay fully informed about what you are doing.

Trade associations, guilds, unions, societies, and camera clubs all serve a purpose, and the purpose is twofold. You serve it and it serves you.

In Conclusion

Starting your own photographic business is a venture that should receive a great deal of consideration. Being a good photographer does not ensure success, especially as an owner of a studio or other photography business. When you start earning your living by photography, you become a professional, and your work and manner of operation will be judged by professional standards. You will be competing with photographers who may be well known, who may have had years and years of experience, and who do good photographic work consistently.

It is not unusual for a beginning photographer to go into business for himself, but it is unusual for that photographer to remain solvent if business conduct is ignored. That is why it is vital, imperative, essential, mandatory, for you to understand the business aspects of photography.

It is tragic to have an initial outlay of expenses such as equipment, studio, film, and all the rest and then find it all goes down the drain simply because the photographer failed to understand that photography is a business, just like any other.

It is all well and good to have an artistic approach to what you are doing, to do what you want, to shoot what you want. But, more often than not, photographers look the other way when it comes to taxes, insurance, business forms, and legalities. Many think that is not in keeping with the "artistic spirit" of the profession of photography. As a result, photographers put themselves at the low end of the totem pole, gaining little respect from their clients, primarily because they themselves have little respect (except for the artistic aspect) for what they are doing.

There are, of course, exceptions to the rule; those who succeed in spite of everything. The fact remains that the majority of professional photographers who fail do so because of their own failure to recognize the rudiments of their profession.

Don't let this happen to you. Be smart ... and succeed!

175

APPENDIXES

The information contained in these appendixes was in effect as of the date this book was written. Accordingly, addresses and telephone numbers may have changed. Moreover, certain regulations may also have been altered.

Taxable Status of Supplies Used by Photofinishers

(Supplied by the Taxpayer Services Division, Technical Services Bureau, State of New York)

The following listing has been prepared as a guideline to assist persons engaged in the business of photography to determine which photographic products of Eastman Kodak Company, GAF Corporation, and Philip A. Hunt Chemical Corporation are actually transferred to the final product. Those products that are transferred may be purchased tax exempt by issuing a properly completed resale certificate; those photographic products that are not transferred are subject to tax at the appropriate state and local tax rate.

KODAK

Item	Trans-ferred	Not Trans-ferred	Item	Trans-ferred	Not Trans-ferred
Kodak Stop Bath, Process C-22		X	Acid Hardener	X	
Ektachrome Film Processing Kit (E-4 and E-6)	X		Liquid Hardener	X	
			Chromium Intensifier	X	
Developer Kit (E-4 and E-6)	X		Print Flattening Solution	X	
Processing Kit (Ektaprint 2, 3, and R-500)	X		Developer Cleaner System		X
			Hypo Clearing Agent		X
Color Processing Kit, Process C-22	X		Fixer System Cleaner		X
Flexicolor Processing Kit	X		Photo-Flo Solution		X
Blue Toner	X		D-11 Developer		X
Brown Toner	X		D-19 Developer		X
Poly-Toner	X		D-76, D-76R Developer		X
Selenium Toner	X		Microdol-X Developer		X
Sepia Toner	X		Durafin Developer Replenisher		X
			Ektaflo Developer		X

Item	Trans-ferred	Not Trans-ferred	Item	Trans-ferred	Not Trans-ferred
Versamat, Type A Developer Replenisher		X	Neutralizer and Replenisher, Process E-4		X
Versamat, Type B Developer Replenisher		X	Ektachrome Movie Neutralizer and Replenisher		X
Versamat, Type C Developer Replenisher		X	Stop Bath, Process E-4		X
Versaflo Developer Replenisher		X	Stop Bath and Replenisher, Process E-4		X
Kodalith Developer		X	Ektachrome Movie Stop with Bath and Replenisher		X
Developer Starting Solution		X	Bleach, Processes E-4 and E-6		X
Versaflo Developer Starting Solution		X	Bleach Replenisher, Processes E-3, E-4, E-6, and E-6AR		X
Versamat Developer Starting Solution		X	Bleach and Replenisher, Process E-4		X
Flomatic Stop Bath		X	Ektachrome Movie Bleach and Replenisher		X
Hi-Matic Stop Bath		X	Ektachrome Film Bleach and Replenisher, Process E-3		X
Indicator Stop Bath		X			
Ektaflo Fixer		X			
Photo-Fix		X	Liquid Developer, Process C-22	X	
Rapid Fixer		X	Liquid Developer Replenisher, Process C-22	X	
Flomatic Fixer		X	Flexicolor Developer	X	
Hi-Matic Fixer		X	Flexicolor Developer Replenisher	X	
Versamat Fixer		X	Flexicolor Developer Replenisher, Parts B and C	X	
Farmer's Reducer		X	Flexicolor AR Developer Replenisher C	X	
Ektachrome Movie Prehardener Replenishers A and B	X		Vericolor Developer Replenisher	X	
Ektachrome Film Hardener, Process E-3	X		Internegative Replenisher	X	
Prehardener and Replenisher, Process E-4	X		Hardener, Process C-22	X	
Ektachrome Movie Color Developer Replenisher A	X		Hardener and Replenisher, Process C-22	X	
Color Developer, Processes E-3, E-4, and E-6	X		Vericolor Hardener and Replenisher	X	
Color Developer Replenisher, Processes E-3, E-4, and E-6	X		Flexicolor Stabilizer and Replenisher	X	
Ektachrome Color Developer Process E-3	X		Ektacolor Print Film Stabilizer and Replenisher	X	
Ektachrome Movie Stabilizer and Replenisher	X		Flexicolor AR Stabilizer and Replenisher		X
Stabilizer, Processes E-3, E-4, and E-6	X				
Neutralizer, Process E-4		X			

Item	Trans-ferred	Not Trans-ferred	Item	Trans-ferred	Not Trans-ferred
Stabilizer and Replenisher, Process C-41V	X		Ektaprint Formalin Fixer and Replenisher	X	
Ektacolor Print Film Additive		X	Ektaprint R-500 Stabilizer	X	
Internegative Starting Solution		X	Stabilizer and Replenisher; Ektaprint R and R-5	X	
Vericolor Filtering Agent		X	Stabilizer and Replenisher R-100	X	
Fixer, Process C-22		X	Coupling Agent, C-10	X	
Vericolor Stop-Fix and Replenisher		X	Coupling Agent, C-11	X	
Hardener and Replenisher, Process C-41V		X	Coupling Agent, C-16	X	
			Coupling Agent, M-31	X	
Developer, Ektaprint 2, 3, and 300	X		Coupling Agent, M-32	X	
			Coupling Agent, M-38	X	
Developer and Replenisher, Ektaprint 2 and 3	X		Coupling Agent, Y-50	X	
			Coupling Agent, Y-54	X	
Ektaprint Developer Replenisher, Parts A, B, D		X	Coupling Agent, Y-55	X	
Ektaprint 3HC Developer Replenisher, Parts A and B		X	Color Movie Film Lubricant	X	
			Hardening Agent, HA-2	X	
Ektaprint 3000 Developer Replenisher, Parts A, C, D		X	Potassium Iodide		X
			Anti-Calcium, No. 4		X
Developer Replenisher Additive		X	Sodium Carbonate, Anhydrous		X
			Sodium Sulfate, Anhydrous		X
Ektaprint R Hardener Stop Bath	X		Sodium Ferrocyanide, 10H20		X
			Potassium Persulfate		X

GAF CORPORATION

Item	Trans-ferred	Not Trans-ferred	Item	Trans-ferred	Not Trans-ferred
Color Print Developer Part B		X	Acetic Acid (all sizes)		X
Color Print Developer Part C		X	Sodium Bisulfite		X
			DA-3		X
Color Print Developer Part D		X	DA-7		X
			DA-5		X
Color Print Developer Part E		X	Phenidone		X
			Igepal		X
Formaldehyde (all sizes and concentrations)	X		Flexogloss	X	
			Film Cement	X	
Sodium Thiocyanate Liquid		X	Edge Number Ink	X	
Sodium Sulfite Anhydrous		X	Microwet 1 and 2	X	
Sodium Carbonate		X	Flemish Toner (all size packages)	X	
Sodium Thiosulfate (Powder and Solution)		X	Copper Intensifier	X	
			Vivitoner (all sizes)	X	
Sodium Hydroxide		X	Sepia Toner (all sizes)	X	

Item	Trans-ferred	Not Trans-ferred
Staflat Clear		X
Staflat Matte		X
Reducer		X
Systems Cleaner and Neu-tralizer		X
Systems Cleaner		X
Wetting Agent		X
Microwet		X
Stripping Cement		X
Wash Saver (all sizes)		X
Superdol Developer		X
Superfinol Developer		X
Isodol		X
Transflo Developer and Re-plenisher		X
Transflo Developer Starter		X
Transflo Start-Up Kit		X
Transflo Developer A		X
Transflo Developer B		X
Transflo Prebath		X
Activator		X

Item	Trans-ferred	Not Trans-ferred
Stabilizer		X
Starter, Developer, and Re-plenisher		X
Mergenthaler Activator, Developer Starter, and Stabilizer		X
Liquamat Developer (In-dustrial)		X
Medical Developer SC/90		X
Reproflo Developer (all sizes)		X
Hyscan Developer		X
Hyscan Rinse		X
Cine First Developer and Replenisher		X
Cine Reversal Second De-veloper		X
Liquid Contact Developer		X
Reprodol "P" Developer		X
Hyscan Cleaning Bath		X
Cine Reversal Clearing Bath		X

PHILIP A. HUNT CHEMICAL CORPORATION

Item	Trans-ferred	Not Trans-ferred
Developer Starter		X
Developer Replenisher	X	
Bleach-Fix and Replenisher		X
Bleach-Fix and Regenerator		X
Stabilizer and Replenisher	X	
Developer	X	
Stop Bath and Replenisher		X
Hardener and Replenisher	X	
Bleach and Replenisher		X
Fixer and Replenisher		X
Bleach Regenerator		X
Bleach Test Reagent		X
Graph-O-Stat Fixer		X
Graph-O-Stat Stop Bath		X
Safety Stop	X	
Starfix Fixer		X
Starlith Developer		X
Type-2 Starlith Developer		X
Type-B Starmat Developer-Replenisher	X	
Ultra No. 1 Developer and Replenisher		X

Item	Trans-ferred	Not Trans-ferred
Ultra No. 1 Developer and Starter		X
Ultra No. 2 Developer		X
Ultra No. 3 Developer		X
Ultra Finishing Solution	X	
Universal Hardening Fixer	X	
AD-500 Developer Replen-isher	X	
AS-500 Developer Starter		X
AP-80 Developer		X
AP-80 Developer Replen-isher		X
A-100 Activator		X
S-300 Stabilizer		X
S-400 Stabilizer	X	
Acid Hardener	X	
Copy Set Developer Replen-isher		X
Cine Reversal Bleach	X	
Cine Reversal Cleaning So-lution		X

Item	Transferred	Not Transferred	Item	Transferred	Not Transferred
Cine Reversal Redeveloper		X	Color Developer Starter		X
Developer Tank Cleaner		X	Color Developer Replenisher	X	
Fixer Tank Cleaner		X	Bleach and Replenisher		X
Flash-O-Graph Fixer with Hardener (4 × 1 gal.)	X		Bleach Regenerator		X
Flash-O-Graph Fixer (5 gal. cube)		X	Bleach Test Reagent		X
Prehardener and Replenisher	X		Fixer and Replenisher		X
Neutralizer and Replenisher		X	Stabilizer and Replenisher	X	
First Developer Starter		X	First Developer Starter		X
First Developer Replenisher		X	First Developer Replenisher		X
Stop Bath and Replenisher		X	Stop Bath and Replenisher		X
			Bleach-Fix Replenisher		X
			Bleach-Fix Regenerator		X
			Stabilizer and Replenisher	X	

State Rules for Small Claims Actions

NOTES ON SMALL CLAIMS COURTS

Claim limit: The maximum amount for which you can sue (as of the latest information available to the authors).

Jurisdiction: Who can sue and who can be sued within the scope of the particular court.

Use of Lawyers: Whether the court bars, admits, or limits lawyers.

Miscellaneous: Additional information to help clarify questions regarding the small claims courts in your state.

ALABAMA

Claim limit:	$300
Jurisdiction:	District where defendant resides
Use of lawyers:	Permitted but are not required
Miscellaneous:	There are no small claims courts in Alabama; hearings are usually heard before a justice court.

ALASKA

Claim limit:	$1,000
Jurisdiction:	District where defendant resides
Use of lawyers:	Corporations must be represented by a lawyer; individuals may have a lawyer present but there is no requirement.
Miscellaneous:	Small claims court is held at the discretion of the district court

ARIZONA

Claim limit:	$500
Jurisdiction:	Most suits may be brought in district where defendant resides or where particular problem occurred

Use of lawyers: Corporations must be represented by a lawyer. Individuals may have a lawyer present but there is no requirement.

Miscellaneous: Small claims court known as justice of the peace court

ARKANSAS

Claim limit: $500

Jurisdiction: District where defendant resides

Use of lawyers: Not required

Miscellaneous: Small claims court known as justice of peace court

CALIFORNIA

Claim limit: $500

Jurisdiction: District where defendant resides or where problem occurred

Use of lawyers: Barred from small claims court

Miscellaneous: Tremendous use of small claims courts throughout California; considered one of the best judicial systems of its type in the United States

COLORADO

Claim limit: $500

Jurisdiction: District where defendant resides or where obligation in question was to be performed

Use of lawyers: Corporations must be represented by a lawyer

CONNECTICUT

Claim limit: $750

Jurisdiction: District where either plaintiff or defendant resides

Use of lawyers: Permitted but not required

DELAWARE

Claim limit: $1,500

Jurisdiction: Anywhere throughout state

Use of lawyers: Permitted but not required

Miscellaneous: Claims come before a justice of the peace

DISTRICT OF COLUMBIA

Claim limit: $750

Jurisdiction: Within Washington, D.C.

Use of lawyers: Permitted but not required

Miscellaneous: Located at 613 G Street, NW

FLORIDA

Jurisdiction: Florida has no small claims court; county courts hear small claim cases.

GEORGIA

Claim limit: Varies throughout the state; each county has its own limitation.

Jurisdiction: District where defendant resides

Use of lawyers: Permitted but not required

Miscellaneous: There are small claims courts and

justices of the peace throughout the state to handle these matters. Extremely varied and complicated

HAWAII

Claim limit: $300

Jurisdiction: Where defendant resides or where cause of action arose

Use of lawyers: Permitted but not required

IDAHO

Claim limit: $200

Jurisdiction: District in which defendant resides

Use of lawyers: Barred

ILLINOIS

Claim limit: $1,000

Jurisdiction: District in which defendant resides or where cause of action arose

Use of lawyers: Required only for corporations

INDIANA

Claim limit: $500

Jurisdiction: District where defendant resides

Use of lawyers: Required only for corporations

Miscellaneous: Cases come before a justice of the peace

IOWA

Claim limit: $300

Jurisdiction: District where defendant resides or cause of action arose

Use of lawyers: Barred

Miscellaneous: Claims come before a justice of the peace

KANSAS

Claim limit: $100

Jurisdiction: District where defendant resides or where plaintiff resides if defendant in same location at time

Use of lawyers: Barred

KENTUCKY

Claim limit: $500

Jurisdiction: Where plaintiff or defendant resides

Use of lawyers: Permitted but not required

Miscellaneous: Cases come before a justice of the peace

LOUISIANA

Claim limit: $500

Jurisdiction: Where defendant resides

Use of lawyers: Permitted but not required

Miscellaneous: Comes before justice of the peace, except in New Orleans, where matters go before the city court

MAINE

Claim limit: $200

Jurisdiction: Where either plaintiff or defendant resides

Use of lawyers: Permitted but not required

MARYLAND

Claim limit: $1,000

Jurisdiction: Where defendant resides or does business

Use of lawyers: Permitted but not required

MASSACHUSETTS

Claim limit: $400

Jurisdiction: District where defendant resides or does business

Use of lawyers: Permitted but not required

MICHIGAN

Claim limit: $500 (depending on area)

Jurisdiction: Where defendant resides

Use of lawyers: Permitted but not required

Miscellaneous: Range is from $300 to $500 throughout state; generally higher in cities.

MINNESOTA

Claim limit: $500 (depending on area)

Jurisdiction: District where defendant resides; if defendant not a resident, district where plaintiff resides.

Use of lawyers: Barred

Miscellaneous: Varies from $300 to $500 throughout state

MISSISSIPPI

Claim limit: $200

Jurisdiction: District in which defendant resides or where cause of action arose

Use of lawyers: Permitted but not required

Miscellaneous: Cases come before a justice of the peace

MISSOURI

Claim limit: Varies from county to county

Jurisdiction: District where defendant resides or where plaintiff resides *and* defendant is within that jurisdiction

Use of lawyers: Permitted but not required

Miscellaneous: Cases come before a magistrate's court with limits of from $2,000 to $3,500

MONTANA

Claim limit: $300

Jurisdiction: Where defendant resides

Use of lawyers: Permitted but not required

Miscellaneous: Cases come before a justice's court

NEBRASKA

Claim limit: $500

Jurisdiction: District where defendant resides or cause of action arose

Use of lawyers: Barred

Miscellaneous: Cases come before a justice of the peace or municipal courts within larger cities

NEVADA

Claim limit: $300

Jurisdiction: Where defendant resides

Use of lawyers: Permitted but not required

NEW HAMPSHIRE

Claim limit: $300

Jurisdiction: Where either plaintiff or defendant resides

Use of lawyers: Permitted but not required

NEW JERSEY

Claim limit: $200

Jurisdiction: Where defendant resides

Use of lawyers: Permitted but not required

NEW MEXICO

Claim limit: $2,000

Jurisdiction: District where defendant resides or where cause of action arose

Use of lawyers: Permitted but not required

NEW YORK

Claim limit: $1,000

Jurisdiction: County where defendant resides. In New York City, small claims court applies to defendants who have an office or who are employed within the city.

Use of lawyers: Corporations must be represented by a lawyer; individuals may use lawyers but are not required to do so.

NORTH CAROLINA

Claim limit: $300

Jurisdiction: District where defendant resides or where cause of action arose

Use of lawyers: Permitted but not required

NORTH DAKOTA

Claim limit: $200

Jurisdiction: District where defendant resides

Use of lawyers: Permitted but not required

OHIO

Claim limit: $150

Jurisdiction: District where defendant resides or where cause of action arose

Use of lawyers: Permitted but not required

OKLAHOMA

Claim limit: $400

Jurisdiction: Place where cause of action arose

Use of lawyers: Permitted but not required

OREGON

Claim limit: $500

Jurisdiction: District where defendant is located

Use of lawyers: Only if court agrees

PENNSYLVANIA

Claim limit: $500

Jurisdiction: Place where defendant is located or where cause of action arose

Use of lawyers: Permitted but not required; corporations must be represented by lawyer in Philadelphia court.

PUERTO RICO

Claim limit: $2,500

Jurisdiction: Place where cause of action arose

Use of lawyers: Permitted but not required

RHODE ISLAND

Claim limit: $300

Jurisdiction: District where either plaintiff or defendant resides

Use of lawyers: Mandatory for plaintiffs who are corporations

SOUTH CAROLINA

Claim limit: $1,000

Jurisdiction: District where defendant resides or where cause of action arose

Use of lawyers: Permitted but not required

Micellaneous: Cases come before a magistrate's court

SOUTH DAKOTA

Claim limit: $500

Jurisdiction: District where defendant resides or where cause of action arose

Use of lawyers: No limitations

TENNESSEE

Claim limit: $3,000

Jurisdiction: District where defendant resides or where cause of action arose

Use of lawyers: Permitted but not required

Miscellaneous: Cases come before a justice of the peace

TEXAS

Claim limit: $200

Jurisdiction: District where defendant resides or where cause of action arose

Use of lawyers: Permitted but not required

UTAH

Claim limit: $200

Jurisdiction: District where defendant resides or where cause of action arose

Use of lawyers: Permitted but not required

VERMONT

Claim limit: $250

Jurisdiction: District where defendant resides

Use of lawyers: Permitted but not required

VIRGIN ISLANDS

Claim limit: $300

Jurisdiction: Place where defendant resides or is served

Use of lawyers: Barred

VIRGINIA

Claim limit: $3,000

Jurisdiction: District where defendant resides or where cause of action arose

Use of lawyers: Permitted but not required

Miscellaneous: Cases come before an entity known as courts not of record

WASHINGTON

Claim limit: $200

Jurisdiction: District where defendant resides or where cause of action arose

Use of lawyers: Barred except with court's permission

WEST VIRGINIA

Claim limit: $300

Jurisdiction: District where defendant resides or cause of action arose

Use of lawyers: Permitted but not required

Miscellaneous: Cases come before a justice of the peace

WISCONSIN

Claim limit: $500

Jurisdiction: District where defendant resides or where cause of action arose

Use of lawyers: Permitted but not required

WYOMING

Claim limit: $100

Jurisdiction: District where defendant resides or where cause of action arose

Use of lawyers: Permitted but not required

Miscellaneous: Cases come before a justice of the peace

American Arbitration Association Regional Offices

ARIZONA
Security Center
Suite 669
222 North Central Avenue
Phoenix, AZ 85004
(602) 252-7357

CALIFORNIA
443 Shatto Place
Los Angeles, CA 90020
(213) 383-6516

San Diego Trust and Savings Bank
 Bldg.
Suite 909
530 Broadway
San Diego, CA 92102
(714) 239-3051

690 Market Street
Suite 800
San Francisco, CA 94104
(415) 981-3901

CONNECTICUT
37 Lewis Street
Room 406
Hartford, CT 06103
(203) 278-6000

DISTRICT OF COLUMBIA
1730 Rhode Island Avenue NW
Suite 509
Washington, DC 20036
(202) 296-8510

FLORIDA
2250 S.W. Third Avenue
Miami, FL 33129
(305) 854-1616

GEORGIA
Equitable Building
100 Peachtree Street
Atlanta, GA 30303
(404) 788-4151

ILLINOIS
180 North LaSalle Street
Suite 1025
Chicago, IL 60601
(312) 346-2282

MASSACHUSETTS
294 Washington Street
Boston, MA 02108
(617) 542-1071

MICHIGAN
City National Bank Building
Suite 1234
645 Griswold Street
Detroit, MI 48226
(313) 964-2525

MINNESOTA
Foshay Tower,
Suite 1001
821 Marquette Avenue
Minneapolis, MN 55402
(612) 335-6545

NEW JERSEY
96 Bayard Street
New Brunswick, NJ 08901
(201) 247-6080

NEW YORK
585 Stewart Avenue
Garden City, NY 11530
(516) 222-1660

140 West 51 Street
New York, NY 10020
(212) 977-2090

731 James Street
Syracuse, NY 13203
(315) 472-5483

34 South Broadway
5th Floor
White Plains, NY 10601
(914) 946-1119

NORTH CAROLINA
3235 Eastway Drive
Suite 205
Charlotte, NC 28218
(704) 568-5420

OHIO
Carew Tower
Suite 2308

441 Vine Street
Cincinnati, OH 45202
(513) 241-8434

215 Euclid Avenue
Room 930
Cleveland, OH 44114
(216) 241-4741

PENNSYLVANIA
1520 Locust Street
12th Floor
Philadelphia, PA 19102
(215) 732-5260

Two Gateway Center
Pittsburgh, PA 15222
(412) 261-3617

TEXAS
Praetorian Building
Suite 1115
1607 Main Street
Dallas, TX 75201
(214) 748-4979

WASHINGTON
Central Building
Room 310
810 Third Avenue
Seattle, WA 98104
(206) 622-6435

AAA COMMUNITY DISPUTE SERVICES

CALIFORNIA
443 Shatto Place
Los Angeles,CA 90020
(213) 383-6683

690 Market Street
Suite 800
San Francisco, CA 94104
(415) 981-3901

DISTRICT OF COLUMBIA
1730 Rhode Island Avenue NW
Suite 509
Washington, DC 20036
(202) 296-8510 and (202) 296-2533

MASSACHUSETTS
294 Washington Street
Boston, MA 02108
(617) 542-2278

NEW YORK
36 West Main Street
Room 410
Rochester, NY 14614
(716) 546-5110

OHIO
177 South Broadway Street
Room 438
Akron, OH 44308
(216) 762-8636

215 Euclid Avenue
Room 930
Cleveland, OH 44114
(216) 241-4741

Photographic and Picture Sources

The following list of photographic and picture sources is not intended to be all-encompassing; it is simply a partial list culled from various sources.

SOURCES OF 2 × 2-INCH COLOR SLIDES

General

Alpha Photo Associates
251 Park Avenue South
New York, NY 10010

Blackhawk Films
The Eastin-Phelan Corporation
1235 West Fifth Street
Davenport, IA 52808

The Center for Humanities, Inc.
2 Holland Avenue
White Plains, NY 10603

Donars Productions
P.O. Box 24
Loveland, CO 80537

Marc Ellefsen
Ellefsen Communications, Inc.
8 East Boulevard, St-Joseph
Montreal, Quebec, H2T 1G8

Freelance Photographers Guild, Inc.
251 Park Avenue South
New York, NY 10010

Mrs. Martine Gilschrist
22 East 78 Street
New York, NY 10021

Librairie Beauchemin Limitée
450 Avenue Beaumont
Montreal, Quebec H3N 1T8

Media Systems, Inc.
3637 East 7800 South
Salt Lake City, UT 84121

Meston's Travels, Inc.
3801 North Piedras Street
El Paso, TX 79930

G.P. Slides, Inc.
2608 Sunset Boulevard
Houston, TX 77005

National Film Board of Canada
1251 Avenue of the Americas
New York, NY 10020

Photography for Environments
 Limited
745 Fifth Avenue
New York, NY 10022

Photo Lab, Inc.
3825 Georgia Avenue NW
Washington, DC 20011

Rolf Slide Laboratories, Inc.
21 Schoen Place
Pittsford, NY 14534

Roloc Color Slides
Lt. Col. M.W. Arps, Jr., A.U.S.
 Retired
P.O. Box 1715
Washington, DC 20013

The Skills Group
2 Holland Avenue
North White Plains, NY 10603

Singer/Society for Visual Education
1345 Diversey Parkway
Chicago, IL 60614

Walt Sterling Color Slides and Color
 Postcards
224 Haddon Road
Suite 100
Woodmere, NY 11598

Architecture and Arts

American Crafts Council
44 West 53 Street
New York, NY 10019

American Museum of Natural
 History
Photography Department
Central Park West at 79 Street
New York, NY 10024

Architectural Color Slides
Franziska Porges
187 Grant Street
Lexington, MA 02173

Architectural Delineations
World Architecture Slide Program
20 Waterside Plaza
New York, NY 10010

Barney Burstein
29 Commonwealth Avenue
Boston, MA 02116

Color Slide Enterprises
P.O. Box 150
Oxford, OH 45056

Educational Art Transparencies
27 West Summit Street
Chagrin Falls, OH 44022

Environmental Communications
64 Windward Avenue
Venice, CA 90291

ESM Documentations
Suite 204
114 Liberty Street
New York, NY 10006

European Art Color Slides
Peter Adelberg, Inc.
120 West 70 Street
New York, NY 10023

Douglas Grimm
Route 7, West Rattlesnake
Missoula, MO 59801

Photo Lab, Inc.
3825 Georgia Avenue NW
Washington, DC 20011

Prothmann Associates, Inc.
650 Thomas Avenue
Baldwin, NY 11510

Sandak, Inc.
180 Harvard Avenue
Stamford, CT 06902

Scala Fine Arts Publishers, Inc.
28 West 44 Street
New York, NY 10036

Singer/Society for Visual Education
1345 Diversey Parkway
Chicago, IL 60614

Universal Color Slides Co.
136 West 32 Street
New York, NY 10001

Visual Media for the Arts and
 Humanities
Box 737
Cherry Hill, NJ 08003

Walters Art Gallery
Museum Store
600 North Charles Street
Baltimore, MD 21201

Religion

National Cathedral Association Slide
 Lectures
Washington Cathedral
Washington, DC 20016

University Slide Sets
1657 Sawtelle Boulevard
Los Angeles, CA 90025

Science, Medicine, and Nature

Alaska Wildlife Films and Slides
Cecil and Helen Rhode
Cooper Landing, AK 99572

American Dental Association
211 East Chicago Avenue
Chicago, IL 60611

American Meteorite Laboratory
P.O. Box 2098
Denver, CO 80201

American Museum of Natural
History
Central Park West at 79 Street
New York, NY 10024

Harwyn Medical Photographers
1001 City Avenue
Suite 918 W.B.
Philadelphia, PA 19151

Imperial Educational Resources
P.O. Box 7068
4900 South Lewis Avenue
Tulsa, OK 74105

Matson's Audiovisual
P.O. Box 308
Milltown, MO 59851

Eugene Memmier
Natural Science Films
3287 Dunsmere Road
Glendale, CA 91206

U.S. Department of Agriculture
Office of Information
Washington, DC 20250

Outdoor Eduquip
Wilderness Leadership Center
North Fork, CA 93643

Outdoor Pictures
P.O. Box 277
Anacortes, WA 98221

Bird Photographs, Inc.
254 Sapsucker Woods Road
Ithaca, NY 14850

Camera M.D. Studios, Inc.
Library Division
122 East 76 Street
New York, NY 10021

CIBA Pharmaceutical Company
Medical Education Division
Summit, NJ 07901

Clay-Adams, Division of Becton
Dickinson & Co.
299 Webro Road
Parsippany, NJ 07054

Cleveland Health Education Museum
9811 Euclid Avenue
Cleveland, OH 44106

Cornell University
Laboratory of Ornithology
Department K
159 Sapsucker Woods Road
Ithaca, NY 14853

Esteday Nature Photography
7603 North Pennsylvania Street
Indianapolis, IN 46240

Science and Mankind, Inc.
2 Holland Avenue
White Plains, NY 10603

Scientificom
708 North Dearborn Street
Chicago, IL 60610

Singer/Society for Visual Education
1345 Diversey Parkway
Chicago, IL 60614

Jeff D. Swinebroad, Wildlife
Photographer
P.O. Box 927
Frankfort, KY 40601

Media Library
Towsley Center for Continuing
Medical Education
University of Michigan
Ann Arbor, MI 48109

Ward's Natural Science
Establishment, Inc.
P.O. Box 1712
Rochester, NY 14603

Wolfe Worldwide Films
1657 Sawtelle Boulevard
Los Angeles, CA 90025

Travel and Scenics

GAF Corporation
Consumer Photo Division
Pana-Vue Scenic Slides
P.O. Box 444
Portland, OR 97207

Photo Lab, Inc.
3825 Georgia Avenue NW
Washington, DC 20011

The Preservation Society of Newport
County
Washington Square
Newport, RI 02840

Mike Roberts Color Productions, Inc.
2023 Eighth Street
Berkeley, CA 94710

Walt Sterling Color Slides and Color
Postcards
Suite 100
224 Haddon Road
Woodmere, NY 11598

Transparencias de Mexico
Paul Stade
Calle Gral. Molinos del Campo 36
Mexico 18, D.F., Mexico

Wolfe Worldwide Films
1657 Sawtelle Boulevard
Los Angeles, CA 90025

World Color Slides
Division of Rolf Slide Laboratories,
Inc.
P.O. Box 129
Pittsford, NY 14534

SOURCES OF PHOTOGRAPHS AND PICTURES

Animals Animals Enterprises
203 West 81 Street
New York, NY 10024
(212) 580-9595
Stock photographs of birds, fish,
insects, and mammals

Architectural Color Slides
187 Grant Street
Lexington, MA 02173
(617) 862-9431
25,000 slides of buildings, cities, and
urban life

Arizona Photographic Associates, Inc.
2350 West Holly
Phoenix, AZ 85009
(602) 258-6551
More than 300,000 stock photos of
Arizona, western America, Alaska,
and Hawaii

Peter Arnold Inc.
1500 Broadway
New York, NY 10036
(212) 840-6928 Telex: 428281
Specializes in anthropology,
biomedical, human interest,
industry, photomicrography

BBM Associates
Box 24
Berkeley, CA 94701
(415) 848-5826

William C. Baughman
1190 Yellowstone Road
Cleveland, OH 44121
(216) 382-7192
Stock photos of Cleveland

Bettmann Archive, Inc.
136 East 57 Street
New York, NY 10022
(212) 758-0362

Black Star Publishing Company
450 Park Avenue South

New York, NY 10016
(212) 679-3288
Represents 100 photographers in the
United States and thirty-two
countries overseas; assignment
work and stock photographs

Raimondo Borea Photography
245 West 104 Street
New York, NY 10025
(212) 663-4463
File of animals, children, industrial,
nature, personalities

Ray Boultinghouse, Inc.
Box 12
Kent, CT 06757
(203) 679-7950

Dennis Brokaw Photography
Box 273
Carmel, CA 93921
(408) 624-6133

Cactus Clyde Productions
Box 14876
Baton Rouge, LA 70808
(504) 387-3704
More than 10,000 transparencies of
wildlife and related subjects

Camera Clix
Division of Globe Photos, Inc.
404 Park Avenue South,
New York, NY 10016
(212) 684-3526
More than 500,000 stock
transparencies in large format 4 × 5
to 8 × 10

Alan Caruba
Box 40
9 Brookside Road
Maplewood, NJ 07040
(201) 763-6392
Collection of author portraits and
candid photos

Walter Chandoha Photography
Annandale, NJ 08801
(201) 782-3666
More than 100,000 Chandoha-made
 stock photographs of animal,
 horticulture, and nature subjects

Bruce Coleman, Inc.
381 Fifth Avenue
New York, NY 10016
(212) 683-5227
Comprehensive library of original
 color transparencies

College Newsphoto Alliance
EPA Newsphoto Affiliate
342 Madison Avenue
New York, NY 10017
(212) 697-1136
Combined photographic output of
 major university newspapers in the
 United States and Canada

Creative Services
Box 5162
Carmel, CA 93921
(408) 624-7573
Prints of old California

CYR Color Photo Agency
Box 2148
Norwalk, CT 06852
(203) 838-8230
100,000 stock color transparencies

Design Photographers International,
 Inc. (DPI)
521 Madison Avenue
New York, NY 10022
(212) 752-3930
All subjects

Leo DeWys, Inc.
60 East 42 Street
New York, NY 10017
(212) 986-3190
Africa, Asia, the Americas, sports,
 industrial, human interest

Eastfoto Agency
25 West 43 Street
New York, NY 10036
(212) 921-1922
Photographs from Eastern Europe

Engel Associates
Schillings Crossing Road
Canaan, NY 12029
(518) 781-4171
Specialists in auto-racing photographs

European Art Color/Peter Adelberg
120 West 70 Street
New York, NY 10023
(212) 877-9654
Color transparencies from art media

Free Lance Photographers Guild, Inc.
 (FPG)
251 Park Avenue South
New York, NY 10010
(212) 777-4210
1 million subjects in color, 5 million
 in B&W

Globe Photos, Inc.
404 Park Avenue South
New York, NY 10016
(212) 689-1340
10 million photos on all subjects

The Granger Collection
1841 Broadway
New York, NY 10023
(212) 586-0971 Cable: Illustrate New
 York
General historical picture collection

Berne Greene
1833 S.E. Seventh Avenue
Suite 5
Portland, OR 97214
(503) 232-5964
More than 250,000 photos

Gabriel D. Hackett Photo Archives
130 West 57 Street
New York, NY 10019
(212) 265-6842
Exclusive pix

Grant Heilman Photography
Box 317
Lititz, PA 17543
(717) 626-0296
100,000 stock photographs of
 agriculture, zoology, natural and
 earth sciences

Historical Pictures Service, Inc.
Steven Building
17 North State Street
Suite 1700
Chicago, IL 60602
(312) 346-0599
3 million rare historical prints and
 photographs

Cliff Hollenbeck Photography
Box 98901
Seattle, WA 98188
(206) 824-7700
Stock file color transparencies and
 B&W: Alaska, Canada, Hawaii, the
 Northwest

Jeroboam, Inc.
1041 Folsom
San Francisco, CA 94103
(415) 863-7975
Stock photographic agency supplying
 documentary and editorial

Keystone Press Agency, Inc.
156 Fifth Avenue
New York, NY 10010
(212) 924-8123
News and feature picture service

Jill Krementz
228 East 48 Street
New York, NY 10017
(212) 688-0480
Portraits, photojournalism, American
 scenery, children

Robert Lee II
1512 Northlin Drive
St. Louis, MO 63122
(314) 965-5832
26,000 color slides

Lewischam Productions, Ltd.
663 Fifth Avenue
New York, NY 10022
(212) 753-4493

Liaison Agency, Inc.
150 East 58 Street
New York, NY 10022
(212) 355-7310
Represents top photographers in the
 United States and overseas

Library of Congress
Prints and Photographs Division
Reference Section
Washington, DC 20540
(202) 426-5836

Life Picture Service
Time-Life Building
1271 Avenue of the Americas
Room 2858
New York, NY 10020
(212) 556-4800

Lincoln Farm Teen Camp
140 Heatherdell Road
Ardsley, NY 10502
(914) 693-4222
B&W photos of teen-agers

Magnum Photos, Inc.
15 West 46 Street
New York, NY 10036
(212) 541-7570
Selective historical archives

NYT Pictures
Division of the New York Times
229 West 43 Street
New York, NY 10036
(212) 556-1234
Photojournalism, personalities

New West Agency
Box 4574
1350 Santa Fe
Denver, CO 80204
(303) 449-7450
Outdoor photography

Photofile Ltd.
76 Madison Avenue
New York, NY 10016
(212) 989-0500

PhotoPhile
2311 Kettner Boulevard
San Diego, CA 92101
(714) 234-4431
Specializing in international travel

H. Armstrong Roberts
4203 Locust Street
Philadelphia, PA 19104
(215) 386-6300
Contemporary stock photographs

Scala Fine Arts Transparencies
342 Madison Avenue
New York, NY 10017
(212) 354-9646; (212) 697-1136
Color transparencies of more than
 50,000 art objects

Seakaibunka Photo
501 Fifth Avenue
New York, NY 10017
(212) 490-2180 Cable: Sebunpub
 New York
Japan, Far East

Shostal Associates, Inc.
60 East 42 Street
New York, NY 10017
(212) 687-0696
Color file covering every subject of
 general interest

Bradley Smith Photography
5858 Desert View Drive
LaJolla, CA 92037
(714) 454-4321
Files from fine books; erotic
 paintings, scenics

Sovfoto
25 West 43 Street
New York, NY 10036
(212) 921-1922
Photo coverage from the USSR

Sports Illustrated
Picture Sales Department
Time-Life Building
1271 Avenue of the Americas
New York, NY 10020
(212) 841-3663
Stock photography and assignments

Stock, Boston
739 Boylston Street
Boston, MA 02116
(617) 266-2573
Edited files of contemporary
 photographs

Taurus Photos
118 East 28 Street
New York, NY 10016
(212) 683-4025
Marine life, Europe, Russia

Time Inc.
Life Picture Service

Time-Life Building
1271 Avenue of the Americas
New York, NY 10020
(212) 841-4800

UniPhoto
1219 Wisconsin Avenue NW
Box 3678
Washington, DC 20007
(202) 333-0500
Photo library, film strips

United States Naval Institute
Annapolis, MD 21402
(301) 268-6110

Van Cleve Photography, Inc.
Box 1366
Evanston, IL 60204
(312) 475-4960
2 million up-to-date color
 transparencies

Visual World
Box 804
Oak Park, IL 60303
(312) 524-0405

Webb Photos
1999 Shepard Road
St. Paul, MN 51116
(612) 647-7317
125,000 color, 35 mm and $2\frac{1}{4} \times 2\frac{1}{4}$
 for editorial and advertising

Wide World Photos, Inc.
50 Rockefeller Plaza
New York, NY 10020
(212) 262-6300
Feature and news photographs in all
 fields (subsidiary of the Associated
 Press)

Photography Guilds and Organizations

American Association of School
 Photographers, Inc.
3555 Cowan Place
Jackson, MS 39216

American Photographic Artisans
 Guild
1090 Executive Way
Des Plaines, IL 60018

American Racing Press Association
68 Weston Road
Weston, CT 06880

American Society of
 Cinematographers
Box 2230
1782 North Orange Drive
Hollywood, CA 90028

American Society of Magazine
 Photographers
205 Lexington Avenue
New York, NY 10016

American Society of Photogrammetry
105 North Virginia Avenue
Falls Church, VA 22046

American Society of Photographers
1090 Executive Way
Des Plaines, IL 60018

American Society of Picture
 Professionals
Box 5283
Grand Central Station
New York, NY 10017

Architectural Photographers
 Association
435 North Michigan Avenue
Suite 1717
Chicago, IL 60611

Associated Photographers
 International
Box 206
Woodland Hills, CA 91365

Association of Audio Visual
 Technicians
P.O. Box 19268
Denver, CO 80219

Association for Educational
 Communications and Technology
1201 16 Street NW
Washington, DC 20036

Association of Federal Photographers
7210 Tyler Avenue
Falls Church, VA 22042

Association of Graphic Equipment
 Repairmen
Box 230
Lynn, MA 01902

Association for Multi-Image
947 Old York Road
Abington, PA 19001

Atlanta Press Photographers
 Association
Box 562
Atlanta, GA 30301

Association of Professional Color
 Laboratories
603 Lansing Avenue
Jackson, MS 49202

Biological Photographic Association
6650 Northwest Highway
Chicago, IL 60631

Boston Press Photographers
 Association
Box 122
Boston, MA 02101

California Press Photographers
 Association
2452 40 Avenue
Sacramento, CA 95822

Canadian Photographic Trade
 Association
94 Lakeshore Road East
Mississauga, Ontario L5G 1E3 Canada

Chicago Press Photographers
 Association
211 East Chicago Avenue
Chicago, IL 60611

Colorado Press Photographers
 Association
1711 South Newport Way
Denver, CO 80202

Connecticut News Photographers
 Association
180 Goodwin Street
Bristol, CT 06010

Cooperstate Press Photographers
 Association
Box 465
Tempe, AZ 85281

Dakotas Press Photographers
 Association
2929 8 Street
Fargo, ND 58102

Educational Film Library Association
43 West 61 Street
New York, NY 10023

Evidence Photographers International
601 Brookview Court
Oxford, OH 45056

Federal and International Media
 Communicators
Box 23620
L'Enfant Post Office
Washington, DC 20024

Graphic Arts Technical Foundation
4615 Forbes Avenue
Pittsburgh, PA 15213

Gravure Technical Association
60 East 42 Street
New York, NY 10017

Houston Gulf-Coast News
 Photographers Association
12411 Longbrook
Houston, TX 77072

Film and Video Communicators/IFPA
3518 Cahuenga Boulevard West
Hollywood, CA 90068

Illinois Press Photographers
 Association
3345 West 91 Street
Evergreen Park, IL 60642

Indiana News Photographers
 Association
3930 Ivory Way
Indianapolis, IN 46227

Industrial Photographers Association
 of New York
c/o Sanford Speiser
51 West 52 Street
New York, NY 10019

Industrial Photographers Association
 of New Jersey
232 Central Avenue
Caldwell, NJ 07006

Information Film Producers of
 America
Box 1470
Hollywood, CA 90028

International Fire Photographers
 Association
588 West De Koven Street
Chicago, IL 60647

International Photographers
 Association
2063 North Leavitt
Chicago, IL 60647

International Photographers of
 Motion Picture Industry
Local 644
250 West 57 Street
New York, NY 10019

International Photo Optics
 Association
1156 Avenue of the Americas
New York, NY 10036

International Society for
 Photogrammetry
Piazza Leonardo Da Vinci, 32
Milan, Italy 20133

International Color Council
c/o Department of Chemistry
Rensselaer Polytechnic Institute
Troy, NY 12181

Michigan Press Photographers
 Association
Box 1731
Grand Rapids, MI 49501

Milwaukee Press Photographers
 Association
35 East Van Norman Avenue
Cudahy, WI 53110

National Association of Government
 Communicators
P.O. Box 1590
Arlington, VA 22210

National Association of Photographic
 Equipment Technicians
1240 Mt. Olive Road
Washington, DC 20002

National Association of Photographic
 Manufacturers
600 Mamaroneck Avenue
Harrison, NY 10528

National Audio-Visual Association
3150 Spring Street
Fairfax, VA 22030

National Directory of Camera
 Collectors
Box 4246
Santa Barbara, CA 93103

National Free Lance Photographers
 Association
4 East State Street
Doylestown, PA 18901

National Microfilm Association
8728 Colesville Road
Silver Spring, MD 20910

National Press Photographers
 Association
Box 1146
Durham, NC 27702

Nebraska Press Photographers
 Association
206 Avery Hall
University of Nebraska
Lincoln, NB 68508

New Jersey Press Photographers
 Association
91 Douglas Street
Lambertville, NJ 08530

New York Press Photographers
 Association
225 East 36 Street
New York, NY 10016

Ohio News Photographers Association
1446 Conneaut Avenue
Bowling Green, OH 43402

Oklahoma News Photographers
 Association
830 Crestview
Ada, OK 74820

Opthalmic Photographers Society
Cabrini Health Care Center
227 East 19 Street
New York, NY 10003

Pennsylvania Press Photographers
 Association
1919 South Broad Street
Lansdale, PA 19446

Photo Chemical Machinery Institute
1717 Howard Street
Evanston, IL 60201

Photo Marketing Association
603 Lansing Avenue
Jackson, MS 49202

Photographic Administrators
3 Province Lane
Glen Head, NY 11545

Photographic Credit Institute
370 Lexington Avenue
New York, NY 10017

Photographic Historical Society of
 America
Box 1839
Radio City Station
New York, NY 10019

Photographic Manufacturers and
 Distributors Association
866 UN Plaza
New York, NY 10017

Photographic Society of America
2005 Walnut Street
Philadelphia, PA 19103

Press Photographers Association of
Long Island, New York
5 Firelight Court
Dix Hills, NY 11746

Professional Photographers Guild of
Florida
Box 1307
Homestead, FL 33030

Professional Photographers of
America
1090 Executive Way
Des Plaines, IL 60618

Professional Photographers of Canada
318 Royal Bank Building
Edmonton, Alberta T5J 1W8, Canada

Professional Photographers of San
Francisco
44 Montgomery Street
San Francisco, CA 94104

Puget Sound Press Photographers
Association
16823 First Street SE
Bothell, WA 98011

Royal Photographic Society
145 Audley Street
London, W1, England

Société Française de Photographie et
de Cinématographie
9 rue Montalembert
Paris, France VII

Society for Photographic Education
Box 1651
FDR Station
New York, NY 10022

Society of Motion Picture and
Television Engineers
862 Scarsdale Avenue
Scarsdale, NY 10583

Society of Northern Ohio Professional
Photographers
23611 Chargin Boulevard
Beachwood, OH 44122

Society of Photo-Optical
Instrumentation Engineers
Box 10
405 Fieldston Road
Bellingham, WA 98225

Society of Photographers and Artists
Representatives
Box 845
FDR Station
New York, NY 10022

Society of Photographic Scientists and
Engineers
1411 K Street NW
Washington, DC 20005

Society of Photo-Optical
Instrumentation Engineers
338 Tejon Place
Palos Verdes Estates, CA 90274

Society of Photo-Technologists
Box 3174
Aurora, CO 80041

South Florida News Photographers
Association
Box 3107
Miami, FL 33101

Studio Suppliers Association
548 Goffle Road
Hawthorne, NJ 07506

Underwater Photography Society
Box 15921
Los Angeles, CA 90015

United States Senate Press
Photography Gallery
United States Senate
Room S-317
Washington, DC 20510

University Photographers Association
of America
c/o Photographic Services
Department
Austin Peay University
Clarksville, TN 37040

Wedding Photographers of America
Box 66218
Los Angeles, CA 90066

White House News Photographers
Association
1515 L Street NW
Washington, DC 20005

Index